Michelangelo

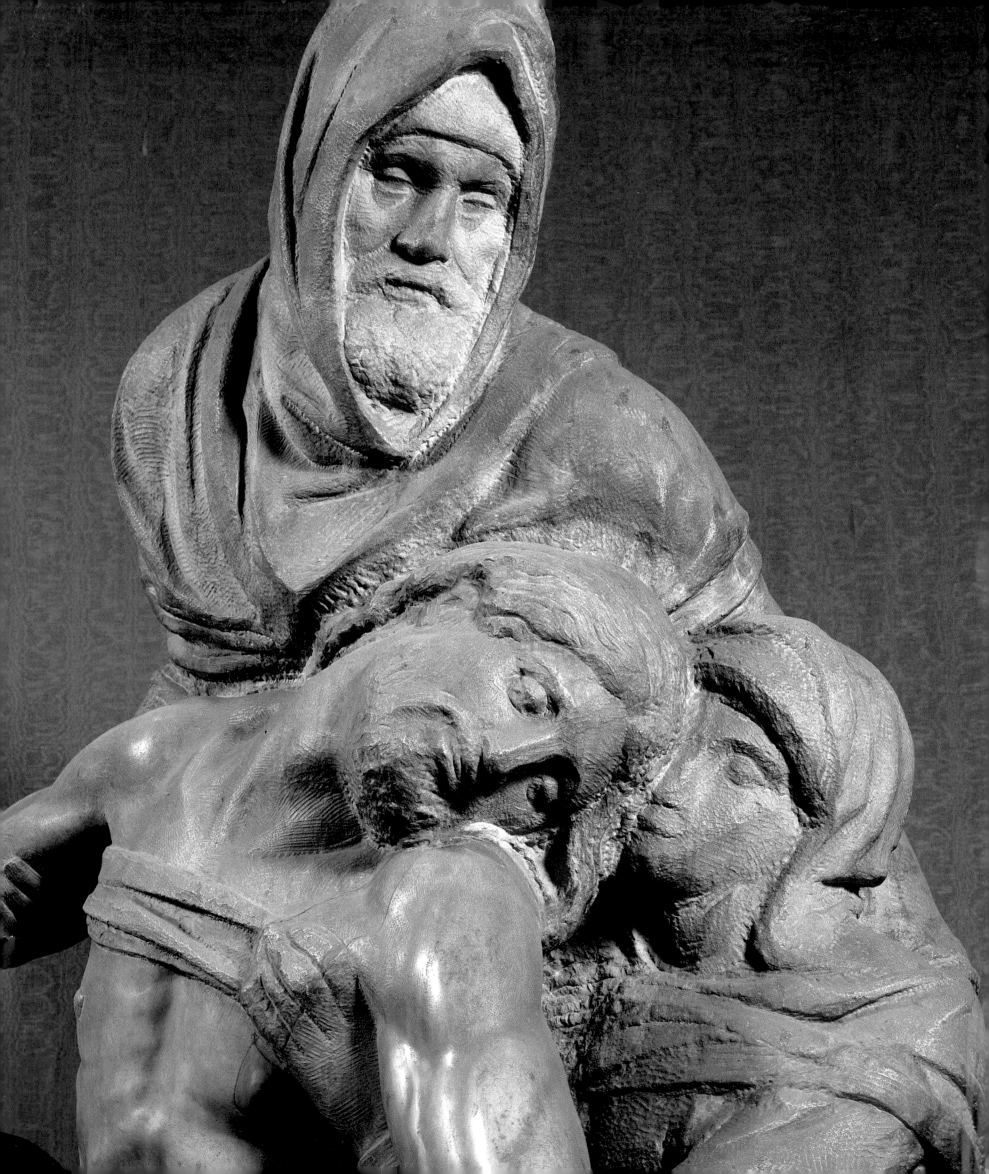

Gabriele Bartz
Eberhard König

Michelangelo

Buonarroti

1475–1564

KÖNEMANN

1 (frontispiece)
Pietà (detail ill. 116), started before 1550
Marble, h. 226 cm
Museo dell'Opera del Duomo, Florence

© 1998 Könemann Verlagsgesellschaft mbH
Bonner Str. 126, D-50968 Köln

Art Director: Peter Feierabend
Project Manager and Editor: Sally Bald
Assistant: Susanne Hergarden
German Editor: Ute E. Hammer
Assistant: Jeannette Fentroß
Translation from the German: Christian von Arnim
Contributing Editor: Michael Scuffil
Production Director: Detlev Schaper
Assistant: Nicola Leurs
Layout: Marc Wnuck
Typesetting: Greiner & Reichel, Cologne
Reproductions: Omniascanners, Milan
Printing and Binding: Neue Stalling, Oldenburg
Printed in Germany

ISBN 3-8290-0253-X
10 9 8 7 6 5 4 3 2 1

Contents

ART BETWEEN THE DIVINE AND THE TERRIBLE

With the advent of Michelangelo, attitudes towards the artist change: immortalized in a self portrait which depicts the horror of the flayed skin of the Apostle Bartholomew below Christ sitting in judgement on the world (ill. 99), Michelangelo became the subject of younger artists who made bronze busts of him even during his lifetime. In his features they sought the traces of an extraordinary existence, already engrained in his face during his youth with a nose broken by Torrigiani; they sought his solitary, unique character in order to express in the image of this Titan the contrast between the toughened face of the old man and the beauty of his universal art.

No one changed the image of the artist so thoroughly and recast it for posterity so decisively as did Michelangelo Buonarroti. Even his contemporaries referred to him as the divine or terrible, accorded him *divinità* or *terribilità* (ill. 2). In a world in which all experience was based in the glorious lost past of Antiquity, he made a new beginning. Michelangelo, more even than Raphael or Leonardo, embodies a standard of artistic genius which reveals a radically changed image of human beings and their potential and no longer has anything to do with craft traditions.

It was not because his character or his works were agreeable that the great painter from Florence, who became one of the most important sculptors and architects of all time, had such an effect on his surroundings and future generations. On the contrary, Michelangelo's personal manner as well as his works divided opinions, aroused ridicule and outright rejection. Thus he alone was accorded the unenviable honor of seeing one of his works, *The Last Judgement* in the Sistine Chapel of the Vatican (ills. 93–99), debated by a Council and thereafter heavily reworked by another painter.

His work made clear to the educated world for the first time that in art it was not the patron but the artist who might be right; did Michelangelo not show that a painter and sculptor was able to defy unpunished even the Pope in Rome? He did not need to pay homage in his works to the great figures of the world by placing their actions in a better light, as artists have done at all times. His patrons were sufficiently satisfied if this stubborn and difficult, dismissive and strange man honored them by working for them at all. What he delivered was soon no longer measured by the traditional standards of the artistic craftsman; even his unfinished work, sometimes rough-hewn pieces, provided sufficient evidence of his genius.

In no way did the artist subject himself to the standards of his time. Unmarried and without an appropriate household, he should not have been allowed to practice his art at all in communities with strict craft laws. It is true, of course, that Michelangelo did not come from artisan stock, but from an upper-class family which counted itself among Florence's aristocracy and could look back to an impressive past in the 14th century but had largely lost its importance in the artist's youth. Such an artistic personality was unthinkable in any context other than those of the Medici in Florence and the papal court in Rome. Within two generations, the Medici had achieved a quasi-princely position without thereby negating the city's constitution; this, however, also guaranteed the members of their court privileges outside the normal order of things. The young Michelangelo profited from this. It was, nevertheless, always true that at any opportunity his heart beat for the Republic of Florence rather than for the princely house of the Medici.

Art served Michelangelo as an ideal way to restore his family's position. In doing so, the artist followed a social pattern which he saw in the popes: Like them, he did not found a family himself and had neither wife nor children. All his patronage went to his nephews, as was the case in the large papal families. But in contrast to the spiritual princes of his time, his personal requirements remained completely modest. The money which he earned in his long life was used to purchase houses in Florence and large estates, as was the norm in the lower strata of the aristocracy. Indeed, through his art he laid the foundation stone for the ennoblement of the Buonarroti which still finds visible and monumental expression today in an impressive Florentine palace, the Casa Buonarroti, in the quarter where Michelangelo used to live near Santa Croce.

It is not only in this respect that Michelangelo opened up the horizons of a profession whose members had been regarded as craftsmen and no more. More intensely than any artist before him, he linked his person and character with his work, presented himself to the world as a titanic genius whose dark side came to expression almost violently in his work. By this means he introduced an ethic into art which turns the artist struggling with himself into the object of the way that art is observed. But Michelangelo was not alone in this linkage between art and life, between the human image presented in the works and his individual character. The striking difference between his own characteristic style and personal attitude and the friendly image of the young Raphael (1483–1520) gave each of the two

artists at the papal court in the first two decades of the 16th century that unique character which was to remain unforgettable over half a millennium.

The breakthrough of the artist to an unprecedented level of self-confidence as an individual did not occur in some remote place but – and this is the most astonishing thing about Michelangelo – at the center of an old power which was under threat from two sides. For after a short introductory phase, the artist worked exclusively for the papacy at a time when the Reformation was calling its authority into doubt and the Habsburg emperor Charles V, who had remained true to the old faith, had his army sack the Eternal City in 1527.

THE BEGINNINGS IN FLORENCE AND ROME

3 *Madonna of the Stairs (Madonna della Scala)*,
ca. 1489–1492
Marble, 55.5 x 40 cm
Casa Buonarroti, Florence

This first sculpture still extant is related technically and in terms of motif to Donatello (ill. 16), in stark contrast to the *Battle of the Centaurs* (ill. 4) which was created a short while later. The small boy intimately snuggles into his mother's breast. Mary has lifted her garment so that the little head is almost covered and the child appears from the back. Gently Christ's right arm rests on the left arm of the Mother of God, providing a beautiful alignment of the back of the adult woman's hand with the palm of the infant's hand. Mary's classical profile is framed by cloth, her nimbus bumps against the head of a putto in the relief, who is actually playing further in the background.

Michelangelo Buonarroti was born on 6 March 1475 in the Tuscan village of Caprese. His father was a minor official in Florence but came from a family which had achieved standing and a certain degree of wealth in the 14th century. The family had a house in Florence and a country house outside the city, and the boy grew up in both of them. A decisive influence on the inner development of the future artist may have been the early death of his mother, which occurred when he was six years old. Yet given the lower life expectancy of the time, he shared this fate with many of his contemporaries.

Motifs are evident in the reports about Michelangelo's early life which return in the lives of numerous later artists. Thus he came to art in conflict with his father. Against the latter's will – he had planned an appropriate career as an official for his son – he is said to have asserted his wish to become a painter. At thirteen years of age, in 1488, he was apprenticed to Domenico Ghirlandaio (1449–1494), the leading fresco painter in the city. Michelangelo retained more of Ghirlandaio's art than is evident from his biography. For during the next year he left the studio, which was occupied with the monumental cycle for the Tornabuoni family in the Dominican church of Santa Maria Novella.

Even Michelangelo's first artistic essays must have created a stir. This is evident from reports that he already upset Ghirlandaio with his drawings in the master's studio – which may not have been altogether true. Be that as it may, Michelangelo's life was given a decisive turn when Florence's ruler, Lorenzo de' Medici, who will be remembered as *Il Magnifico*, "the Magnificent", took the 15-year-old into his palace in 1490.

By doing so, the prince removed the young apprentice painter from the social context of the guilds, so that henceforth Michelangelo was no longer subject to the restrictions of their regulations. One practical result of this may have been that he became interested in sculpture. The Medici palace not only contained gardens with important classical sculptures but also an artist who impressed the young man: Bertoldo di Giovanni (ca. 1440–1491), who in the Medici church of San Lorenzo across from the palace had completed the pulpit reliefs started by his teacher, the unforgotten Donatello (1386–1466). But in contrast to many successors to a great master, Bertoldo had not adopted Donatello's gentle way and diluted it further; on the contrary, he emphasized the austere characteristics of the existing model. His work appears to have taught the young Michelangelo above all that the important thing is not that art should be pleasing, but that its expression should be unmistakable, even if this does cause irritation and dislike.

Michelangelo's change from painting to sculpture could no more be taken for granted than the idea of a "universal genius". There had been masters before, like Andrea del Verrochio (1436–1488), who had worked in Florence both as painters and as sculptors and bronze casters. But his way of working was far removed from the rules which governed the business life and production of the time.

Nevertheless, Leonardo (1452–1519) imitated his master Verrochio in the service of the Sforza in Milan when, as a painter, he designed an equestrian statue for them in bronze. Michelangelo may have followed the example of such artists in taking the liberty, as a youth in the Medici palace, of overcoming the barriers between the arts. Indeed, he assumes a completely new role in the history of artistic training. For after he broke off his apprenticeship with Ghirlandaio he became part of the first generation of up-and-coming artists to be trained in what was a kind of academy. While he had to acquire his technical skills largely for himself, intellectually he was fostered from two sides. Donatello's aged pupil pointed out to him the artistic traditions of his own city, and scholars such as Agnolo Poliziano, tutor to the Medici, acquainted the young artist with the spiritual traditions of Antiquity in the context of Florentine humanism.

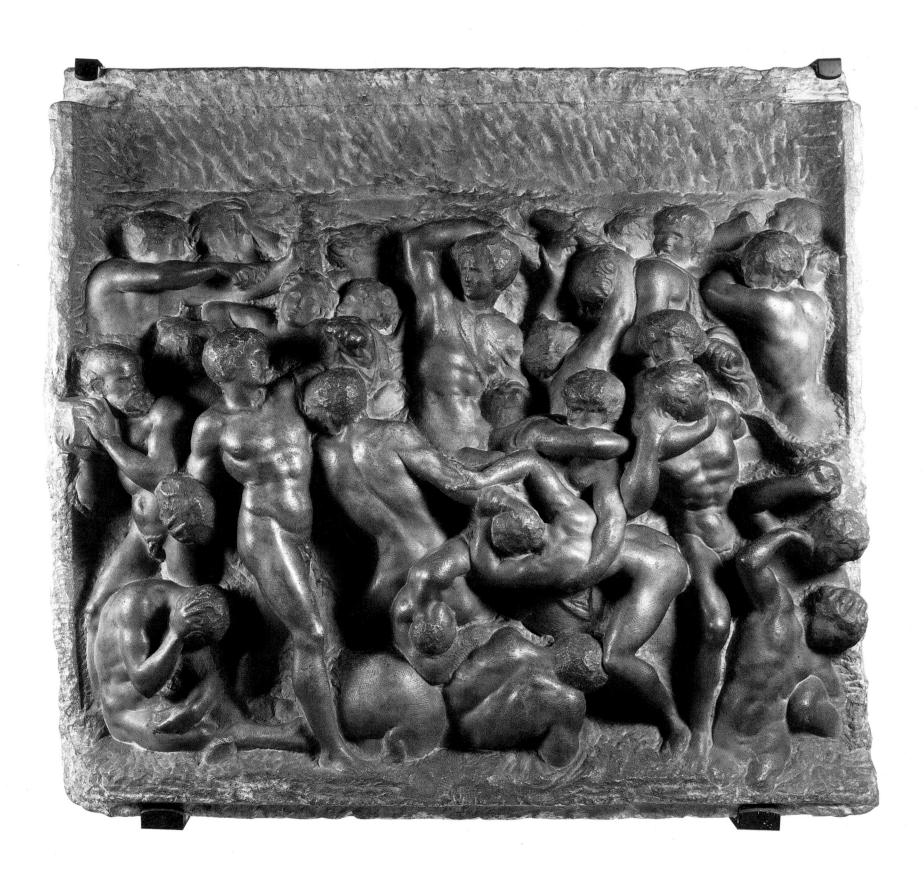

THE BATTLE OF THE CENTAURS AND PAGAN ANTIQUITY

When we speak of the Renaissance, we refer to a period in which patronage lay in the hands of great princes of the church, the old aristocracy and a newly arising bourgeoisie in the cities. The Church cultivated its theological traditions, the temporal lords preferred to seek their roots in the high Middle Ages rather than Antiquity, and for ordinary people the pious prayer-book was still the main, and often the only, reading-matter.

There is little sign of the "rebirth" of Antiquity denoted by both the Italian word *rinascità* and the French term *renaissance*. This is particularly so as the Middle Ages themselves had no other roots than Antiquity, whose pagan and Jewish elements were merged into a single whole. The most important characteristic of the period is that the Greek and Roman authors were seen as indisputable authorities who stood above any views and experiences one might have held or made oneself. Among the Medici, at the court of Lorenzo the Magnificent, people prayed, it is true, in the palace chapel surrounded by the frescoes of Benozzo Gozzoli (1420–1498) and by Filippo Lippi's (1406–1469) poetic Christmas picture, which today is on display in Berlin. But classical philosophy was studied much more comprehensively, and also more courageously, than by previous generations. Thus Marsilio Ficino discovered the gnostic texts of Hermes Trismegistos, while Poliziano transformed the classical myths he discovered in Ovid and others into didactic poetic works of his own.

This is the context in which Michelangelo's origins have to be seen. Among his earliest works is the highly unusual relief of the *Battle of the Centaurs* (ill. 4) which stands out through a peculiar fact: it remained in the possession of the artist and his family as an example of the work of the youthful genius. Perhaps the young Michelangelo originally intended it for the Medici, but he stopped work on it after they were expelled from the city in 1494, and kept the relief himself, before finally leaving it to the Buonarrotis.

The content of the picture must be seen in the same context. Naked figures fight in a wild frenzy without any recognizable central figure. Researchers have tried to define a concrete situation, to find a text, which Michelangelo might have illustrated here. There is, for example, the kidnap of Hippodameia and the battle between the Centaurs and the Lapiths, which was also depicted by the Florentine Piero di Cosimo (1462–1521) and which is represented in powerful sculptures on the Parthenon in Athens or the Temple of Zeus in Olympia – although these would only have been known from classical descriptions. But it is impossible to tie it down in this way: Michelangelo clearly saw the relief as a virtuoso piece which does not tell a story from mythology but in which the battle between humans and centaurs gives him the opportunity to measure himself as an artist against the ancients.

He copied reliefs from the Roman imperial period which worked with deep relief and are likewise difficult to interpret. It would be instructive to know whether he intended to turn the broad band at the top, which has not been worked, into decorative architecture as an indication of a wedding hall, which would indicate the scene to be the battle between Centaurs and Lapiths at the wedding of Peirithous, or whether there was a particular reason why this section remained unworked.

There is something organic about the way that the figures grow out of the stone up to three quarters of their body volume. The heads in the upper section in particular are depicted in flat relief as round discs only without bodies, reinforcing the impression of an immense crowd. Fighting bodies intersect in many places but the free-standing sections are not developed in any detail. All the unclothed, and thus unidentified, bodies reveal that Michelangelo, even as a young man, was more interested in questions of composition than in telling a story.

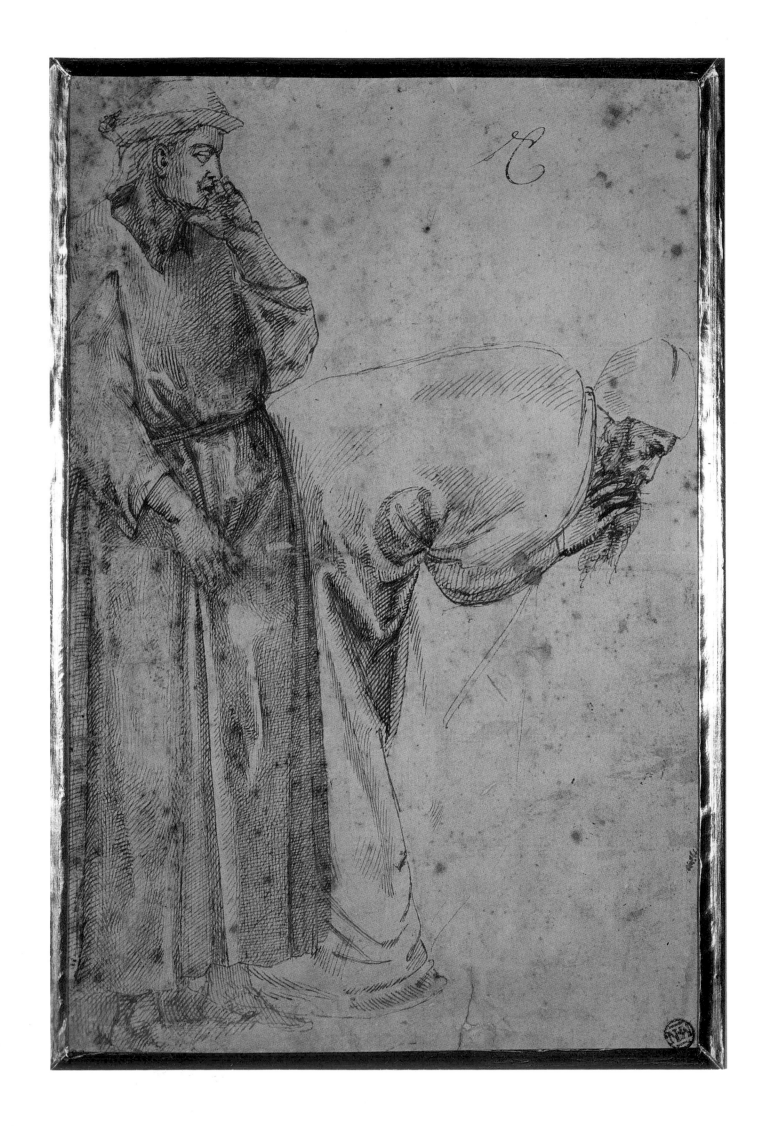

6 (above) Giotto (ca. 1266–1337)
Ascension of John the Evangelist, ca. 1335
Fresco
Santa Croce, Cappella Peruzzi, Florence

Giotto rejuvenated painting with his art after a long period of decline – that at least was the opinion of Giorgio Vasari, the founder of art historiography. Michelangelo was already familiar in his youth with this historical view of Giotto and its high estimation of the deceased master. Michelangelo copied the group to the left of Giotto's extraordinary fresco which, in a low rectangle, has the aged evangelist John ascending to heaven. The group represents a study of movement which is full of vitality and which in Michelangelo's version almost makes us forget the distance in time to the original.

5 (opposite) *Two figures in the style of Giotto*, ca. 1490
Pen on paper, 32 x 19.7 cm
Musée du Louvre, Cabinet des Dessins, Paris

A key influence on Michelangelo was the awareness of Florentine art. In Giotto's (ca. 1266–1337) late work in Santa Croce he recognized a force which provided his own inspiration. Two unnamed figures in the fresco dating from about 1335 fascinate him by their dynamic sequence of standing and bending motion in humble activity. In this drawing, he transforms this motif into an early sample of his own style.

MICHELANGELO AND THE ART HISTORY OF FLORENCE

Michelangelo was to concern himself with classical art for the whole of his life. But his youth was determined just as decisively by the local tradition of his native city. Of course artists in Florence before him had drawn inspiration from remains there of Roman Antiquity. But they worked such images repeatedly into a style of their own in full consciousness of the historical nature of their actions. In doing so, they preserved the memory of the artistic heritage of their city, which even in the late 14th century was already beginning to stand apart from developments round about.

The history of art is less about the actual course of events than about what remains as a fertile influence in the mind. Artists can refer back to forgotten things which may lie many generations in the past and thus revitalize them. Michelangelo could simply have continued Verrochio's finely wrought style which Richard Hamann, in his popular "Kunstgeschichte" ("Art History"), equates with Riemenschneider's work as an expression of the late Gothic. But the elegant interplay of lines of the sinewy figures with their flying hair fascinated Michelangelo as little as did the delicate nature of the surrounds.

That is probably why he sought monumental models, which he found generations earlier in Giotto's (ca. 1266–1337) frescoes from the 1330s (ills. 5, 6) and Masaccio's (1401– ca.1428) Brancacci Chapel, which dates from ca. 1425 (ill. 7). There the figures are deprived of almost all fashionable accessories and reduced to massive bodies in simple garments. Neither Giotto nor Masaccio sought effects through pretty ideas but through the plasticity of the body and the volume of the form as well as in the characteristic movement and the eloquent gesture. Through their reduction of the form, these earlier painters stood apart from what was happening in art around them. They were masters in the observation not of surfaces, but of the human condition.

Michelangelo understood this, having been able to observe in Ghirlandaio the stylishness with which genre-related decoration could be reproduced even in frescoes, which had to be done in a very fast procedure. His first teacher had astonished Florence with his skill in meticulously portraying his patrons, not forgetting to

give each nobleman something of the idle trumpery of the fashion of the day. Neither the multiplicity nor the love of detail of such a master interested the young genius. He rigorously simplified even his older models so that in view of his extant drawings after Giotto and Masaccio (ills. 5–7) one has the feeling that the influence of older artists, so often invoked by art historians, should be understood rather as the younger generation forcefully making them their own.

Donatello, however, is closer to Michelangelo, perhaps because Bertoldo di Giovanni was able to acquaint the young artist more profoundly with his predecessor, who died in 1466 and whose work all over Florence bore witness to an inexhaustible imagination where form was concerned (ill. 16). His temporary closeness to Donatello may also have been enhanced, however, by the memory of Masaccio. After all, both of them, together with the architect Filippo Brunelleschi (1377–1446), had revolutionized the depiction of reality in terms of perspective in the 1420s. Michelangelo follows Donatello in the consistent translation into sculpture of the image with a central vanishing point. For this purpose, the older master had developed a special form of flattened relief, the *rilievo schiacciato*, a relief with the finest of gradations but minimal depth. Michelangelo's work with marble began with an example of this kind: the *Madonna of the Stairs* (ill. 3), which today is on show in the same room of the Casa Buonarroti as the *Battle of the Centaurs* (ill. 4), predates the classical virtuoso piece.

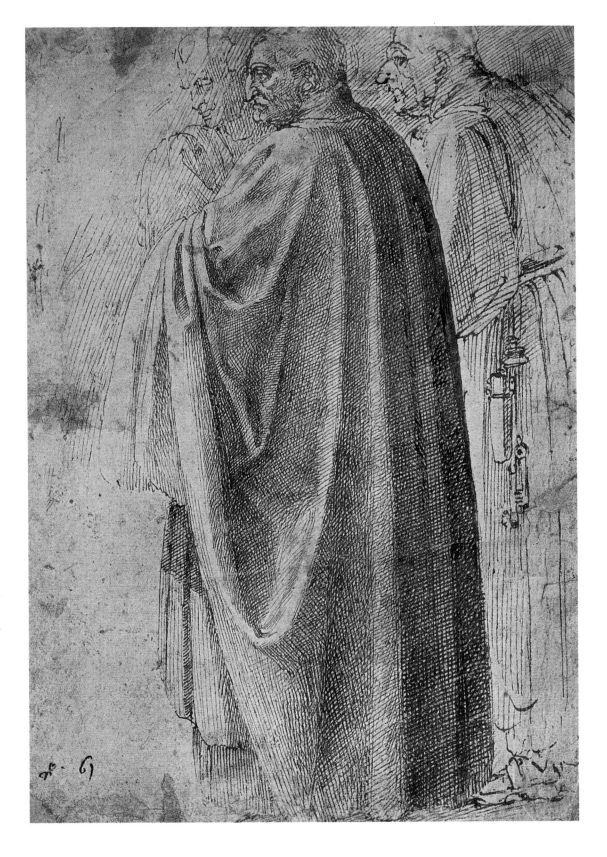

7 Copy of Masaccio's *Sagra del Carmine*, ca.1490
Pen with additions in red chalk on paper, 31 x 18.5 cm
Graphische Sammlung Albertina, Vienna

In Michelangelo's view, Masaccio (1401–ca. 1428) represented the second milestone in the history of Florentine art, which to him had few equals. Masaccio died at an early age after a few creative years. Michelangelo depicts a group of figures from his fresco, lost today, in the vault of the Brancacci Chapel of Santa Maria del Carmine in Florence. It provides documentation of a work of art which has been destroyed but which appears in a new monumental style in the hands of the young artist in the same way as his reproduction of Giotto's figures.

8 *Angel holding a Candlestick*, 1494/95
Marble, h. 51.5 cm
San Domenico, Bologna

The unrest which was created by the rule of the preacher
Savonarola caused Michelangelo to leave Florence shortly
before King Charles VIII of France expelled the Medici
family from the city in 1494. Through Gianfrancesco
Aldovrandi in Venice he was commissioned to make
statues for the tomb of St Dominic. The muscular angel,
whose massive body has rather small wings attached,
already displays the full mastery of the young sculptor.
The garments fall in generous folds with powerful depths
and through views.

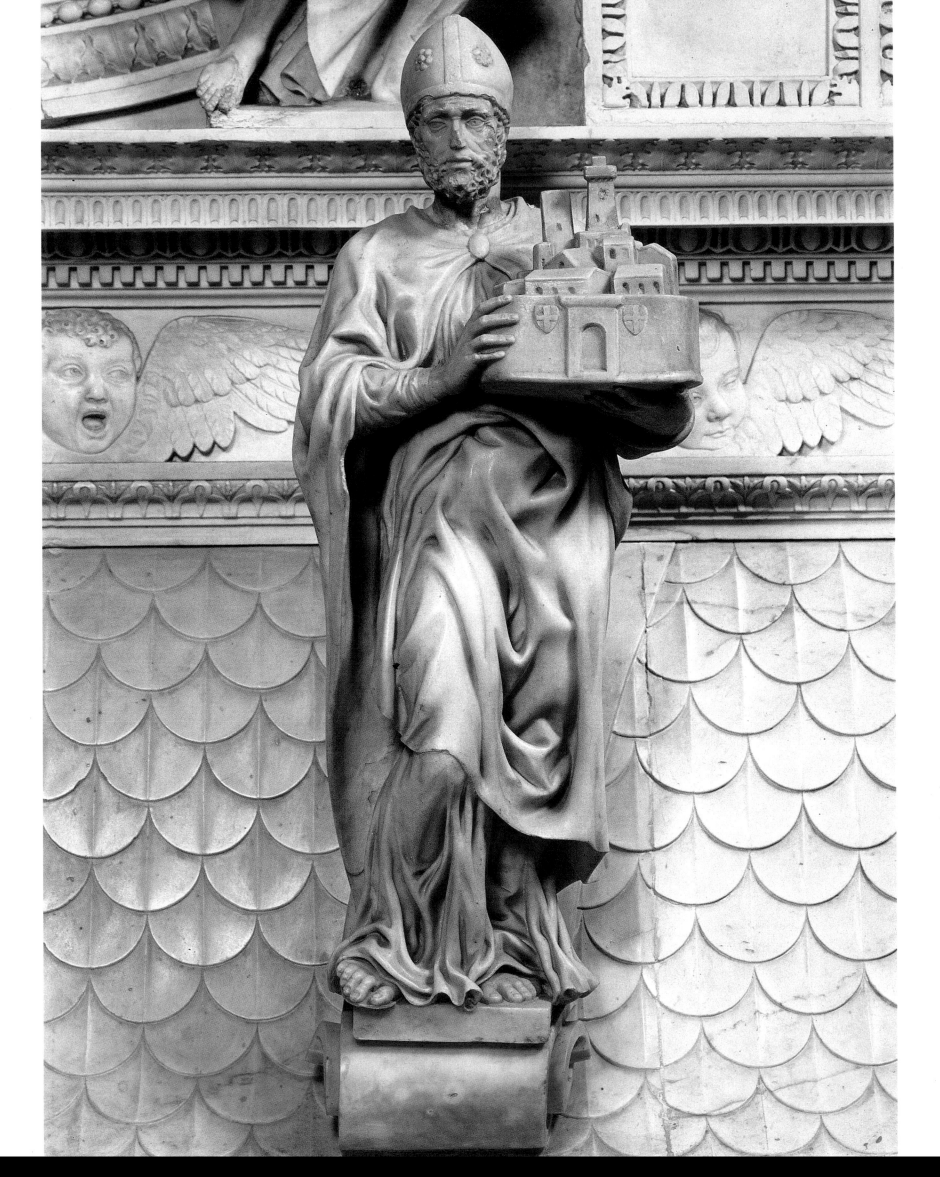

THE ENCOUNTER WITH ART IN VENICE AND BOLOGNA

After the death of Lorenzo the Magnificent in April 1492, Michelangelo returned to the family home. As a member of Medici household, he had reason to fear reprisals should the family fall from power, and that is why he fled north before their expulsion in 1494. Initially he found shelter in the house of the Bolognese aristocrat Gianfrancesco Aldovrandi in Venice. Even if we do not have any works by the young man from that period, the significance of the visit should not be underestimated. The foundations for any theoretical understanding of the art of the mature Michelangelo must include the contrast between his art and the Venetian painting of Titian (1488/90–1576). Michel-angelo had no opportunity to meet Titian, but he knew the Venetian art of the closing years of the 15th century better than his central Italian contemporaries. The journey to Venice would have taken Michelangelo through Padua, where Donatello and Giotto left important works of Florentine art.

His Venetian protectors are likely to have been responsible for the only commission of note with which Michelangelo left any trace in northern Italy. In Bologna, the bones of St Dominic, founder of the Dominican order, are venerated in a magnificent tomb, an *Arca,* which was richly decorated with figures by an artist who was thereafter called Niccolo dell'Arca (ca. 1435–1494). According to his earliest biographer Ascanio Condivi, Michelangelo added two statuettes (ills. 8, 9) to this group, and he was possibly working on a third (ill. 10).

The magnificent treatment of the garments and the incredible physical fullness of these 1494/95 Bolognese statuettes reveal more than the spirit already evident in the drawings in the style of Giotto and Masaccio. There is an additional softness, a physicality which Michelangelo is most likely to have acquired through the marvellous reliefs which Jacopo della Quercia (1374–1438) from Siena created for the cathedral façade in Bologna. Looking at Quercia's work today, it is still hard to believe that their "Michelangelesque fleshiness" was already possible in the early 15th century. The astonishing phenomenon of generation-spanning spiritual kinship also applies in this case; it is as if Michelangelo's art embodied not only an individual style, but a determining quality of sculpture.

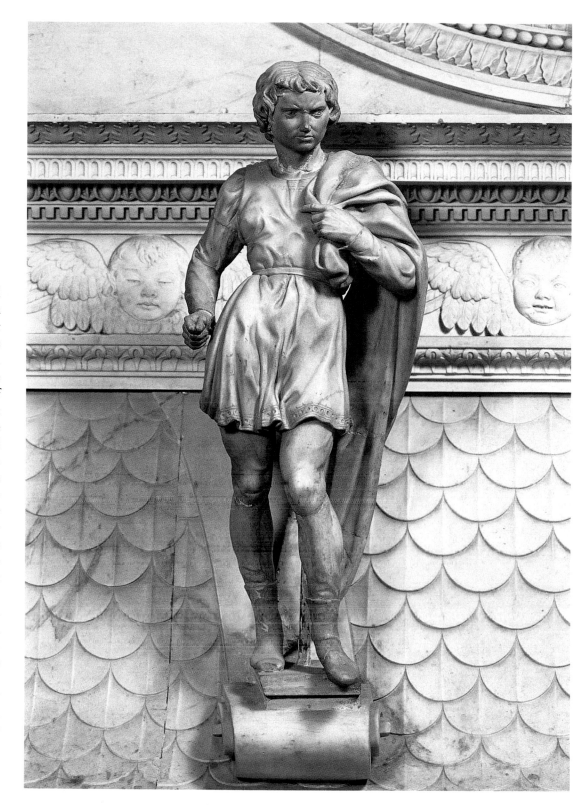

9 (opposite) *San Petronio*, ca. 1494/95
Marble, h. 64 cm
San Domenico, Bologna

San Petronio, the patron saint of Bologna, holds a simple model of the town in his hands. Deep carving creates the locks of his beard, the eye sockets are rather deep, the arches of the eyebrows throw a strong shadow. Despite a clear standing motif, consisting of the free leg on the left and the supporting leg on the right, the shadows thrown by the garments give such an effect of life that it appears as if the saint is about to stride off. Supplementary works such as the model of the city of Bologna are very rare in Michelangelo's later work.

10 (above) *San Procolo*, ca. 1494/95
Marble, h. 58.5 cm
San Domenico, Bologna

It has often been disputed whether *San Procolo* should be ascribed to Michelangelo, as his biographer and pupil, Ascanio Condivi, only mentions two figures in Bologna, *San Petronio* and the *Angel holding a Candlestick.* The statuette of Procolus was knocked down with a ladder in 1572 and was very badly repaired, which makes an evaluation much more difficult. It was probably begun by Nicolo dell'Arca (ca. 1435–1494) and completed by Michelangelo. Evidence of the influence of the younger artist is provided by the magnificent plasticity of the garment folds and the hem.

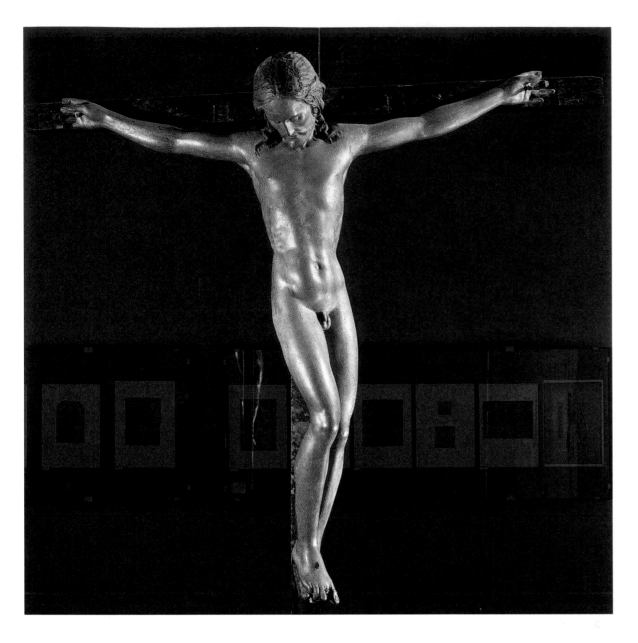

11 (left) *Crucifix*, ca. 1492/93
Colored wood, 135 x 135 cm
Casa Buonarroti, Florence

According to the sources, Michelangelo created a crucifix for the prior of Santo Spirito. But it was disputed for a long time whether the work was still in existence. Some researchers consider this exceedingly fragile looking youth to be that early work which would thus be his only wood carving. As with the later marble statue of the *Risen Christ* in Santa Maria sopra Minerva (ill. 59), the sculptor made the body of Christ naked so that with this crucifix an actual loin cloth must be added to cover his nakedness.

THE YOUNG ARTIST'S IMAGE OF CHRIST AND THE MADONNA

Important as the return to Antiquity was for the Renaissance, this period finds a much more valid expression in the image of the *Madonna*. This is due, on the one hand, to the unbroken supremacy of the Church, which kept up a constant demand for artistic representations of the Virgin Mary. But it may also be connected with the idea that the thought of the Word made flesh, the incarnation of God in a vulnerable child, as well as of Mary's mother love is filled with a high human ethos. Art had made it its task to describe the human condition. In this context many regions developed a local concept of the Mother of God which has often been preserved in numerous examples; Florence is particularly prominent in this respect.

It is not easy to introduce a wooden crucifix, which was transferred from the Florentine church of Santo Spirito to the Casa Buonarroti, into our ideas about Michelangelo's work. It was identified by Margrit Lisner with a piece mentioned in the sources (ill. 11).

According to her, the young artist had created it for a prior who provided him with corpses for his anatomical studies. But this extremely delicate work seems far removed from any such experiences. One has to have seen the work with its enchantingly youthful charm, which could well be integrated into an image of the young artist in search of his form, in order to be able to understand why some researchers at least agree with this attribution.

The Mother of God in Michelangelo's *Pietà* for St Peter's in Rome also has a youthful appearance (ill. 12). Her head is an expression of the noblest Virgins of earlier Florentine artists and one cannot go far wrong in seeing the precise form of the features and the folds of the garment as linked with those masters of the city who otherwise appear to have had little effect on Michelangelo. Thus Verrocchio's delicate ideal of what a figure should be is not far removed.

In the marble sculpture in St Peter's, where this youthful Virgin is the Mater Dolorosa, Michelangelo has given her not the Christ child to hold in her lap, but her dead son, whom she is contemplating in grief. This

12 (opposite) *Pietà*, 1498/99
Marble, h. 174 cm, d. 69 cm
San Pietro in Vaticano, Rome

The Mother of God holds her dead son on her lap in perfect youthful beauty to give the impression of a tragic pair of lovers rather than of the grief of a mother for her dead son. Michelangelo has convincingly created the contrast between the firm body of Mary, who has overcome her pain and is presented to us in the certainty of redemption, and the limp, lifeless body of the Son of God. While the body of the woman disappears under the mass of her garments, the redeemer's body is shown in its regular and beautiful forms.

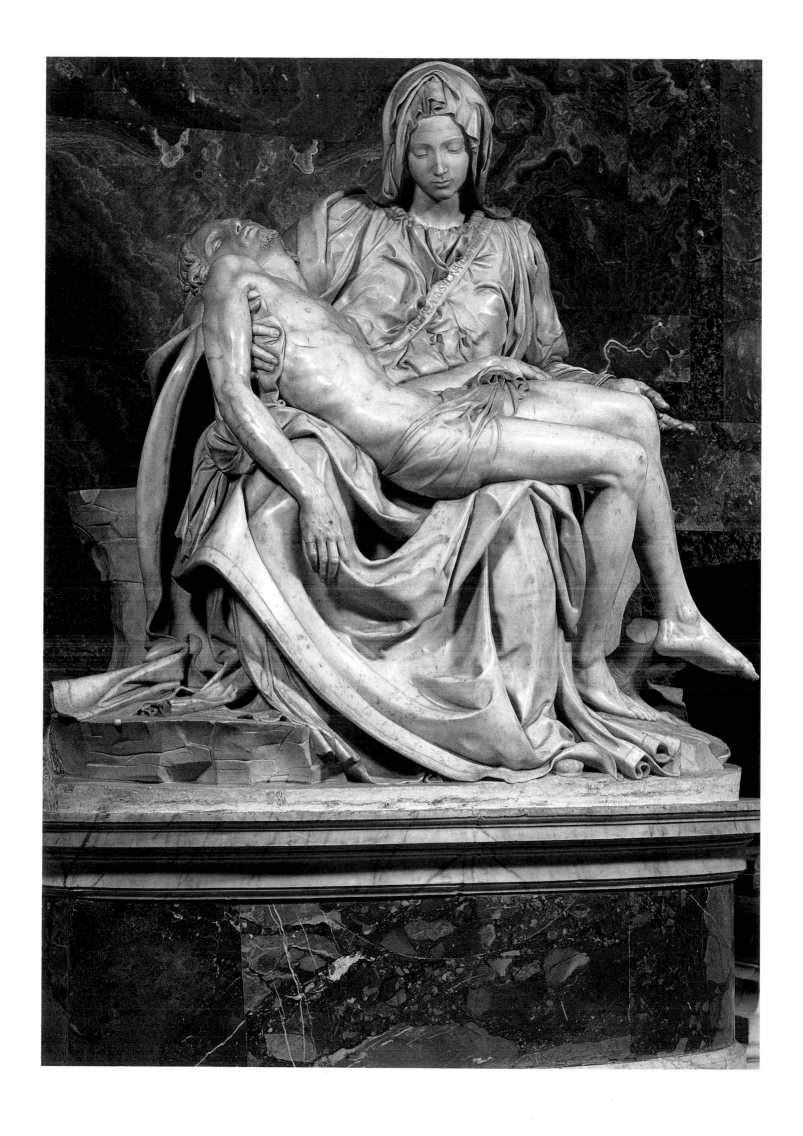

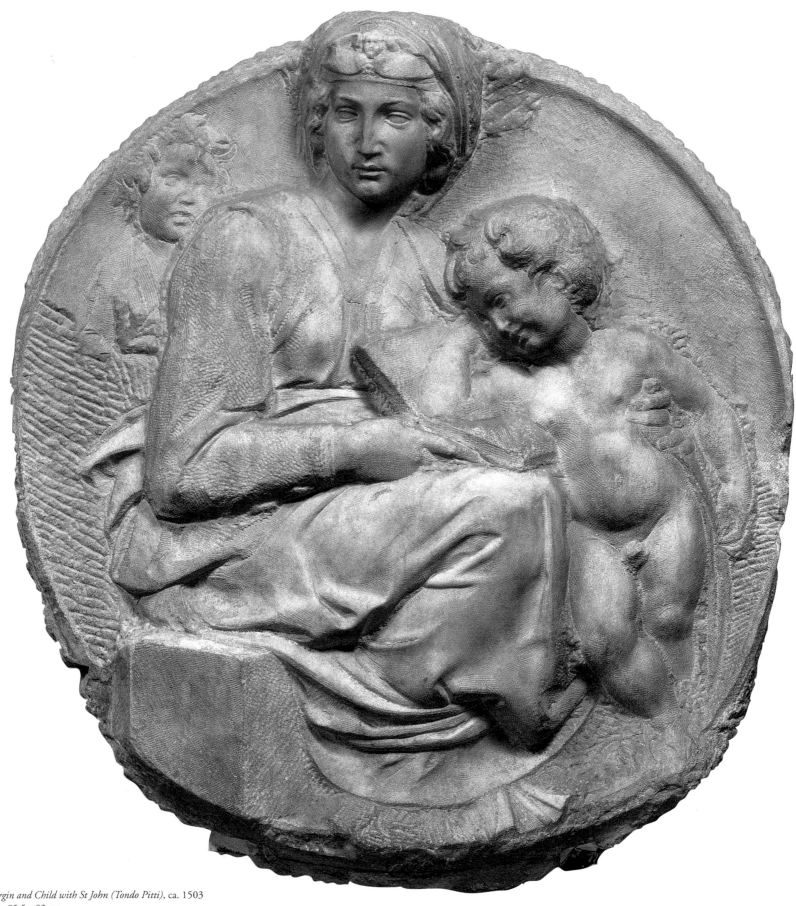

13 *Virgin and Child with St John (Tondo Pitti)*, ca. 1503
Marble, 85.5 x 82 cm
Museo Nazionale del Bargello, Florence

Executed for Bartolomeo Pitti, this tondo was still
incomplete at the time of Michelangelo's departure in
1505. It shows the technical and artistic skills he took to
Rome after his study of classical as well as Florentine
models. He tries out all levels of relief from the almost
plastic head of Mary with a classical diadem to the
infant St John who almost disappears into the block.

Although a unity in terms of composition, the figures
have no eye contact: Mary looks thoughtfully into the
distance, the Christ child, who has cheekily put his arm
on his mother's book to stop her reading, smiles a
beatific smile and the young St John with his curly locks
looks at the group from a greater distance.

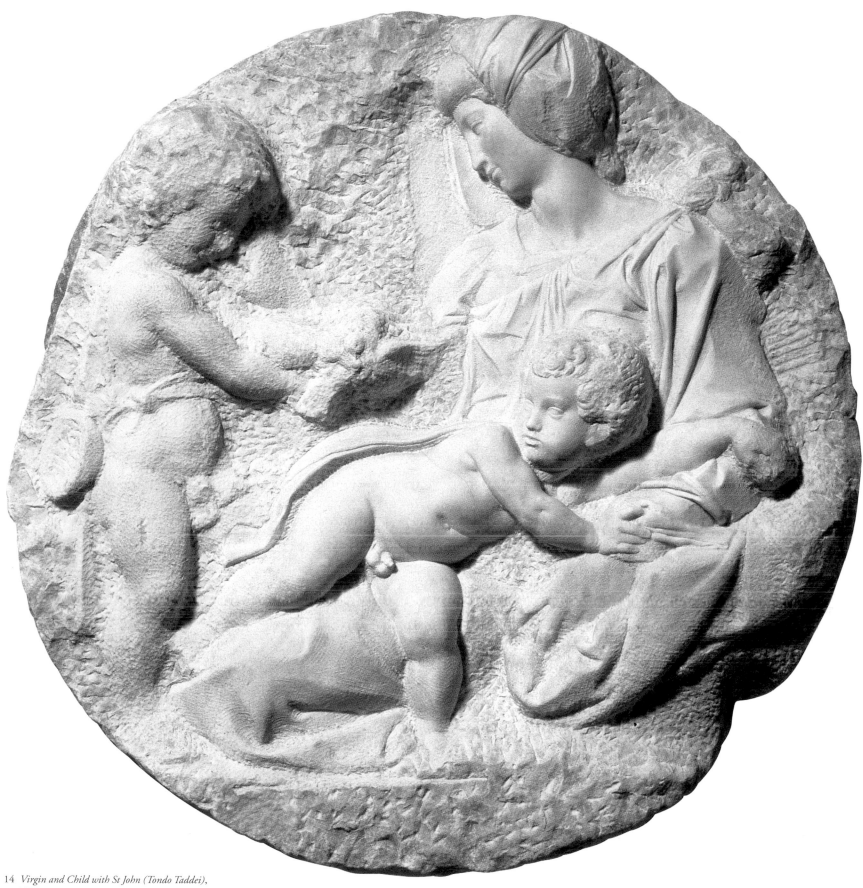

14 *Virgin and Child with St John (Tondo Taddei)*,
ca. 1502
Marble; diameter 109 cm
Royal Academy of Arts, London

The tondo for Taddeo Taddei also remained
uncompleted in 1505. But it is precisely its unfinished
state which wonderfully reveals Michelangelo's mastery
in the sculptural details. The motif is a mysterious one,
toying with antique putti as models: Jesus runs away
from the little bird held out by the St John child into

Mary's arms, hardly fitting in with the image of the
dignified redeemer of the world. Mary is conceived of in
an equally unusual way. Her turban and her top-
garment which covers only one shoulder are less in
accordance with the iconography of the Mother of God
than with classical female figures.

work may have been influenced by ideas which equate the sleeping little boy on Mary's knee with the Man of Sorrows who has been removed from the Cross.

The noble body of the dead Christ is presented in flowing forms by the artist, unusually long and with not very distinctive muscles. The well-known features of Christ as handed down in the *Vera Icon*, the "true image", are used here by Michelangelo no more than in many later works. This in turn has convinced some researchers to see the wooden crucifix (ill. 11) from Santo Spirito as the work of his hand. It is indeed possible to see a progression from the two heads of Christ to the heads of the Virgin of the *Pietà* (ill. 18) and the Bruges *Virgin and Child* (ill. 17), as well as to the statues in Siena cathedral (ills. 23, 24) which Michelangelo created shortly before his departure for Rome while still in Florence.

The appeal of the task of creating a Madonna lay in the possibility of using observations from life to give soul to an icon-like devotional image. One's own ideals of beauty could replace traditional ideas about the representation of women, and the required depiction of tenderness between mother and child demanded an intimacy with room for a personal perspective. Theology and popular devotion offered a wealth of motifs for putting the divinity of the child and the virginity of the mother in a time-transcending context.

Michelangelo's Madonnas start in his earliest sculpture with the mysterious staircase motif (ill. 3), which is wonderfully balanced between two violently opposed ideas. One might think that the artist had observed any mother demurely breastfeeding her child – a beggar woman on the steps of a church rather than the future Queen of Heaven. At the same time, however, the steps symbolize the ascent to salvation: Mary turns in their direction, although not looking directly at them, her head slightly lowered and with a serious demeanor suggesting that she already sees the destiny of the child which she holds protectively to her breast. It would be interesting to know whether the young artist knew of a classical tomb relief in the style of Attic works which show a seated figure taking leave in death.

This figure in strict profile, which has its origins in Donatello's work, as does the technique of flattened relief (ill. 16), shares the prophetic gaze with the circular marble reliefs which Michelangelo left uncompleted in Florence prior to 1505 – even if the sculptor quite obviously regarded them as contrasting samples of his art: in both cases he toys with the old Florentine principle (which does not apply to Donatello's *Pazzi*

Madonna in Berlin) of showing the whole figure of Mary, and in both cases he does not quite succeed in giving the heads a great deal of space or squeezing the bodies into the too small field by optical foreshortening. For Bartolomeo Pitti (ill. 13) he selects the majestic view of the Mother of God from an almost frontal perspective but develops this through a complicated rotation of the motif of the Virgin seated in profile. For *Taddeo Taddei* (ill. 14), on the other hand, he pulls Mary back with a face which is intentionally almost turned away. The playful aspect of mother and child is brought out in different ways, in that the Christ child in the one relief is preventing his mother from reading, while in the other he appears to be romping about with St John. In the *Tondo Pitti*, however, Christ has such a melancholic appearance that the gaze of the mother also appears to be filled with sadness, while Mary in the *Tondo Taddei* protects her child with a sadness which is resigned to the will of God.

The oil painting for Agnolo Doni (ill. 15), which dates from about the same time, lacks the openness of expression which is essentially produced in the two reliefs by their incompleteness. A new motif, rare in 15th century Florentine art, is that of Joseph, the foster father, who takes a prominent role. He acts as support for Mary sitting in front, and is allowed to hold the child in order to hand him to his mother. Michelangelo specialists have generally not realized that a new veneration of Joseph developed at the French court around St Francis of Paula towards the end of the 15th century, and the *Tondo Doni* may be influenced by this.

While in the *Tondo Doni* all that remains of the melancholy, so full of foreboding, of the other Madonnas is the irrefutable connection between Mary and the Sibyls on the later ceiling of the Sistine Chapel (ills. 35, 39, 41, 42), the deep and extraordinary feeling with which Michelangelo imbued the image of the Mother of God is concentrated once more in the wonderfully accomplished Bruges *Madonna* (ill. 17). Her slim features, with the straight nose, the small mouth over a prominent chin, the finely arched brows and her downcast eyes make it appear as if the artist had the same model as served him for the *Pietà* in St Peter's (ill. 18). But we can also imagine in our mind's eye how, as a delicate young girl, she has a bitter premonition of how her sullen-faced child is taking his first steps into a world which he is to redeem through his Passion. She cannot stop him, which is why she sits there so painfully calm, and only secretly assures the little Savior of her love through a firm handhold.

15 *The Holy Family with St John (Tondo Doni)*, ca. 1504–1506
Tempera on wood, diameter 120 cm
Galleria degli Uffizi, Florence

The Holy Family with St. John for Agnolo Doni is the only painting on wood recognized without question as Michelangelo's work today. The original frame is decorated with the coat of arms of the Strozzi, the family of Doni's wife Maddalena. The busts and the fully ornamented frame are among the most beautiful wooden carvings of the time, but underline the distance from Michelangelo's own imagery. The unusual movement of the strongly plastic figures presents certain riddles: Mary interrupts her reading and reaches over her shoulder to receive the child from Joseph, whom many a brave commentator has misunderstood contrary to all dogma as the heavenly Father. The figure of the young St John wanders in a deep trench behind the balustrade. Behind him naked figures are gathered, who have been interpreted both as prophets and as heathen fauns.

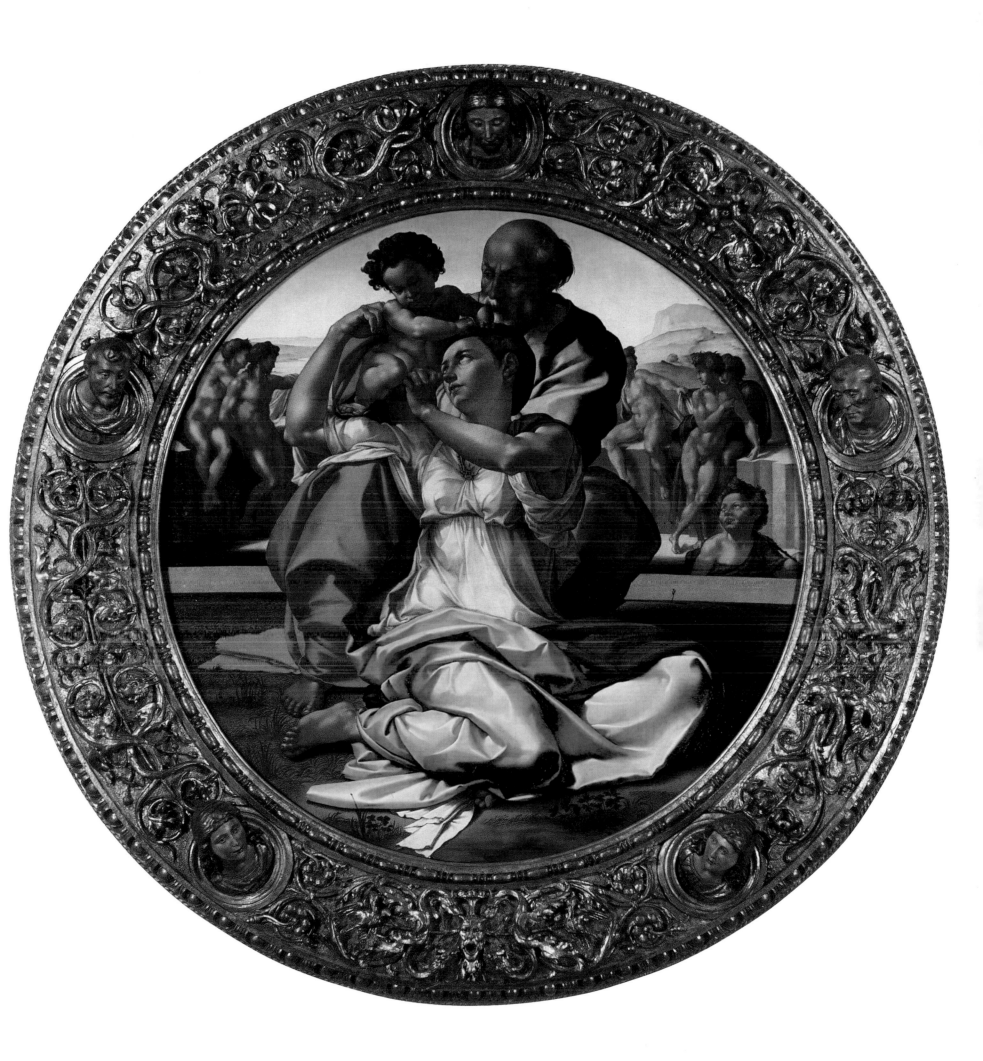

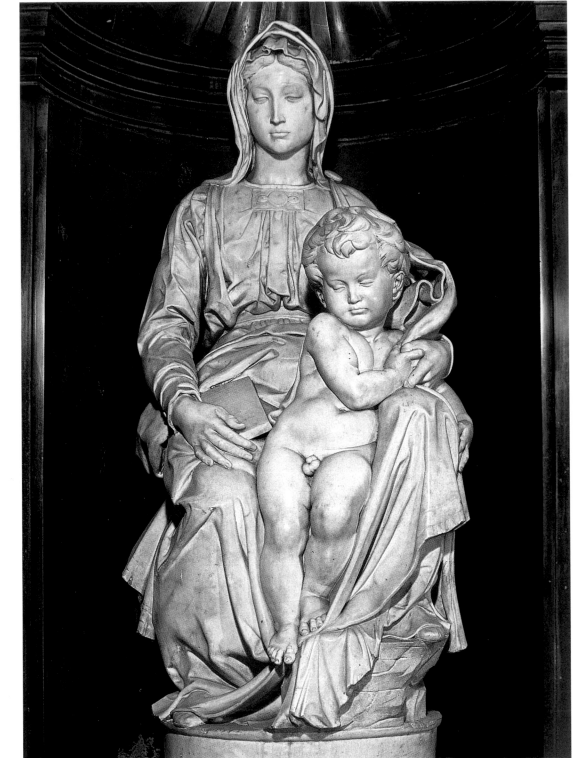

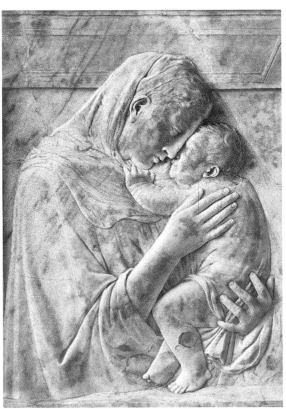

16 (above, left) Donatello (1386–1466)
Virgin and Child (*Pazzi Madonna*), ca. 1417/18
Marble, 74.5 x 69.5 cm
Staatliche Museen zu Berlin – Preussischer Kulturbesitz,
Skulpturengalerie, Berlin

Of the innumerable Madonnas created by Florentine artists
before Michelangelo, this relatively early work by Donatello is
the one that most immediately springs to mind in respect of
the former's *Madonna of the Stairs*, although it represents a
model avoided by the younger artist: in most Florentine reliefs
the Mother of God had previously been depicted as a full-
length figure. The whole figure on the steps, along with the
putti, allow Michelangelo to experiment with figures and space
in a way which is alien to the earlier work. Donatello will
nevertheless have provided him with significant inspiration
with his daring foreshortening in an extremely flat relief.

17 (above, right) *Virgin and Child*, ca.1498–1501
Marble, h. 94 cm (with base 128 cm)
Onze Lieve Vrouwekerk (Church of Notre Dame), Bruges

Shortly after it was completed, this sculpture was taken to
Bruges in Flanders. It was the only sculpture by Michelangelo
north of the Alps during his lifetime. Instead of sitting on
Mary's lap as is usually the case, the Christ child stands in
devout intimacy between her legs. But while the intertwined
hands express familiarity, the inward-looking gaze of Mary and
the reflectively stubborn face of the boy reveal pain.
Michelangelo shows how the child on unsteady feet is
beginning to loosen his bonds with his mother to embark on a
path which will end in the Passion.

18 (opposite) *Pietà* (detail ill. 12), 1498/99

Proudly the artist has signed his sculpture on the band which
ties up Mary's garment. Michelangelo may well have put his
only signature on this work because of the holy site for which
the *Pietà* was intended. He introduced a motif into the papal
church with an image which tended to enjoy greater
popularity north of the Alps. The sculpture now stands behind
thick armored glass after an attack some years ago. Intended as
an aid to devotion, the *Pietà*, like Leonardo da Vinci's
(1452–1519) *Mona Lisa*, has itself become the object of a
temporal veneration of art.

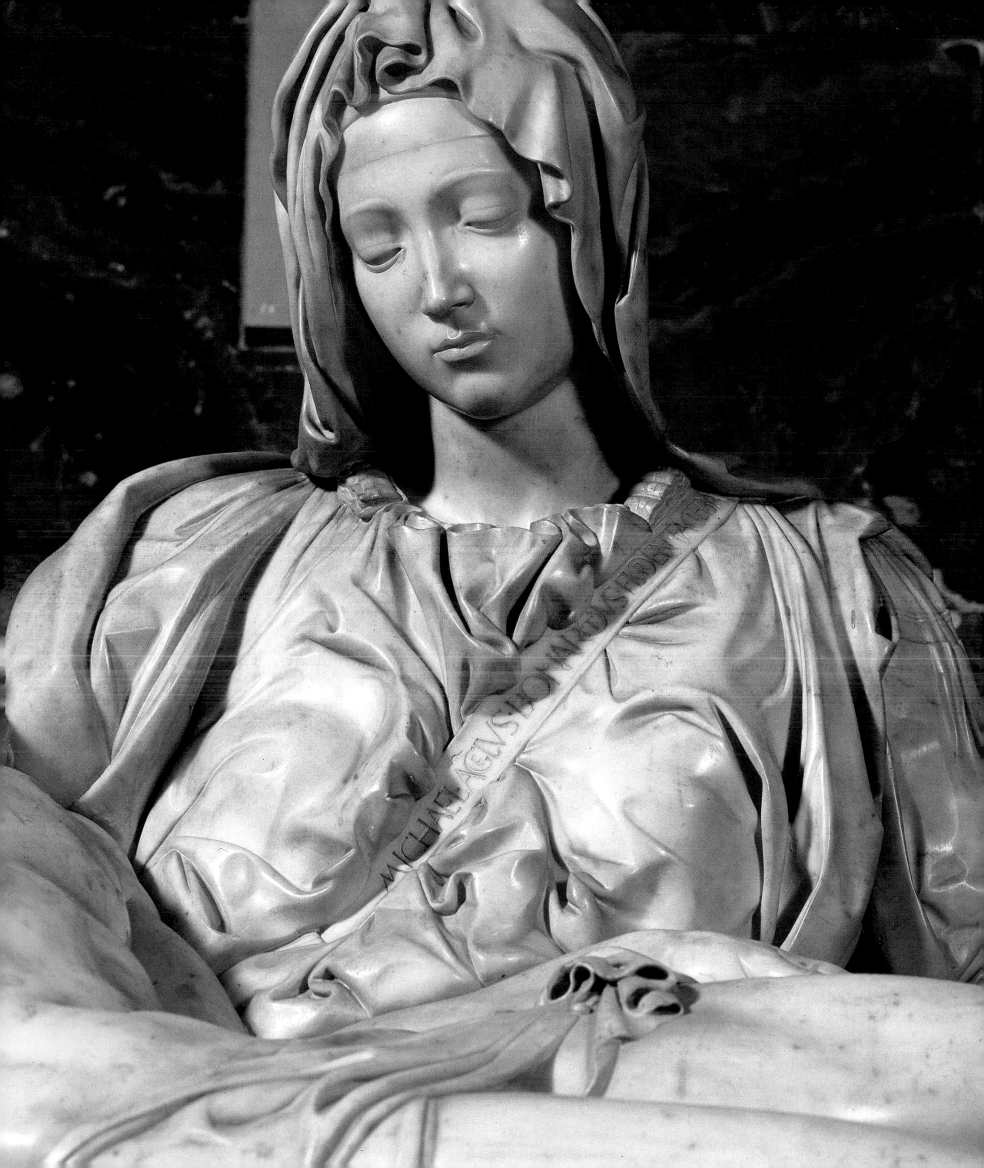

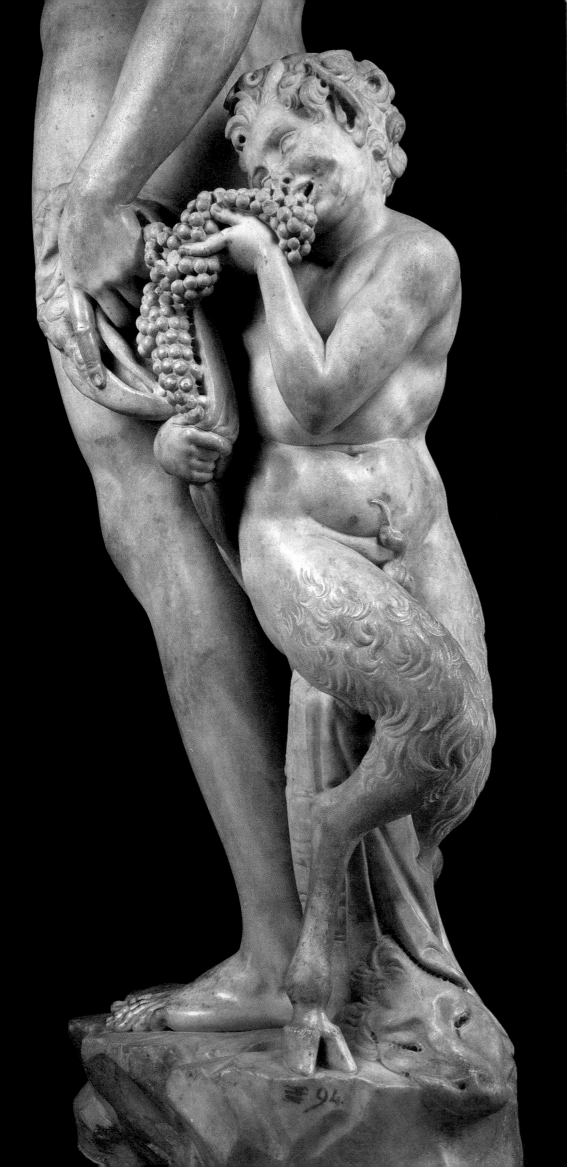

THE MALE NUDE: BACCHUS AND DAVID

It is a double error to believe that the classical sculptors had always shown the gods in paradisical nakedness and that the Church in the Middle Ages had then placed a prohibition on the nude. As early as 1260 Nicola Pisano (ca. 1220–1278/87) created a naked Hercules, which he set up as a support under his pulpit in the Baptistery in Pisa. Nevertheless, the unclothed human figure was accorded quite a different value in the Renaissance. Donatello's bronze *David* stands at the beginning of this process of transformation, which has also influenced our view of Antiquity. But Michelangelo is the most important pioneer in the field of the nude, to which he gives an ethical dimension as no other artist before him.

It is not clear how much of Michelangelo's work has been lost. Early sources refer to a bronze *David* and a *Hercules*. But a most unusual statue of a classical god, begun in 1497, has survived: the youthful god of wine, *Bacchus* (ills. 19, 20) which the sculptor created in Rome "in the style of Antiquity", according to the terms of his commission. Michelangelo caused a stir with this appealing sculpture. Even though his contemporaries might have seen in it the perfect acquisition of the classical style, with this all-round figure Michelangelo himself was embarking on a new art, liberated from Antiquity. Instead of surface-based tectonics, he develops the figure out of a rotational movement, toys with the standing motif of the contrapposto and thus achieves a vitality which must have fascinated all the Mannerist artists who came after him.

Art, as Michelangelo lived it, henceforth required the genius to prove himself in one or more powerful works in a titanic struggle with the material. The sheer management of the material was only secondary in this respect; the real task was to breath into the material the spirit which originated in the spirit of the artist.

Michelangelo, who would later complete almost none of his monumental sculptures, faced up to the first gigantic task of his life by bringing a huge rejected block of material to unsuspected perfection in three years of laborious work. The marble, which the cathedral

19 *Bacchus:* Satyr (detail ill. 20), 1496/97

Although this sculpture is composed only of bodies and a tree stump, the young sculptor experiments to see how far the small companion of the wine god can hide behind the larger figure. This playful aspect is intensified by the detailed face of the satyr with the grapes. Michelangelo's first work in Rome shows the intensity with which still-life-like motifs could imbue his otherwise so often harsh work. The incomplete state of most of his later sculptures makes it easy to forget this quality.

stonemasons' lodge in Florence considered to be spoiled, already had a human form. It had been hewn into shape a generation earlier to the extent that it was already called the "Giant". Without having decided where it wanted to place the work once it was completed, the *Arte della Lana* (Wool Weavers' Guild) agreed a contract with Michelangelo which included wine and payment on a weekly basis and enabled him to complete this mighty task without spectators. A whole chapel in the cathedral was closed off for the purpose.

For Christian Florence, Michelangelo depicted the shepherd boy *David* from the Old Testament in utmost concentration before his decisive attack on Goliath (ills. 21, 22). Although it initially aroused enmity and had to be protected by the authorities from stones thrown by envious local sculptors, the statue immediately became the symbol of the city. No work shows better what art can do while transcending the barriers of belief and ideology. It raises a figure from history long past to an imposing greatness which can only be experienced in the presence of the original. The strength of the mighty body transfers itself to those beholders who do not boast powerful muscles and who have no heroic inclination whatsoever. For David is not yet the victor, but is thrown back in having to decide between fear and self-confidence. He is so great that he can easily admit a slight retreat before the giant Goliath, only to become confident of victory through his cleverness.

Tension, not triumph, is the dominant characteristic of this figure. This tension is endured, which gives it a power transcending a particular period. In his nakedness David is released from the specifics of history and appears as simply human with a tiny attribute which only those in the know recognize as a sling – without the deadly stone. Inspired by a visualization of how the shepherd boy would face up to the Philistine, the image is released from its historical ties into timelessness; it invites even pacifists to identify with it, despite its martial theme, because the body for all its massive presence is wholly imbued with a spirit which proclaims the victory of good and intelligence over coarseness and violence.

20 *Bacchus*, ca. 1496/97
Marble, h. 184 cm (with base 203 cm)
Museo Nazionale del Bargello, Florence

Michelangelo made his debut in Rome with a subject from Antiquity, the first life-size marble statue of a naked classical god to be created during the Christian period. Probably commissioned by Cardinal Riario, the figure was acquired by the banker Jacopo Dalli, who set it up in his garden together with other mainly classical sculptures. Standing on a rock, today placed on an appropriately round base, Bacchus with a satyr is shown in such fluid movement that the motif as a whole cannot be taken in from any one single view. Classical sculptors, in contrast, seldom stimulated the observer to walk around a work.

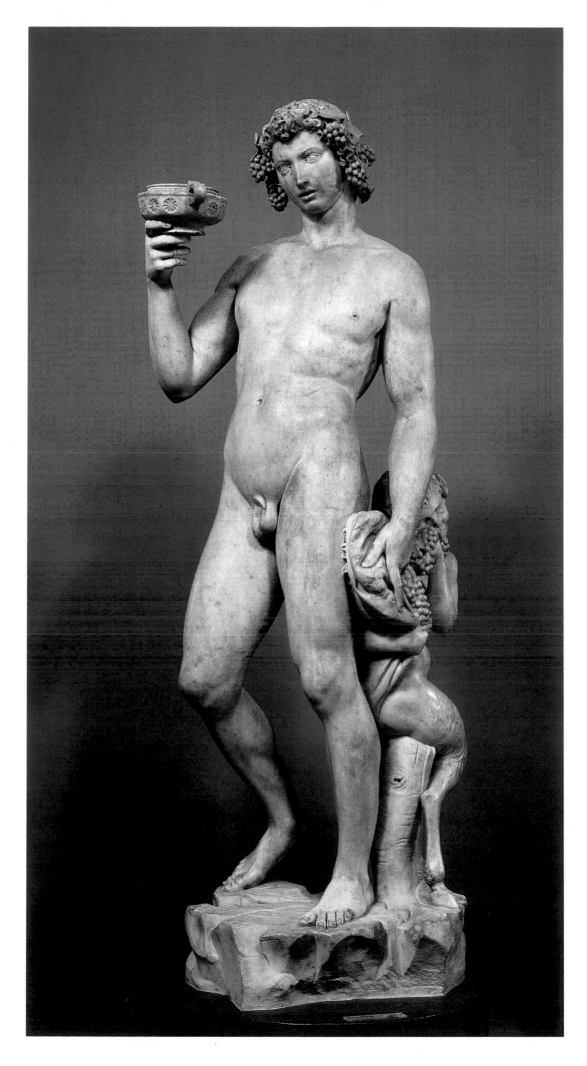

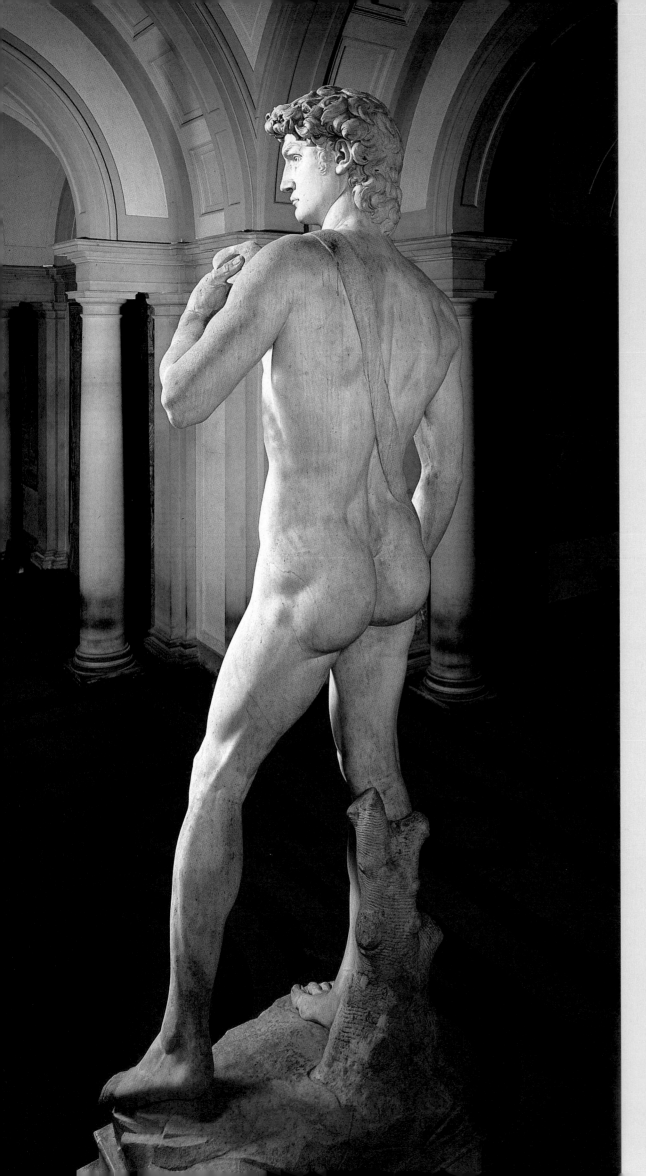

DAVID AND THE CHOICE OF PATRON FOR THE CITY

The victory of the shepherd boy David over the giant Goliath, who with the Philistines threatened the people of Israel, is something with which a small people, which relies not on its strength in the face of an overwhelming enemy but on intelligence and the assistance of God, can identify. David is the chosen one of the Lord, who gives him those gifts which are appropriate for a future king of his people. These include reason and skill, as expressed in the art of the stone sling. For this weapon requires technical mastery and a good deal of spirit.

It is not surprising that a city state like relatively powerless Florence should place its trust in such a hero – as well as Hercules, incidentally, which it also made into a patron and thus a symbolic figure – particularly at times when there was no clear distinction between the memory of Pagan Antiquity and the Jewish tradition of the Bible. But at the same time as Michelangelo was working on the marble *David* (ill. 22), the city called on a further figure from the Old Testament: Judith, who was desired by the general Holofernes as he was besieging the town of Bethulia. She went to his tent, made him drunk and cut his head off, as depicted with irritating hardness by Donatello with his life-size bronze statue. This *Judith* was chosen by the new republic of Florence to be its patron after the Medici were banished in 1494. She stood before the Palazzo Vecchio, the ancient city hall.

Clearly no one had thought about the purpose for which the *David* was to be used when the commission was given to the young Michelangelo. When the artists and authorities of the city were finally allowed to see the statue after long years in which the artist had worked on it in secret, a serious debate started about where it should be

21 *David* (view from the back of ill. 22), 1501–1504

The Florentines identified their city either with Hercules or with David, the hero of the Old Testament. That is why there existed prior to Michelangelo's statue numerous pictures of the shepherd boy killing the giant with his sling. But in contrast to what had been customary up to that time, *David* does not appear in this huge depiction as the victor carrying the head of Goliath, but in the moment before that act of liberation: his sling is hidden on his back while with great concentration he takes the measure of his opponent and gathers all his strength.

put up. A mixed commission made up of artists and state representatives met in January 1505 and some of the comments have been preserved verbatim in the minutes: We can hear the Herald of the city, today we would call him a kind of chief of protocol, thunder against the wretched idea of ever having chosen Judith as patron, a woman, moreover, who kills a man through cunning.

She is replaced by Michelangelo's marble giant. He is put up at the entrance to the city hall and there is still a life-size marble copy there today, since the consequences were drawn as early as 1873 from increasing environmental pollution, and the original was put under a specially built dome in the gallery of the Galleria dell' Accademia together with other works by the master.

Thus a hero continues to guard the gate to the city hall of Florence who, himself already giant-sized, looks up to an even greater giant: to Goliath the Philistine, whom the observer is left by the artist to imagine for himself. This figure symbolizes the power of a small state, based on cunning and intelligence, which considers itself to be on God's side.

By not showing the head of the vanquished, as all other depictions had shown before him, he creates a unique opportunity. Instead of showing the hero in the splendor of victory, he can create the most powerful moment of the story: David sizes up his opponent and reflects on the deed he is about to do like a tragic hero, a deed from which he could still escape. He even draws back slightly with the extended left leg while he collects his thoughts for his deed with the right side of his body. Thus this figure is imbued with a tension which is rarely achieved in a work of art.

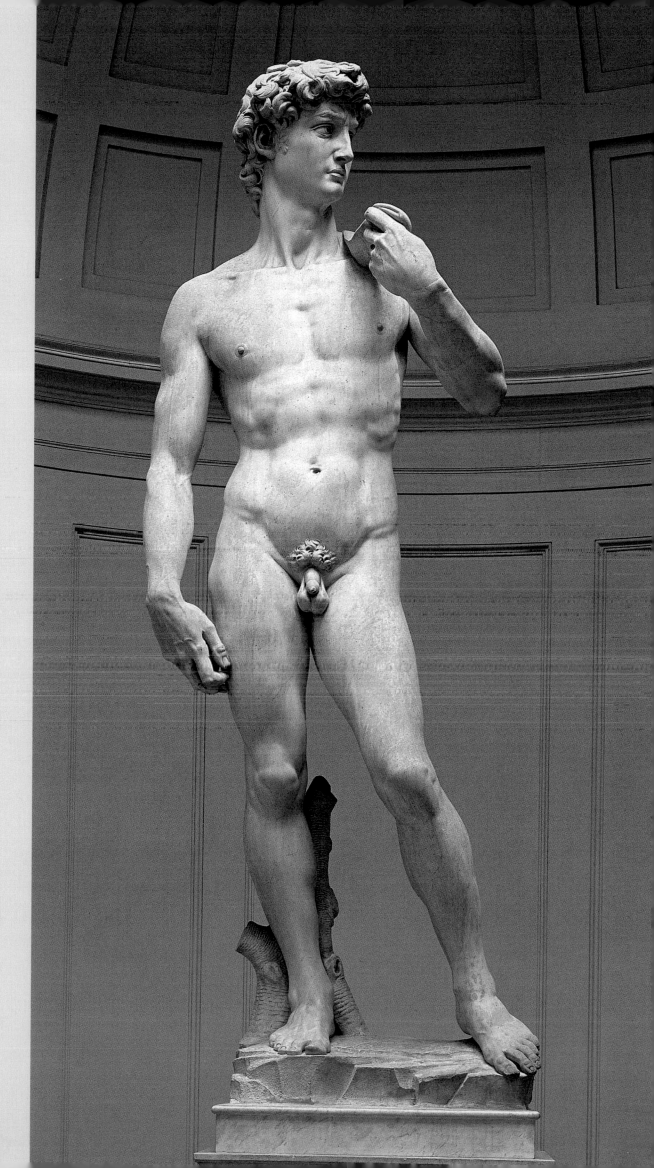

22 *David*, 1501–1504
Marble, h. 410 cm
Galleria dell'Accademia, Florence

On 16 August 1501, the Arte della Lana (Wool Weavers' Guild), commissioned Michelangelo to make the largest monumental sculpture since Antiquity. He was to create a *David* from the block known as the "Giant", which Agostino de Duccio (1418 – after 1481) had incorrectly carved and spoiled a generation previously and which had been stored in the stonemasons' lodge. Michelangelo's Giant, which in fact shows the shepherd boy David preparing for battle with Goliath, finally found a worthy site on the main square in the city, in front of the Palazzo Vecchio.

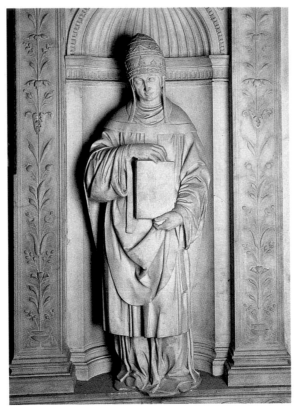

23 (far left) *St Paul* from the Piccolomini Altar, ca. 1503/04
Marble, h. 127 cm
Duomo, Siena

Only after Cardinal Francesco Todeschini-Piccolomini had been pope for a brief period as Pius III, is it likely that any attempt would have been made to complete the tomb, which had been inscribed by Andrea Bregno as early as 1485 and which was also an altar in the form of a triumphal arch. Michelangelo's most individual contribution is the figure of *St Paul*; the intensity of his look and the way he clasps his garment can be seen as a study anticipating the *Moses* on Julius II's tomb (ill. 49). At the same time it is also clear how far the artist still had to go to reach that stage.

MICHELANGELO'S WORK IN THE FLORENTINE REPUBLIC 1501–1505

Michelangelo never forgot that he had been received into the court of Lorenzo the Magnificent and might thus be familiar, from his youth, with later popes from the house of the Medici. That is why he fled to northern Italy after the expulsion of the Medici in order initially to work in Bologna. His reaction to the revolution in the intellectual life of Florence following the sermons of the Dominican prior Savonarola remains the subject of debate. Certainly, he could not endure his rule for very long after returning from Bologna at the end of 1495.

The lack of commissions in Florence will not have been the only reason why he set out again some six months later in June 1496. A profound irritation with the zealot may also have played a role, since it must not be forgotten in any consideration of Michelangelo and Savonarola that the artist went to Rome, where the deadly enemies of the preacher were based. Michelangelo did not, however, come into contact with the group around the Borgia pope Alexander VI, even though he carried out work for some cardinals. He started the *Bacchus* for Cardinal Riario and the *Pietà* for the French Cardinal Jean Bilhères de Lagraulas.

Only after his return in the spring of 1501 did the artist accept sizeable commissions in Florence: he worked on the *David* for a kind of professional association, the Arte della Lana, which was, however, entrusted with the financing of the cathedral building lodge – a highly official task. The transfer of the statue from the cathedral to the Palazzo Vecchio also shows how fluid such relationships could be.

After the most unusual contract for the *David*, which tied the artist to the cathedral building lodge without giving him a regular position within it, Michelangelo ran his own workshop for a short time as Donatello and other sculptors before him had done. Private commissions for reliefs were accepted from the distinguished Florentine houses of the Pitti and Taddei (ills. 13, 14), as was the wish of Agnolo Doni to have something equivalent in painting (ill. 15). Here Michelangelo appears to have worked together with Baccio da Montelupo, who for certain reasons has been credited with the heads which adorn the wooden frame of the *Tondo Doni*.

Together with the same sculptor, Michelangelo carried out a sizable commission for the cathedral of Siena, for which Donatello had once worked. In 1481, Andrea Bregno had started an altar for the tomb of Cardinal Francesco Todeschini-Piccolomini, who was to succeed Pope Alexander VI as Pius III in 1503 only to die within the year, leaving the Holy See to Julius II. After the building itself was completed in 1485, Michelangelo was commissioned to design four statues, whose execution he shared with Baccio da Montelupo (1469–1535) (ills. 23, 24). Perhaps the Bruges *Madonna*, which he sold to the heirs of Moscheroni or Mouscron and which today stands in the Mouscron Chapel of the Church of Notre Dame in Bruges (ill. 17), was once intended for Siena, where the Piccolomini altar is decorated today with an older statue of the Virgin from the group around Jacopo della Quercia.

The first years of the new century made people aware of the tremendous change in their world. This also affected art and the awareness of history. Florence had

24 (above right) *Pius* from the Piccolomini Altar, ca. 1503/04
Marble, h. 134 cm
Duomo, Siena

The garment of a prince of the Church in full dress cannot be dramatized in the same way as that of an apostle. Michelangelo divided up the task in Siena as a medieval master would have done: he kept the apostles in the lower register for himself; he left the popes in the register above that to Baccio da Montelupo because they are artistically less interesting and are not seen at quite such close range. Pius was particularly sacred to the Piccolomini, because in the person of Enea Silvio, who chose the name Pius II (1458–1464), they had provided their first pope. He founded the town of Pienza.

25 Back view of nude, ca. 1504
Pen and pencil on paper, 40.8 x 28.4 cm
Casa Buonarroti, Florence

Michelangelo studied the human body in various ways, as
was the norm among artists at that time: following
Leonardo's example, anatomical dissection provided the
basis for him, although he too still had religious scruples
about this. Living models played less of a role than
classical finds, which is why it is thought that this back
view of a nude with its clear contours is probably based
on a Roman sarcophagus. A variation of the figure returns
in the cartoon for the *Battle of Cascina*.

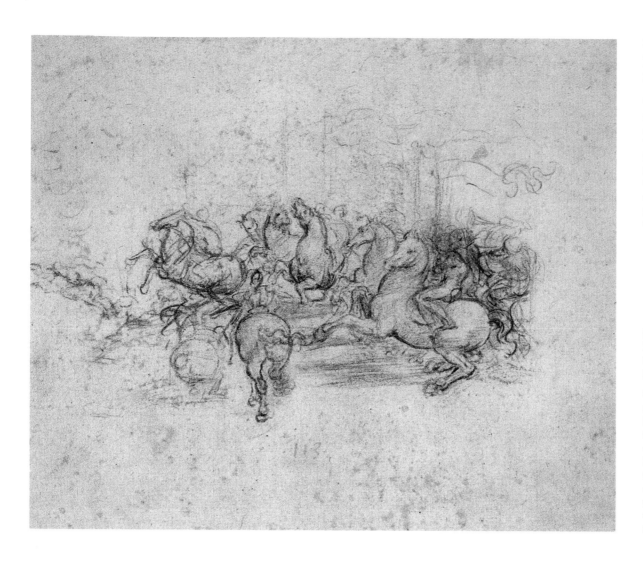

26 (left) Leonardo da Vinci (1452–1519)
Group of riders from the *Battle of Anghiari*, ca. 1503/04
Black chalk, white highlights, 16 x 19.7 cm
Windsor Castle, Royal Library, Windsor

The many uncompleted projects in Leonardo's life included the plan to paint a monumental battle scene in the council chamber of the Palazzo Vecchio in Florence. The subject was the victory of the Florentines at Anghiari in 1434. Although the wall painting of the great master soon disappeared in its incomplete state, its composition with the whirling cavalry groups continued to be known among artists. Peter Paul Rubens (1577–1640) not only painted a brilliant variation on this subject but applied the lessons to be learned from Leonardo in his paintings.

27 (below) Sketch for the *Battle of Cascina*, ca.1504
Pencil and silverpoint on paper, 23.5 x 35.6 cm
Galleria degli Uffizi, Gabinetto dei Disegni e delle Stampe, Florence

It is no longer possible to reconstruct in detail the genesis of this draft for the wall painting in the Palazzo Vecchio in Florence. The artist experimented in sketches such as these with grouping nudes in a landscape environment, which makes do with a few indications of rocks as in the later *Last Judgement* in the Sistine Chapel. The left part of the composition has already been done in some detail but does not yet show the final formula in individual shapes such as the back view of the figure on the left, a formula which was to be the subject of endless variation by many subsequent artists.

28 Aristotile or Bastiano da Sangallo (1481–1551)
Copy of Michelangelo's cartoon for the *Battle of Cascina*,
ca. 1542
Grisaille on canvas
Collection Earl of Leicester, Holkham Hall

In contrast to his older rival, Michelangelo does not
depict the actual battle but with unprecedented artistic
freedom uses the task as an excuse for a picture of naked
bodies. He chooses the moment from the report of the
victory of the Florentines at Cascina in 1364 at which the
army, bathing unawares, suddenly realizes that it is about
to be attacked. The man calling out and the soldiers
surprised by the enemy are the subject of a wall painting
which, like Leonardo's fresco, no longer exists and which
had an equally lasting effect on subsequent generations.

shaken off the yoke both of the Medici and of the
fundamentalism of the preacher Savonarola. Now it was
looking back on its history and wanted works from its
greatest sons as evidence of its own greatness.

Leonardo, who could be extremely difficult, was the
first to be contracted to depict, in the great council
chamber, the *Battle of Anghiari* between the Florentines
and Milanese in 1434. Having had experience with
unfinished works, the council forced the artist to deposit
a security in May 1504, which he did, indeed, have to
forfeit when he discontinued work two years later. It was
not until six months after this that Michelangelo was
engaged. The competition between the older master
and the not yet thirty-year-old was thus not planned
in advance but resulted from the sequence of the
commissions.

A greater contrast between these two battle paintings
could not be imagined. Leonardo created a wild cavalry
skirmish (ill. 26) while Michelangelo concentrated on
naked bodies alone (ills. 27, 28), so that his depiction
of the *Battle of Cascina* came to be better known, among
artists at least, as the *Bathing Soldiers*. Both paintings
suffered the same fate. They remained uncompleted.
The fragments which had been applied to the walls
disappeared as early as the 16th century when Vasari
(1511–1574) redesigned the chamber.

But contemporaries did recognize the immense value
of both paintings, so that Leonardo and Michelangelo
influenced numerous later works precisely by dint of
their competition in the Palazzo Vecchio. The individual
figures were studied as keenly as the overall composition.
In somewhat different guise, variations on the theme can

be found even in the Venetian painting of Tintoretto
(1518–1594). Leonardo's cavalry battle found its way
into Baroque art via Rubens (1577–1640), while
Michelangelo's *Bathing Soldiers* found a late echo in 19th
century masterpieces such as Géricault's (1791–1824)
Raft of the Medusa in the Louvre.

Michelangelo had deeply impressed Florence above
all with his *David*; the statue itself had become a symbol
of the city. For this reason an attempt was made to
include the artist in a major sculptural project of which
only a rough-hewn statue remains: *St Matthew* in the
Accademia (ills. 31, 32). In the meantime, however, the
new pope, Julius II, had already won Michelangelo for
his tomb. This was far superior to the cardinal's tomb in
Siena for the short-lived Pope Pius III, which had been
pieced together at various times and for which the artist
had supplied four statues. That is why *St Matthew*
remained fettered in his marble.

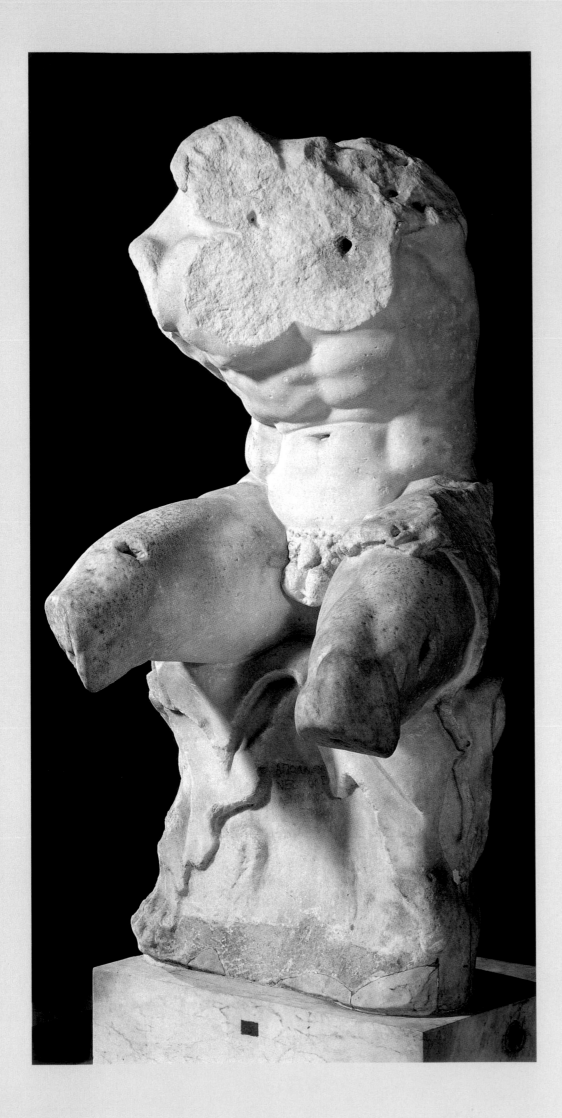

In a world of craftsmen, merchants and bankers it is hard to conceive of a plain artist delivering something unfinished and thus unusable, simply because he does not have the time to finish it. People were just beginning to recognize that art is more than a craft. But contracts were still based on the old quality criteria and had deadlines by which a work of art had to be delivered like any other piece of work.

Conflicts were unavoidable, and they came for Michelangelo particularly in relation to the debate about the tomb of Pope Julius II (ills. 49–53), whose heirs failed to appreciate the way in which the artist was pursuing the commission which he had accepted, and swamped him with court cases. It is not, therefore, surprising that there were quarrels with Michelangelo. But something astonishing happened in relation to the future understanding of art. People were indeed satisfied when at the end of a long struggle for time and money, form and content, Michelangelo's work remained a fragment, a rough stone, at times hardly recognizable as a statue.

As early as the *Battle of the Centaurs* (ill. 4) and the magnificent *tondi* for the Pitti and Taddei (ills. 13, 14), which Michelangelo left unfinished in Florence in 1505, no other sculptor was commissioned to finish the work. People were satisfied to accept what had been touched by genius and learned surprisingly quickly to come to terms with it. Leonardo (1452–1519) had already put Florence to the test with paintings such as the *Adoration of the Magi*. In this case it had been deemed better to have another painting done by Filippino Lippi for the required altar piece, so that the true hand of the great master could be preserved in the unfinished work.

This was the first time that such respect for the giants of art had appeared in the history of European art. It was surely inspired by classical finds, which inspired awe however fragmentary they might be. But most of the fragments of statues were finally completed, including the *Laocoön*

29 Apollonius
Aiax (Torso of Belvedere), ca. 50 BC
Marble, h. 224 cm
Vaticano, Palazzi Vaticani, Museo Pio-Clementino, Rome

The torso of this splendid marble remained free from damage. This work of art, signed on the body, fascinated Michelangelo and other artists since they saw it in such a way that the wonderfully balanced body could epitomize an art form which stood up for itself even without head and limbs. The *ignudi* of the Sistine Chapel (ill. 47) are nothing other than inexhaustible variants of this work, which had been in the possession of the Roman family of Colonna since 1432 and had stood in the Belvedere of the Vatican since the beginning of the 16th century.

(ill. 57) in order to be able to enjoy them fully. Only one marble block was preserved in the face of this, on which Michelangelo's regard conferred nobility for ever: it is still known today as *Torso of Belvedere* (ill. 29).

The torso quality as well as the fact of being unfinished bestow a magic which a finished work does not have. Michelangelo was the first to discover this and it took quite a long time until the great French sculptor Auguste Rodin (1840–1917) rediscovered the torso: The gaze quickly glides over the smooth surfaces of many a highly polished master piece; imagination is not touched by perfection. In order to avoid the effect of the carefully completed work disappearing into thin air, Michelangelo had to give his *David* (ill. 22) an inner tension few other sculptures possess.

It is much easier to experience the suggestive power which radiates from a roughly hewn block such as the *St Matthew* (ills. 31, 32) in the same Florentine Galleria dell' Accademia: when looking at the bearded figure, who appears to have been sleeping in stone and now begins to extract himself from the weight of the material, the observer witnesses an act of creation. In addition, this is an Evangelist with his mighty book in his left hand, so that the shape of the Word arrives with the shape of the human being – as a promise which is still wholly tied to matter.

We can speak here of art as re-creation of the divine creation which breathes life into dead matter and culminates in the human being. Michelangelo's figures such as his Florentine slave which has become famous as the *Atlas* (ill. 30) have a heavy burden to bear with the heavy stone which keeps them imprisoned. The modern observer is less touched by this because he can imagine all the things that might have become of this beautiful marble: in the unfinished work of the sculptor life is always fighting to appear out of matter.

30 *Slave*, called *Atlas*, ca. 1530–1534
Marble, h. 277 cm
Galleria dell'Accademia, Florence

It is always an awesome spectacle when a huge body, still all but headless, emerges from the marble and apparently does battle with the stone in order to free its head. Michelangelo only started work on the figure for the Julius tomb in the early 1530s. Along with other slaves which also were never finished, this giant came into the possession of the Medicis. It was displayed in the Boboli gardens and was then transferred to the Accademia in the 19th century where it stands alongside the *David* (ills. 21, 22), which itself is exquisitely complete in its every detail.

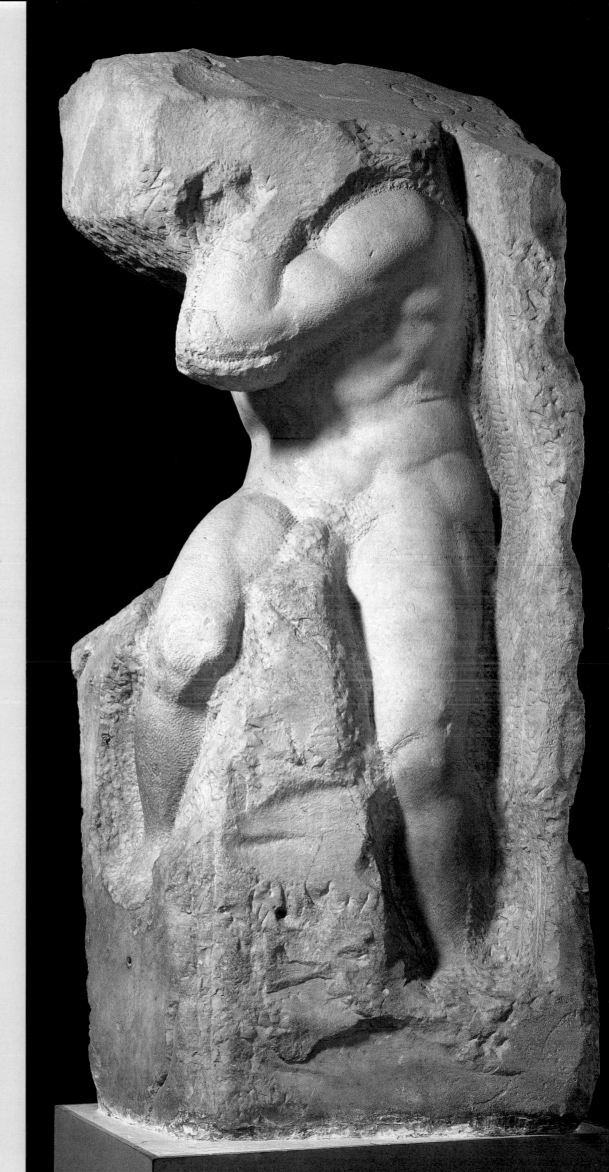

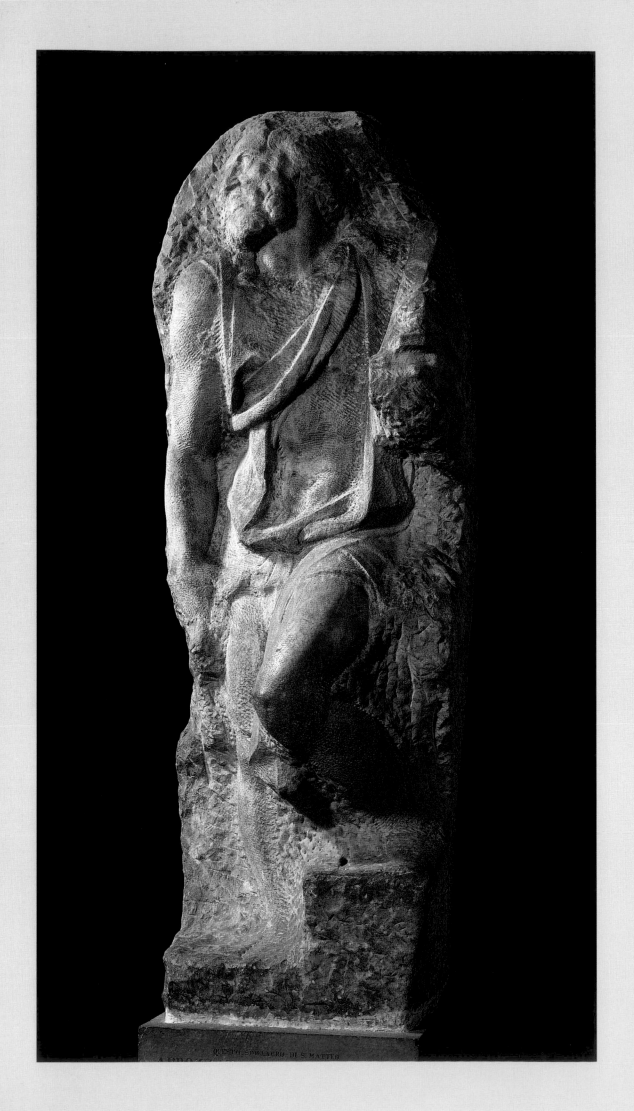

31 (left) *Saint Matthew*, ca. 1503–1505
Marble, h. 271 cm
Galleria dell'Accademia, Florence

The unfinished figure of *Matthew* has survived as
evidence of a commission given to Michelangelo by the
Arte della Lana in 1503. The artist was commissioned to
produce a total of 12 figures depicting the Apostles,
which were destined for Florence cathedral. However,
only the incomplete figure of *Matthew* as shown here was
produced before the commission was cancelled when
Michelangelo left for Rome in 1505.

32 (opposite) *Saint Matthew* (detail ill. 31),
ca. 1503–1505

As soon as a block of marble such as this gives the
impression that an artist has seen a human form within its
confines, we are instilled with the thought that this
human being is slumbering there, waiting to be
awakened. The observer's imagination is quickened into
life as we must imagine the entire figure. However, our
attention inevitably focuses on the technical dimension of
the creative process, when for instance it becomes evident
how quickly Michelangelo came to accord an important
role to the comparatively subtle folds in the sculpture's
surface.

MICHELANGELO AND POPE JULIUS II

33 General view of the Sistine Chapel
Vaticano, Palazzi Vaticani, Cappella Sistina, Rome

In 1508, after his return to Rome, Michelangelo accepted the commission which was to immortalize him. Originally, his task was simply to complete an ornamental depiction of the twelve Apostles. The outcome was a superlatively complex fusion of biblical history with the results of the Renaissance's study of Antiquity. In the Sistine Chapel, which was constructed under Sixtus IV on existing foundations, Michelangelo's work begins between the tops of the windows with scenes from the lives of Moses, Christ and various popes.

34 (following double page) Vault of the Sistine Chapel, 1508–1511
Fresco, 40.23 x ca. 13.3 m
Vaticano, Palazzi Vaticani, Cappella Sistina, Rome

In an artistic vision without precedent, the architectural structure soars above the side walls, thus creating a deliberate optical illusion and providing space for the prophets and sibyls. Above their heads, the structure opens out into fields in which are related stories from the Creation to the Drunkenness of Noah. Other medallions, emblazoned with gold, depict more episodes from the Old Testament. Yet even this is not enough – this ceiling is also peopled with many nameless figures: putti and genii surround the principal figures. They are, however, outnumbered by the bronze-colored naked youths, some of whom attempt to force their way into the triangular spandrel and almost escape the observer's eye, while others in their exuberance are in full view along the border ledge.

In March 1505, Pope Julius II invited Michelangelo to Rome in order to entrust him with a monumental commission. The Pope had already radically changed the face of art in his time through his decision to tear down the old St Peter's basilica and to replace it with a centrally planned building wholly in the spirit of the new age. Now he wished to prepare his own tomb for the church which was still some way from completion. He wished his tomb to be bigger and more magnificent than anything that had existed before (ill. 51). So he summoned the creator of the *David* in Florence, concluded the basic agreement with him and sent him to Carrara, where until December Michelangelo selected stones from the marble quarries which he deemed appropriate for the mighty sculptures.

But when the artist returned to Rome in 1506, he found his access to the Pope denied. He had to find out from elsewhere, and not from the Pope himself, that the project had been abandoned – or at least was in abeyance. Thereupon he took unprecedented action: on 18 April he angrily left the Eternal City and withdrew to Florence, from where he feuded with the Pope until a kind of reconciliation took place on 21 November of the same year at a meeting in Bologna. That is how later biographers set out what happened, without expressing the least surprise at the fact that two characters who were – socially – worlds apart were in collision here, the more powerful not actually being accustomed to coming to a reconciliation with an artist. The blatant self-confidence which Michelangelo dared to display at this first conflict with the Pope determined the future relationship between the artist and the highest powers in the Roman Church; and they tolerated such behavior.

Nothing remains of the first work which the artist executed after the meeting with Julius II. The Pope saw Bologna as the most important bastion of the papal state after Rome, which is why he wished to be represented there by a monumental statue. He had Michelangelo create a statue in bronze of him seated on a throne for the façade of the main church, San Petronio. The artist stayed in Bologna from November 1506 to the unveiling of the sculpture on 21 February 1508, when he returned directly to Florence. But his only papal statue became the victim of popular outrage a few years later. When Bologna liberated itself once again from the shackles of the Papal State in 1511, the republican city government of Otto de la Guerra had the image of Julius destroyed, without regard for its being a Michelangelo.

Back in Florence, whose republic continued to defy the banished Medici, the artist received an honorable commission from the *gonfaloniere*, its constitutional chief magistrate, Pietro Soderini. As a counterpart to the *David* at the gate of the Palazzo Vecchio, he was to create an image of Hercules vanquishing the giant Cacus. The commission was renewed in 1528 under another republican government but it never advanced beyond small models (ill. 58). The massive group of figures on this subject which still stands today in its designated place was carried out by Baccio Bandinelli (1493–1560) in the manner of Michelangelo rather than in his spirit.

THE CEILING OF THE SISTINE CHAPEL

Michelangelo remained two months in Florence. In April he went to Rome again in order to discuss a project with Julius II which was to immortalize both the Pope and the artist. In the years from 1475 to 1481, Giovannino de' Dolci had erected for Pope Sixtus IV, who was a della Rovere like Julius II, a monumental chapel to our Lady in the grounds of the Vatican palace. It was 20.7 m high and had the imposing internal dimensions of 40.5 x 13.2 m (ill. 33). The sculptors Mino da Fiesole (1431–1484), Andrea Bregno (1418–1503) and Giovanni Dalmata created the marble screen which divides the room in the delicate manner of the early Renaissance, along with the balustrade which decorates the famous pulpit.

From 1481 to 1483, this first Rovere pope had then brought in the painters. Botticelli (1444/45–1510), Ghirlandaio (1449–1494) and Cosimo Rosselli (1439–1507) as well as the young Piero di Cosimo (1462–1521) from Florence were there, as were Perugino (1450–1523) and Pinturicchio (ca. 1454–1513) as well as Luca Signorelli (1441–1523) and Bartolomeo della Gatta (1448–1502). Above the high base of the side walls, which traditionally was covered with painted tapestries, they created two great sequences of paintings which are to be read starting from the altar wall. The frescoes on the left tell the story of Moses, the ones on the right depict episodes from Jesus' life between his Baptism and the Last Supper. In the niches between

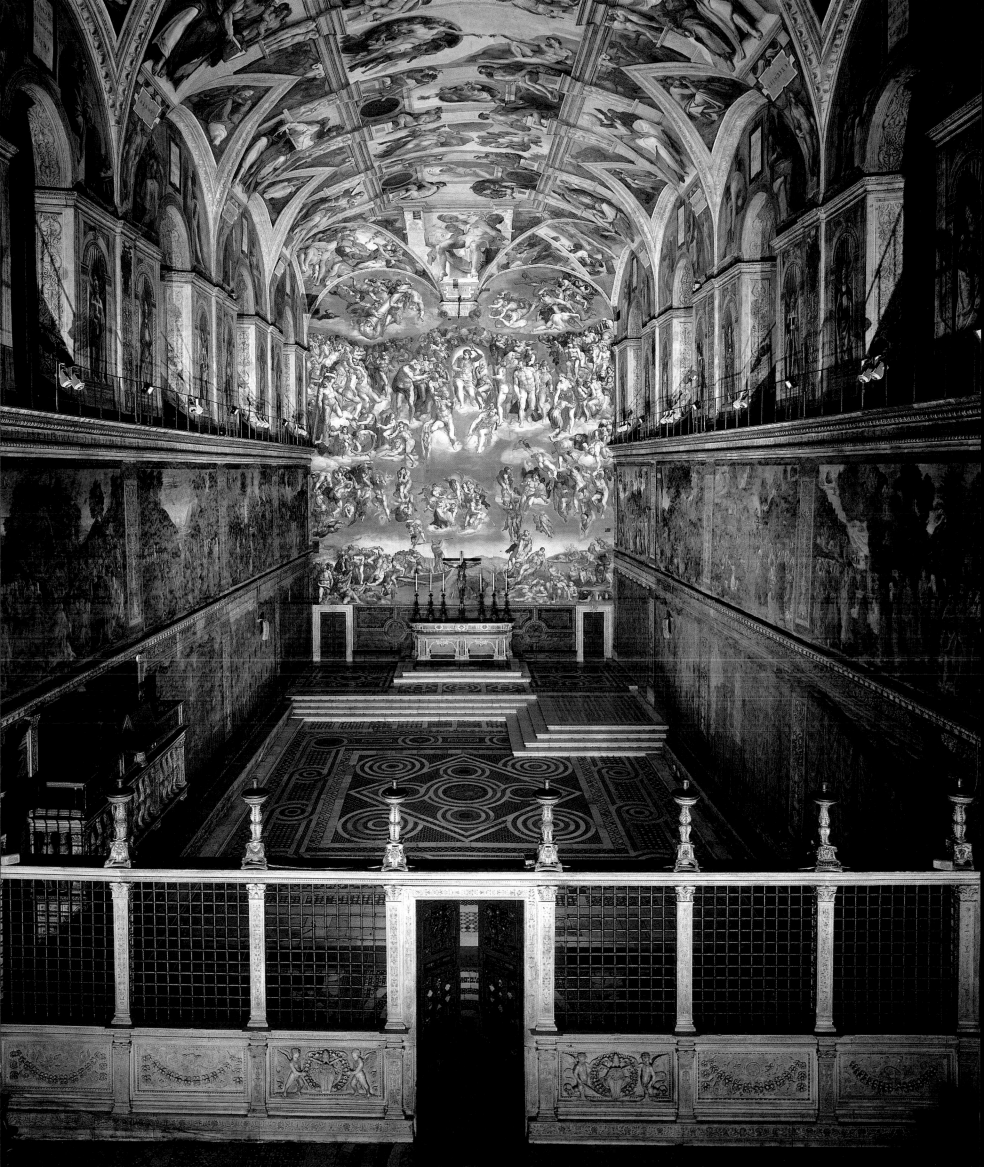

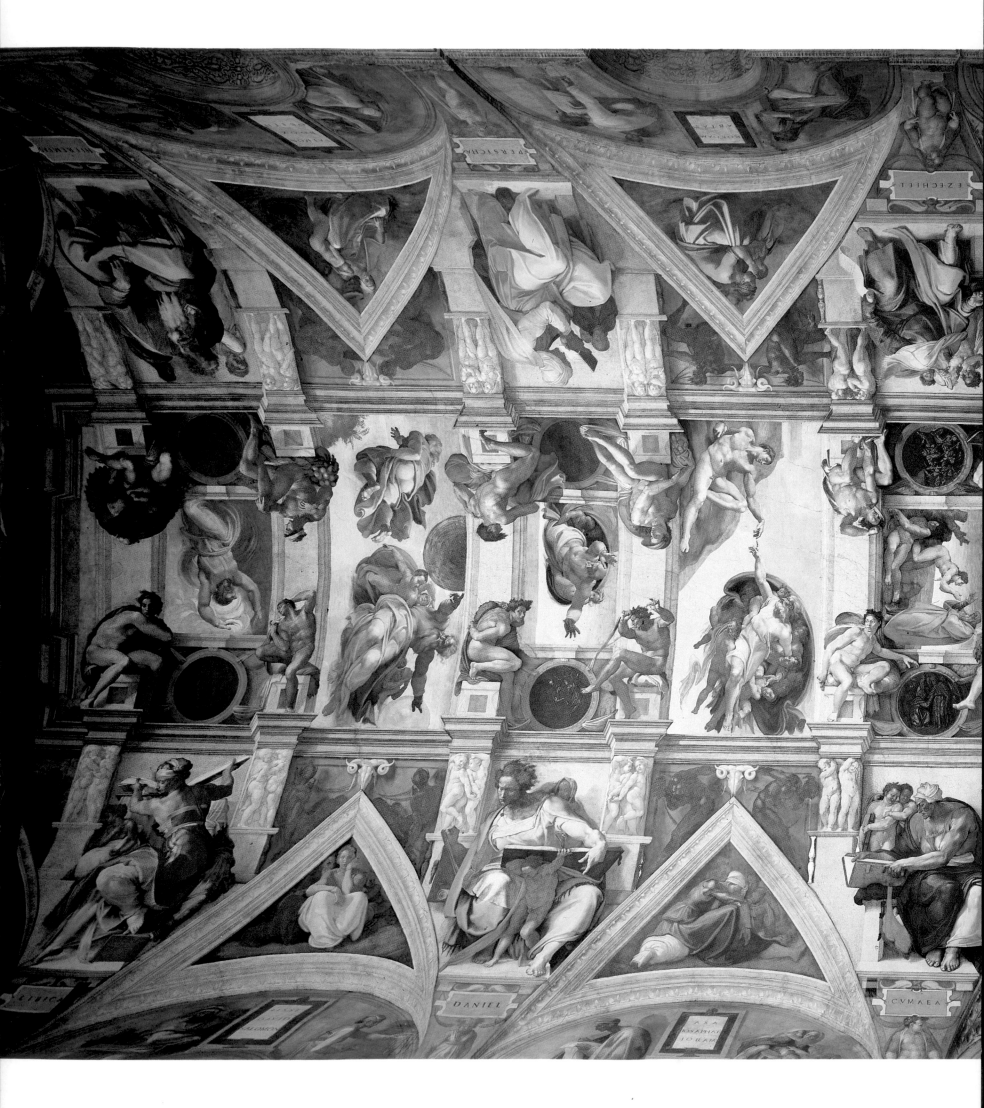

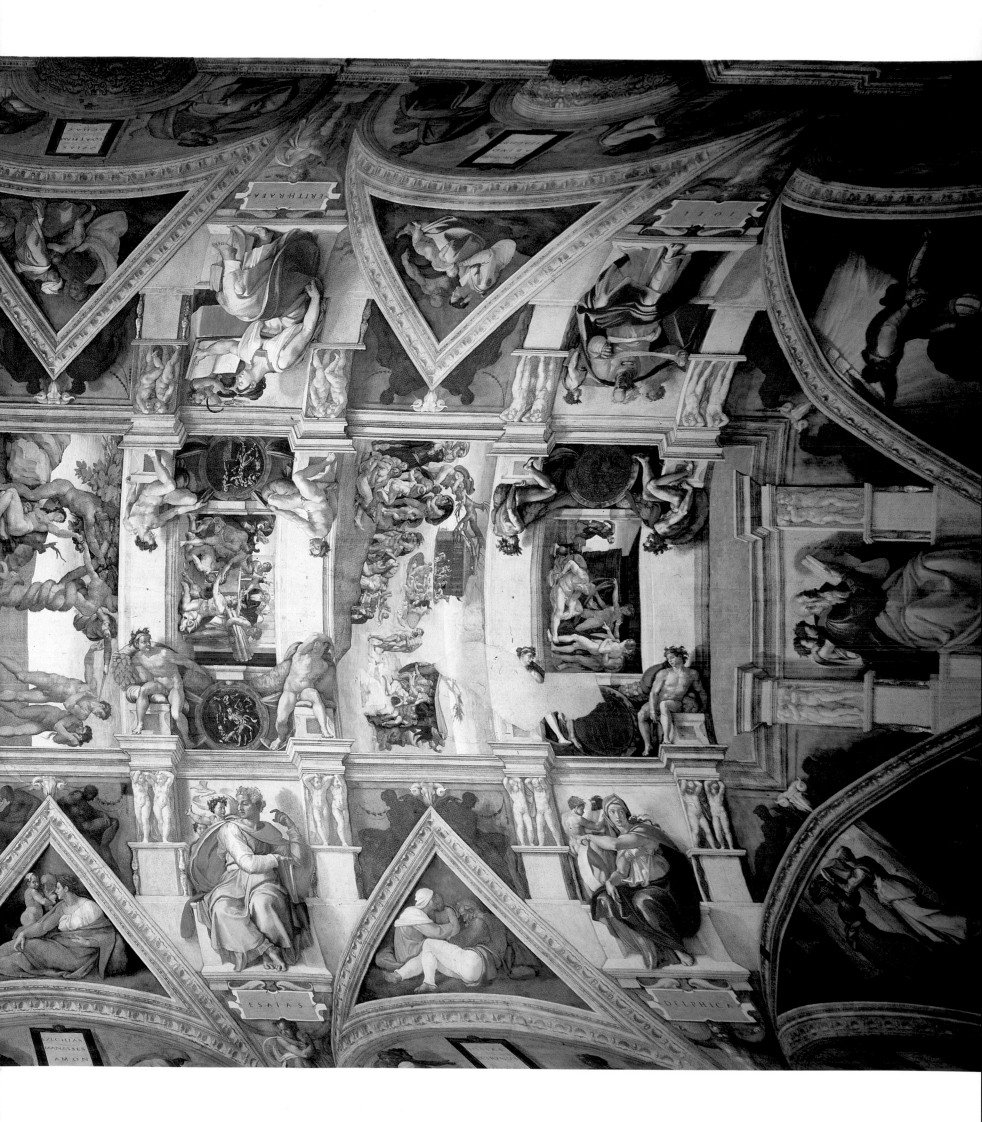

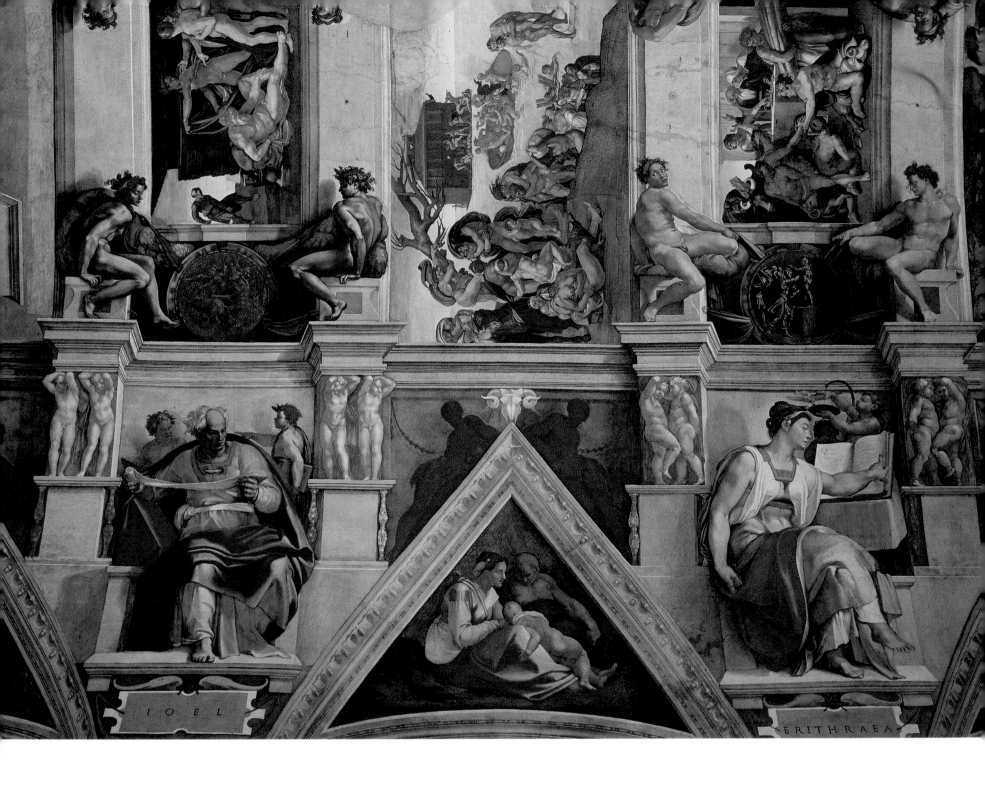

35 Vault between Joel and the Erythraean Sibyl (detail
ill. 34), 1509

The lunette with King Zorobabel is surmounted by the
spandrel above the window arches, in which he is
depicted as a child with his parents. Between the prophet
Joel and the Erythraean Sibyl appear nudes designated by
the Italian term *ignudi*. They wear garlands made of oak
leaves as a tribute to the Rovere family (whose name
translates as "oak"). The illusion of which they are the
main feature also includes the gilded medallions in which
Joram is cast off his chariot by Bidkar and Jehu destroys
the graven image of Baal. At right angles thereto are
pictures of quite a different order recounting the story of
Noah and the Flood, here only partially visible.

the round arched windows, smaller frescoes depict various popes.

The decor did not, however, reach as far as the lunettes above the windows. The wide ceiling was only painted decoratively in blue with stars although, as a relatively flat surface, it seemed made for figurative subjects. Here Michelangelo found his task, albeit reluctantly, since he himself continued to be driven by concern about the tomb of Julius II, in other words by, as he himself put it, the "tragedia della sepultura". It is even said that the project was born out of the resentment of the architect Bramante (1444–1514), who would have been only too glad to see the sculptor Michelangelo fail in the seemingly insoluble task of painting more than 500 square meters of ceiling as well as the lunettes.

Even the initial plan of a figurative design was a Herculean task: Michelangelo was in the first instance to be satisfied with the depiction of the twelve apostles. They were to be placed in the fields above the consoles which stretched towards the middle between the triangular fields above the arched windows. The central ridge of the ceiling was to have been filled only with ornamental painting. That would have accorded with a very common plan – after all, the ceilings of many churches and chapels had apostles or at least the evangelists on them. After this work had started, however, Michelangelo submitted a radical change of plan to the Pope.

As a result he was permitted to develop his own program in accordance with his own judgement – which was actually an incredible liberty for an artist in such a holy place.

Although the historical sources accord such freedom to the painter in the design of the ceiling, academic art historiography likes to assume a scholar as the brains behind the whole affair. Yet it is difficult to determine whether Eugenio da Viterbo or someone else should be seen as the consultant on the subtle theological questions. It seems to us that the thinking behind the ceiling was essentially based on an artistic process. A look at the result is enough to show how the artist wrestled with the task as he was working (ill. 34). To paint a ceiling is, after all, a decorative task which is most easily managed by laying out the dimensions in advance. Yet the size of the figures changes from one end to the other, so that it is hard to believe that a painter could have started with such a small prophet as the ancient *Zechariah* (ill. 37) over the entrance wall in order then to have escalated his work into the unfettered power of the youthful *Jonah* (ill. 38) above the altar wall within the space of two-and-a-half years.

Michelangelo was working within a peculiar context: His predecessors, who had painted the walls in the period just after 1481, had structured the space not from the entrance but from the altar. That is where the stories of Christ and of Moses start, so that the chapel must be

36 *Eleazar and Mathan* (detail ill. 34), 1509
215 x 430 cm

The lunettes complete the wall above the windows. Like the smaller spandrels above, the fourteen fields contain the ancestors of Christ. The source could be the prologue to the Gospel according to St Matthew or else a motet by Josquin des Prés. Only the written tablets in the middle allow these persons to be identified, because their appearances in art are too infrequent. This lunette depicts two families standing opposite one another; the woman at the front left is particularly impressive as she bears witness to Michelangelo's fine sense for clothing and accessories such as the bunch of keys.

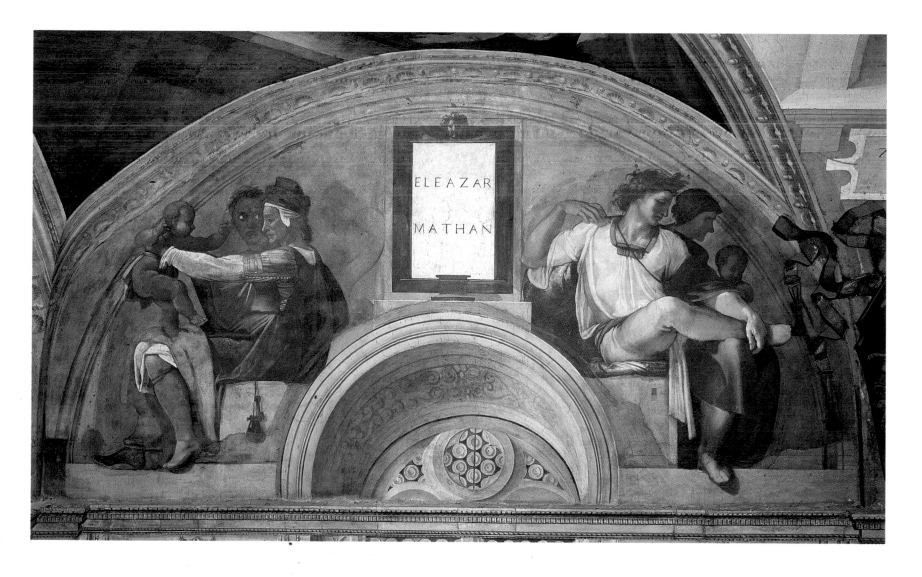

37 *Zechariah* (detail ill. 34), 1509

The ceiling sections between the spandrels above the window arches contain a sequence of sibyls and prophets, as a testimony to Divine Revelation as experienced by man and woman, pagan and Hebrew alike. A manifestation of a lingering measure of hesitation in terms of proportion, *Zechariah* sits in a spacious niche. His figure throws deep shadows on the wall. He is looking into a book, as are the genii behind him, thereby emphasizing the impression of intensive research. Since *Zechariah* is said to have foretold Christ's entry into Jerusalem, his image on the entrance side is also a reference to the Pope's entry on Palm Sunday.

crossed before the pictures can be read. Michelangelo added a third cycle which stretches from the Creation to Noah's drunkenness and likewise starts at the altar end. But here the pictures which tell the main story all appear upside down. They can be read only from the entrance, but in reverse chronological order. A further unusual aspect of their effect is the work sequence, for anyone can see that the art of the master did not develop from the beginnings of the Creation (ill. 46) to the later episodes, but in reverse. Michelangelo started at the entrance and finished his painting above the altar, so that the figures towards that end grow in stature and the thinking behind the pictures becomes ever more impressive.

The whole thing is intended as a majestic opening of the space (ill. 33). On the rising walls behind the round-arched windows one has to imagine niches in which Christ's ancestors sit, squat and wait. Of most of them, we know little more than their names, taken from the list at the start of the Gospel of St Matthew. But they are distributed throughout the space in a peculiar zigzag

so that the progression from Abraham to *Eleazar and Mathan* (ill. 36), the father of the Joseph to whom Mary was betrothed, can be followed only with great difficulty and with text in hand. Mere names are given powerful form by the artist; but even the most scholarly visitor needs labels to identify them. As in the classical tradition, this is done with fake stone tablets, which are tellingly placed in the centers of, and thus dominate, the individual fields. That, indeed, is the purpose of these pictures, which after all can tell no stories and thus only give shape to that line of tradition from which the Redeemer sprang.

The largest figures on the ceiling are also designated with their names, appearing where originally the twelve apostles were supposed to have been. Prophets and sibyls alternate, so that the story of the Creation is framed by those seers who from a Christian perspective had already anticipated the coming of the Messiah for the people of Israel or of a Redeemer for the world of the heathens. The subtle way in which the artist handles the existing dimensions is evident in the way in which he deals with

the number twelve. One might have expected him to divide it into two equal parts in the depiction of the sibyls and prophets; but Michelangelo paints only five sibyls (ills. 35, 39, 41, 42) and seven prophets.

The artist keeps neither to the order of the prophets nor to their designation in the Bible as major or minor, depending on the size of their books. The narrow sides, which are so important for the effect, are filled with the two "minor prophets" *Jonah* (ill. 38) and *Zechariah* (ill. 37) while the four "major" prophets *Isaiah*, *Jeremiah*, *Ezekiel* and *Daniel* (ill. 40) progress in a series of knight's moves and must share the remaining places with the "minor" prophet Joel. Whatever the thinking behind their selection and distribution, there is no clear connection with any obvious conceptual systems of theology.

Within the decorative context, Michelangelo's sibyls and prophets form the climax of the spatial illusion, as if the larger-than-life figures were physically present. They are accorded their place by the painted simulated architecture as if the artist had developed his design from

the original plan to depict the twelve apostles in a seated position. That required at minimum a base for the feet, a seat and a kind of backrest (ill. 42). In order to intensify the plastic effect, Michelangelo assigned a massively projecting piece of wall to each figure; this is so unusual that architectural terminology does not have a word for it: Flanked by balusters, the stone blocks push themselves forwards; on them are reliefs of pairs of putti in lively motion, above them being the powerful right-angled cornice.

This creates a base on which other figures are positioned in turn. These are nameless nudes which sit facing one another in unending variation on low blocks and must be understood as the crowning framework for the sibyls and prophets (ill. 35). It is impossible to give them a concrete historical meaning. Thus they are described today in Michelangelo's words with the simple Italian term for nude as the *ignudi* of the ceiling of the Sistine Chapel. There is no image which has had a more lasting effect on following generations than this. Henceforth similar figures disported themselves in

38 *Jonah* (detail ill. 34), 1511

At the other end, Jonah appears behind the altar as a powerful prefiguration of Christ. Compared to *Zechariah*, he is enormous and has completely freed himself from the architecture in which he was supposed to be housed. His legs hang free over the vault. There is nevertheless enough room for the tree under which the prophet lay when disputing with God and also for the huge whale which swallowed him. The rebellion against God's commands which is rooted in doubt is impressively depicted by the manner in which the figure is made to turn.

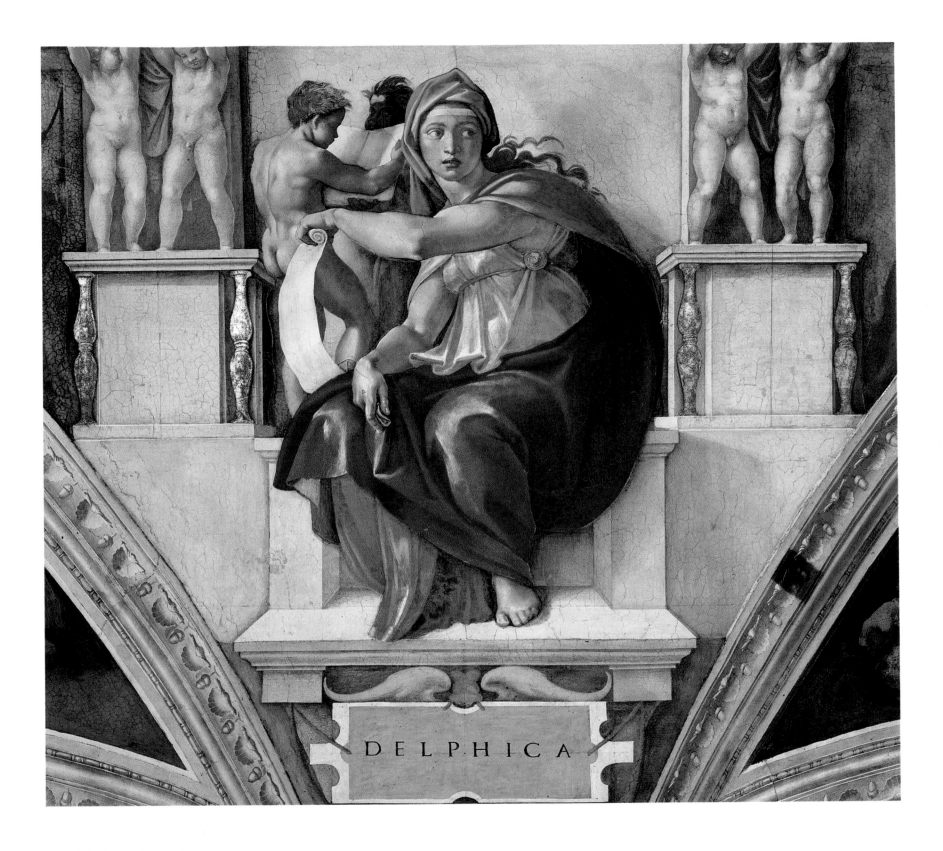

DELPHICA

39 *Delphic Sibyl* (detail ill. 34), 1509

The young woman's face appears half in shadow, half in light as it faces the observer. She looks at the unlit side with the result that the whites of her eyes are endowed with particular luminosity and expressiveness. Michelangelo gave the Sibyl from Delphi, home to the Oracle of Apollo, the youngest appearance, so it could be said that she has Apollonian features. The prophecies made by these pagan seers were viewed as being very important in the unfolding of Salvation right into the early modern era. This fact notwithstanding, the number of sibyls depicted in the ceiling fresco is astonishing.

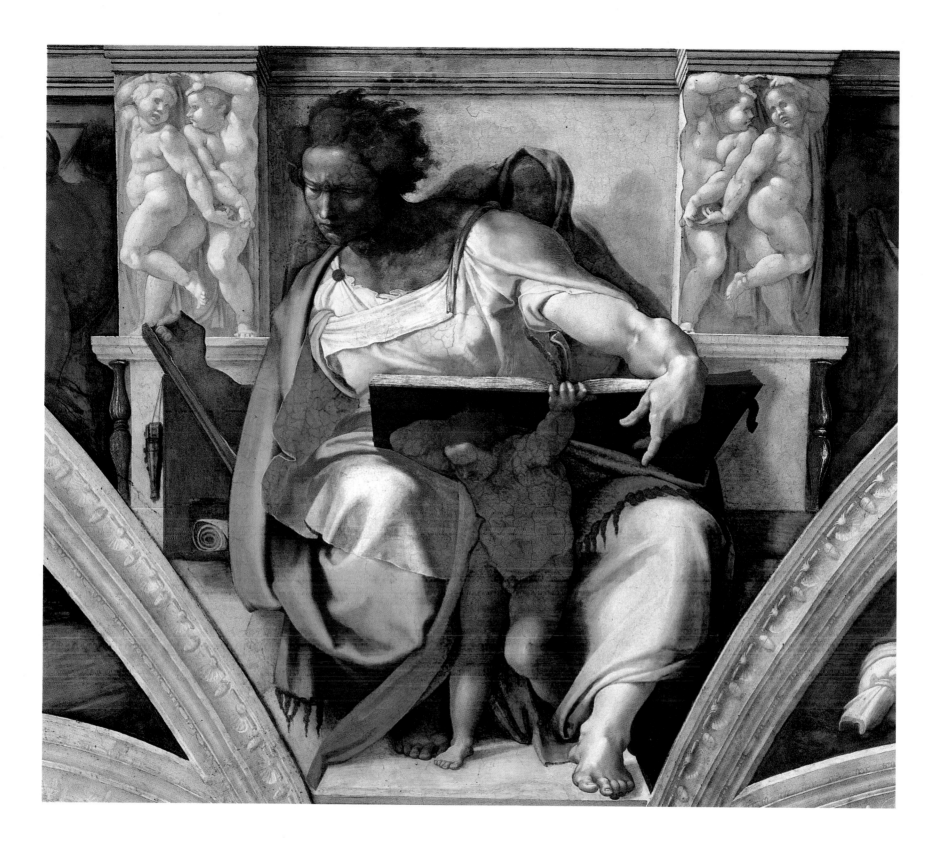

40 (above) *Daniel* (detail ill. 34), 1511

Problems in the structural engineering of the building, along with damage caused by damp, meant that the ceiling pictures were already beset with difficulties at an early stage. Then came the explosion of the powder magazine in Castel Sant'Angelo in the 18th century, which caused parts of the ceiling to fall. Even after the restoration, started in 1986, the colors of the fiercely searching figure of *Daniel* generally failed to be refreshed. The skin tone in particular was still too dull. However, a difference can still be clearly seen between the left arm, which is given a much more flexible appearance through the use of a wide variety of pigments, and the retracted right arm, which is painted in much more uniform colors.

41 (following double page, left) *Cumaean Sibyl* (detail ill. 34), 1510

Cumae is near Rome. Aeneas stopped there in order to receive the prophecy from the depths of the earth which ultimately led to the founding of the Eternal City, even if the privilege of performing this deed was not bestowed upon this Trojan hero. Of all of the wise women on the ceiling of the Sistine Chapel, it is the *Cumaean Sibyl* who makes the most intense impression on the observer. Michelangelo's conception of her is as an old woman. Despite this, she is endowed with the impressive musculature of a body which had once been extremely powerful. It is as if he saw her as a female counterpart to the *Moses* (ill. 49), which he perhaps had already begun planning and was only to complete some years later.

42 (following double page, right) *Libyan Sibyl* (detail ill. 34), 1511

The freedom which Michelangelo permitted himself with the sibyls and prophets in developing motifs of study and inspiration is particularly evident in the *Libyan Sibyl*. The manner in which she turns from her seat is fascinating in its artistry as she half rises and puts her book to one side. After the restoration work was complete, a multiplicity of bright, luminous shades of varying intensity were restored to their full glory. As a consequence, we receive a wonderful glimpse of the powerful spirit of the High Renaissance and the origins of the painter in the workshop of Ghirlandaio (1449–1494).

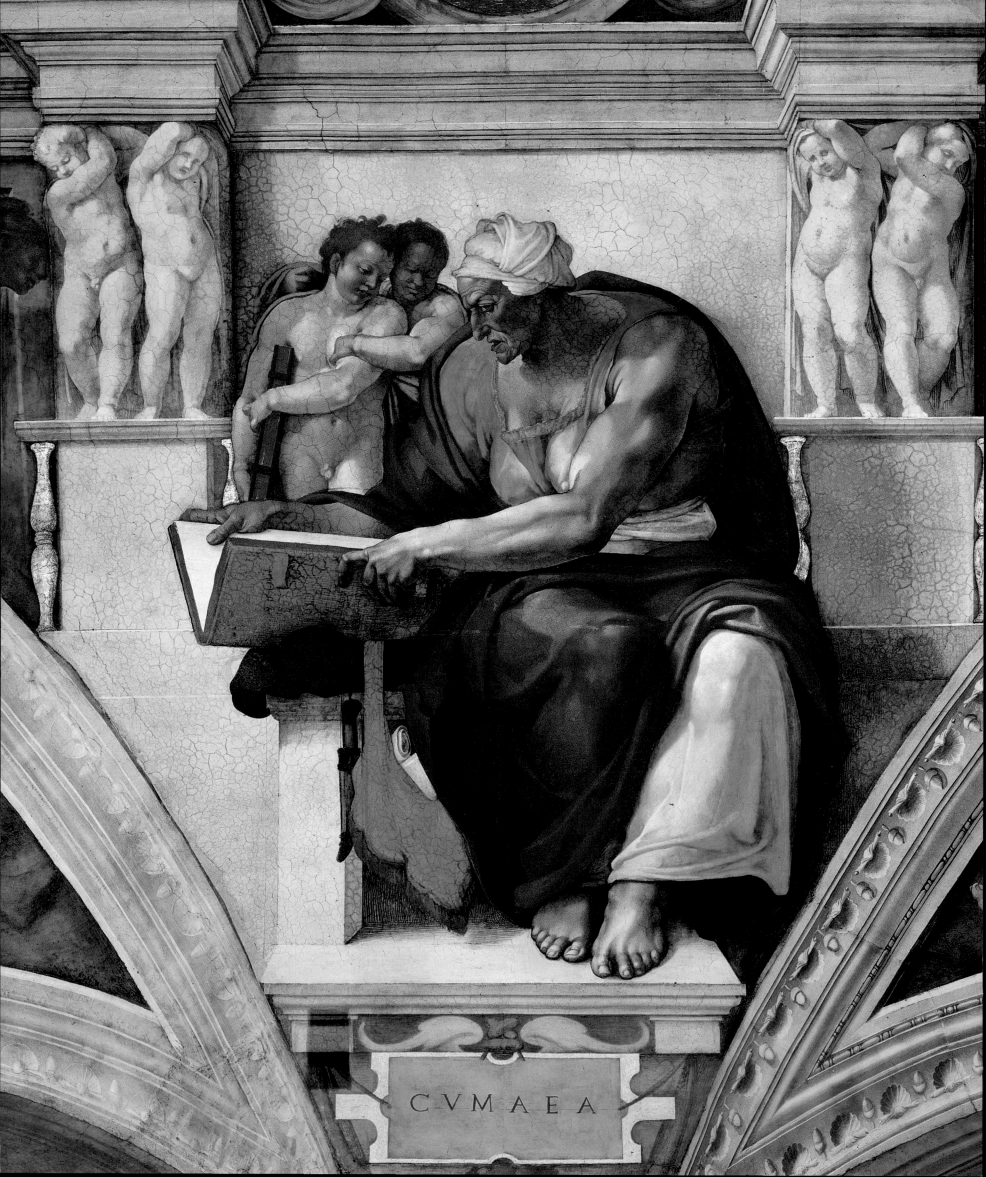

CVMAEA

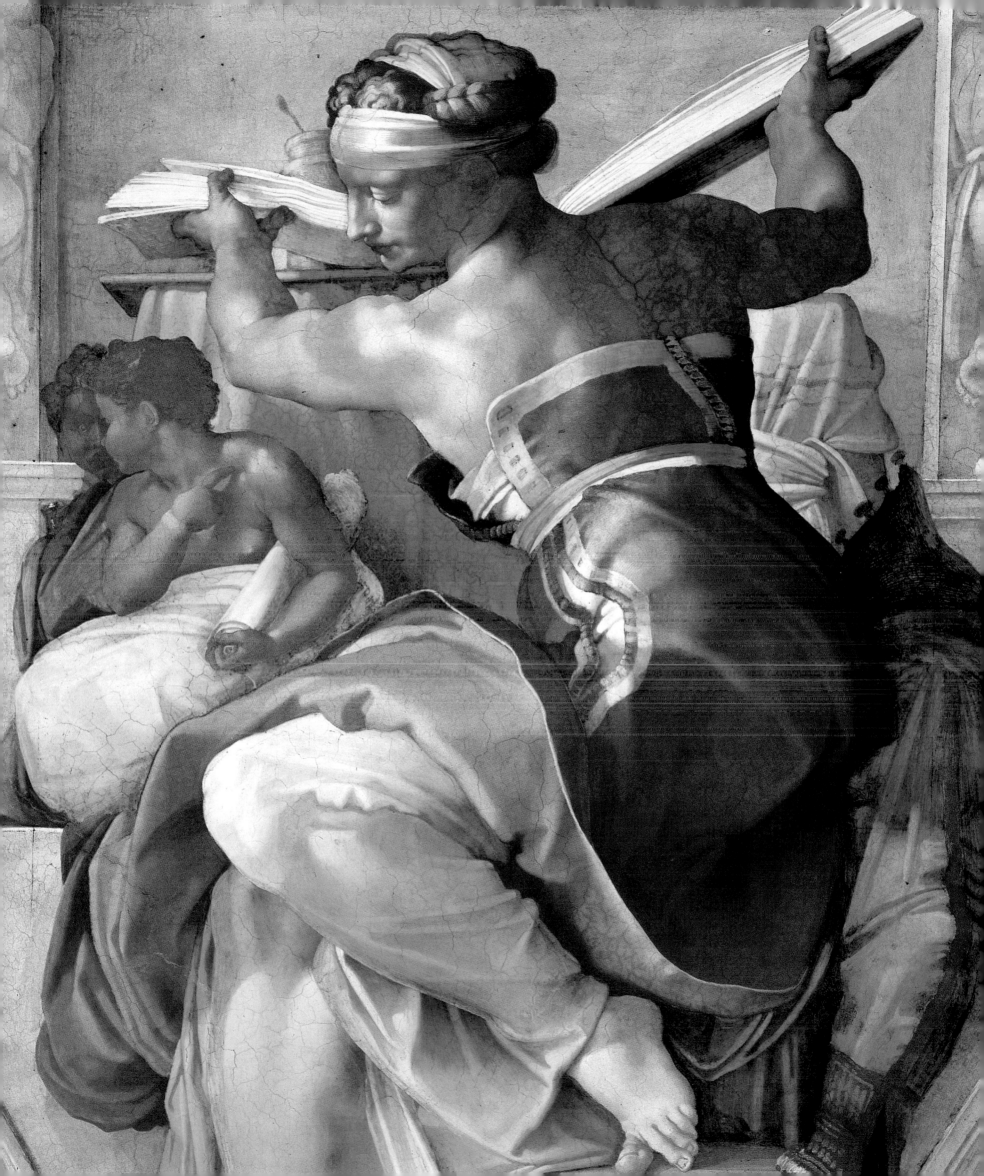

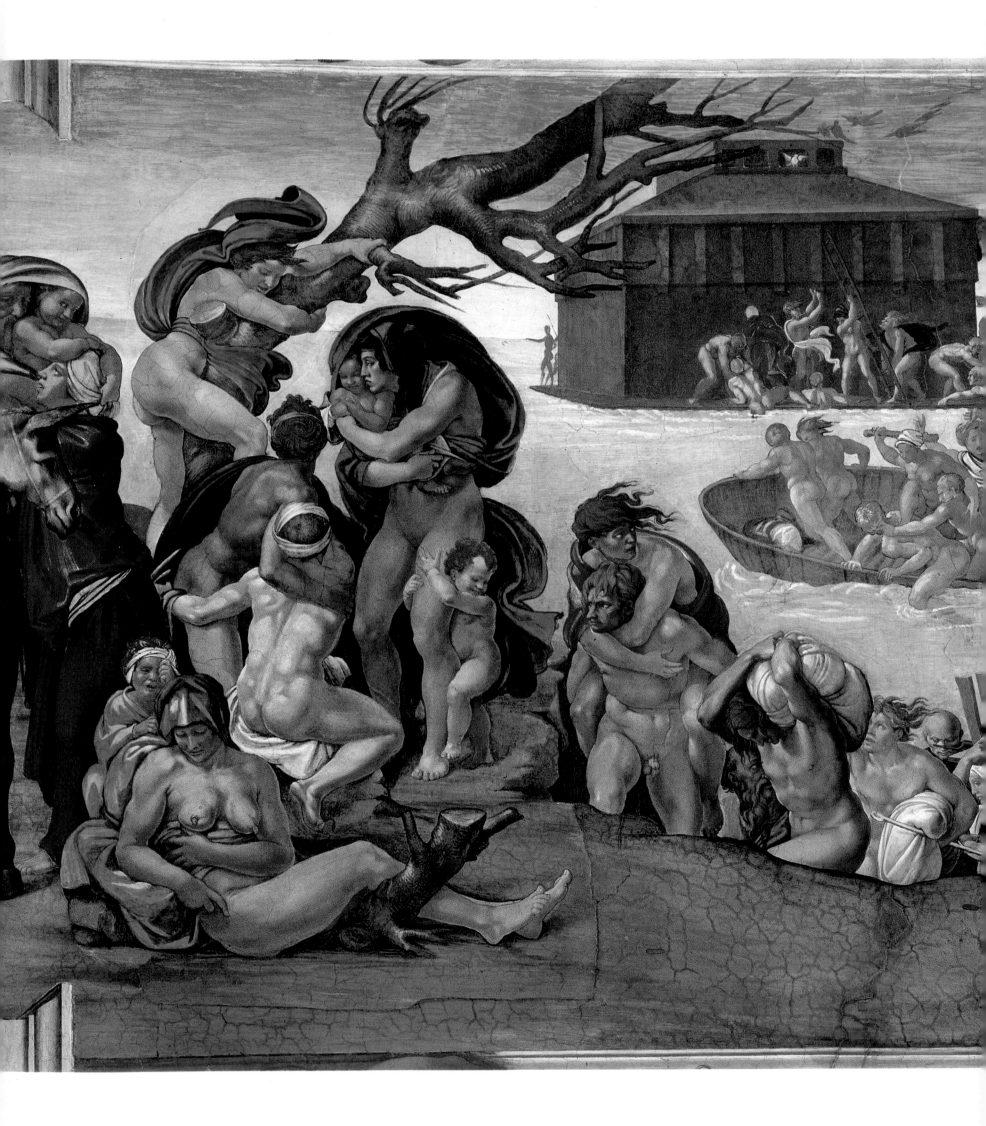

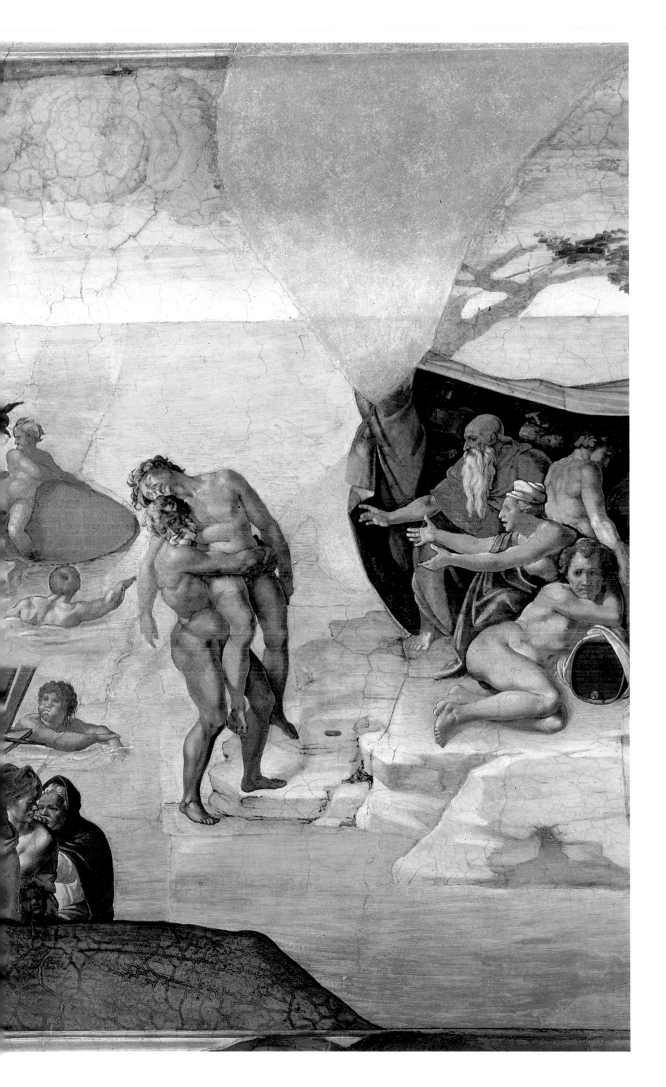

43 *The Flood* (detail ill. 34), 1508/09
280 x 570 cm

It is probable that Michelangelo's work began with this fresco, which, according to Condivi, immediately suffered from mold. In the field one can detect the problems caused by the division of labor between Michelangelo and the assistants from Ghirlandaio's workshop. Michelangelo soon only used the latter for more menial tasks. This composition contains a large number of figures and a great variety of body positions as the people depicted go to the hill in the foreground and clamor in despair for access to Noah's Ark. A tremendous tension is created in the fresco and it is this tension which characterizes the majestic view into the distance.

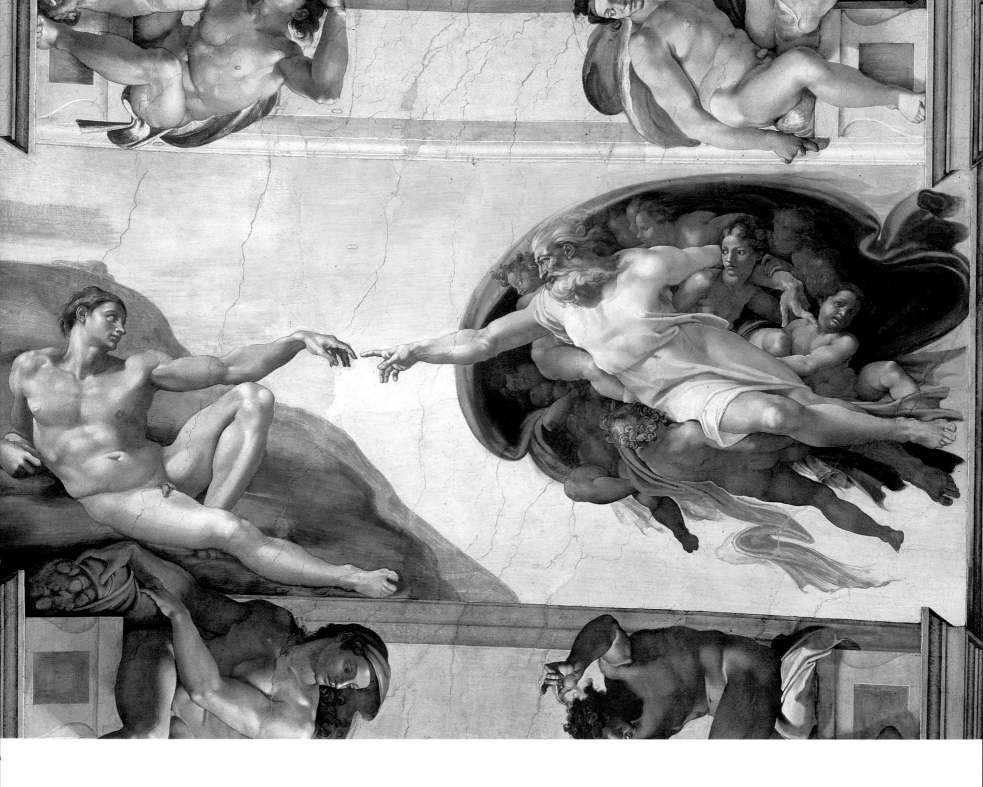

In his depiction of the creation of Man, Michelangelo was truly inspired in his decision to represent the breathing of a soul into Adam's body by painting God's finger. Here, he brings about an exquisite tension between the human body lying on an incline as it quickens into life, and the creating God, thundering forth from a whirling cloud of angels. This representation knows no comparison, and from the time it came into existence, it has been impossible to imagine the creation of Man in any other way.

innumerable decorative works, be they painted, formed in stucco or even sculpted.

The large *ignudi* over the prophets and sibyls are not the only nudes in the ceiling program. Below and between the rectangularly rising places of the monumental figures, there are spandrels which the painter could not leave unfilled. Naked boys, putti, carry the tablets inscribed with the names of the major figures. Lively as are the dancing steps with which these figures move, they are nevertheless part of the fake stone architecture, albeit distinguished by their flesh color from the imitation stone; the pairs of putti at the side of prophets and sibyls recall the Florentine pulpits of Donatello (cf. ill. 35).

Much less lifelike are the bronze-colored naked figures in the spandrels between the simulated architecture and the spherical triangles of the fields above the arched windows. Naked youths appear there in pairs, vaguely painted and clearly set back, without name and difficult to see, but of indefatigable artistic creativity.

Different fields were available for telling picture stories. Spherical triangles are formed by the fields above the arched windows between the prophets and sibyls and the pendentives in the four corners of the building. In the almost flat center, wide rectangles alternate with double bands whose middle also forms a rectangle, while the low spaces above the sibyls and prophets flanked by the *ignudi* contain *tondi*. The greatest riddles are posed by the triangular fields above the arched windows, as they do not tell a clear story but depict genre-like variations on the subject of parent and child. In a strong chiaroscuro they depict families huddling on the

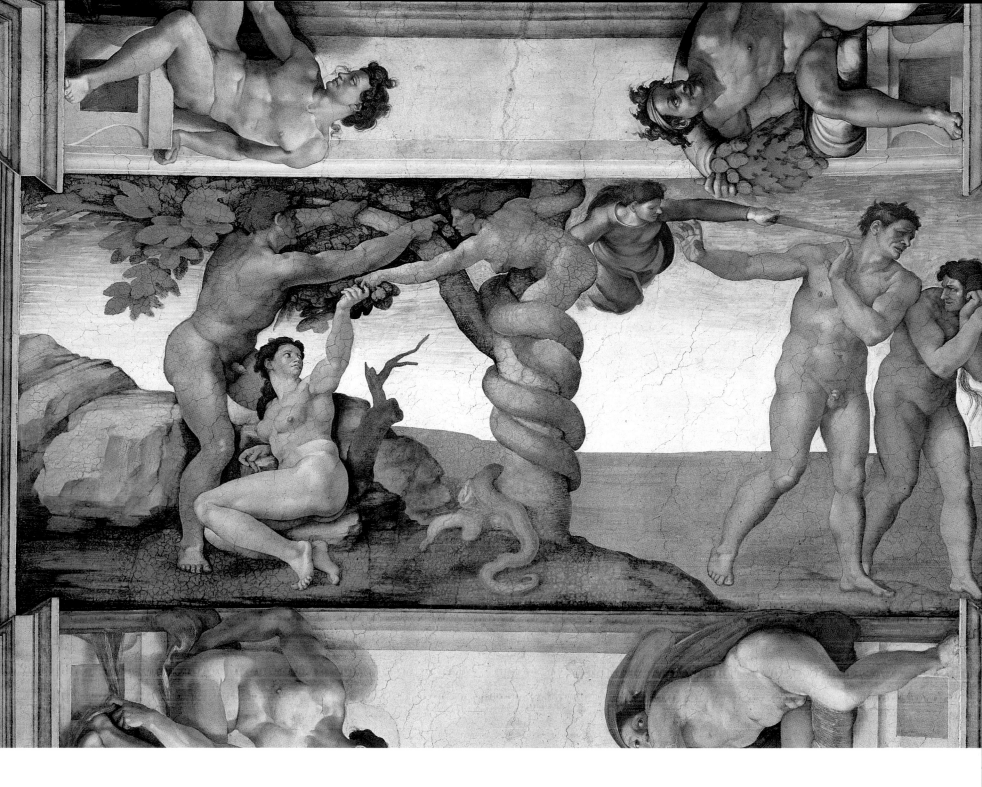

ground, thus apparently associating with them the idea of forebears who bring forth each new generation out of the union of man and woman. Since these fields do not have any inscriptions, they can only be read associatively so that in the peculiar jumps across the room, there results a sequence from Jesse's parents to the Kings of Judah, which is difficult to interpret at first sight.

The pictures which flank the *ignudi* recede clearly behind them, being small, filled with tiny figures and without the same feeling of reality as the rest of the painting, depicting, as they do, round bronze shields with painted reliefs. Once again in classical tradition, they are fastened to the simulated architecture with cloths. Not necessarily carried out by Michelangelo's own hand in each case, these sections form the worst preserved part of the monumental fresco because

important effects of miniature painting could only be achieved *al secco*. They tell of Old Testament events, ranging from the sacrifice of Isaac, via Elijah being taken to heaven in the fiery chariot, to the story of David and the Kings of Judah (ill. 34).

In terms of subject matter, the bronze shields thus tell of events the reports of which are distributed over all the historical books in the Old Testament, starting with Genesis. In contrast, the magnificent middle field of the ceiling with its four large and five small pictures is devoted to Genesis alone: broad bands stretch across the room from the right-angled cornice. They divide the surface into a regular alternation of small fields above the heads of the prophets and sibyls and wider ones above the triangular fields which surmount the arched windows. The small strips are restricted even further by

45 *The Fall of Man* (detail ill. 34), 1509/10
280 x 570 cm

This field marks the completion of the first phase of the work. From here on, Michelangelo worked on larger fields, which meant that he could get more painted in a day's work, and the scale of the figures also increased significantly. The bare Garden of Eden with its withered tree emphasizing Eve's gesture is an eloquent testimony to how little the painter was interested in landscapes. The first human couple, muscular, but with deeply furrowed faces, are situated on a green patch of land to the right, banished from Paradise. The red-haired Archangel Gabriel, who is also clothed in red, hovers at the upper edge in such a way that the artist does not need to provide him with wings.

the fact that they contain the large *ignudi* with the bronze shields. Michelangelo has framed them with broad painted stone profiles, while in the larger fields he fills the whole space between the feigned cornice and the fake bands.

It is not size which characterizes these pictures, however, but the increasingly free style which Michelangelo discovered in the three and a half years between 1508 and 1512. Since the earliest events in the history of the world were painted last, God the Creator reveals the greatest freedom (ill. 46) while the stories about the people at the time of Noah and the Flood are somewhat petty (ill. 43) as if this effect had been artistically intended.

Thus the story starts with the freest and most daring depiction, which has the Creator appearing from a whirlpool of light and dark (ill. 46). God is depicted twice in the next picture, appearing majestically from the right, against the direction of reading, in order to fix the sun to the firmament, surrounded by angels which give His figure even greater magnificent fullness. But then He turns his back on the observer and disappears to the left into the depths of space. Scholars dispute what happens next, for in the third scene, another small field, God the Father hovers above the waters.

According to Condivi, the Creator, with his body turned, is representative of the creation of the plants following the events of the fourth day of Creation, something which is also indicated by the few green twigs and grasses at the bottom left to which God the Father is pointing with his outstretched right hand. If we assume a certain continuity, however, then this view is contradicted by Vasari's identification of the smaller picture field above it. Vasari interpreted it as the separation of water and land (Gen 1, 9) which created the conditions for vegetation to appear. The Creator floats in the heavens, appearing from a great swirl of cloth; angels support him, partly hidden by the cloth. There is water below him, depicted as a small area, but no fishes (Gen 1, 20) are visible – even with the best will in the world. It is difficult to accept Condivi's explanation here, that this fresco – an earlier stage in the context of the story – represents their creation.

Altogether five fields were set aside for the story of the Creation, of which two were devoted to the creation of the human being, so that a traditional programme of pictures was not possible in any case. In the picture fields above the altar, the artist concentrated on describing the cosmic conditions required for the creation of the human being with the division of light and darkness (ill. 46), the creation of the stars and the separation of the waters. It is also likely that it was more in line with his artistic inclination to depict abstract processes focusing on God in human form than to lose himself in the depiction of fishes and birds escaping from the Creator's hand.

Two pictures are devoted to the creation of Man and Woman. According to the story, Adam came first, but it is worth remembering that Michelangelo painted Eve first. She is represented almost conventionally as a relief figure placed at the very front of the picture. Adam is asleep in the shadow of a tree stump. God has come from the right in order to bless Eve, who appears from the side of the man to pray to the Creator. What a step it is from this beautiful picture, in which Michelangelo might have recalled the magnificent marble work of Jacopo della Quercia on the cathedral façade in Bologna, to the unprecedented invention in the other picture of the creation. Here the mind's eye of the artist sees the contrast of heaven and earth (ill. 44). The beautiful figure of a man lies completely enclosed in the contour of a hill; God floats towards him in a mantle filled to the brim with angels. Only Adam's left forearm is released from the grip of the earth while the Creator extends His right forearm from His own domain. They do not touch, but vivification flows from the nearness, from the instruction of the hand of God and the seeking of the hand of Man.

At this point Michelangelo has freed himself from images which were still in many respects rooted in tradition. The further one follows the events in Genesis on the ceiling of the Sistine Chapel, the deeper one penetrates this past. The next picture repeats the depiction of the same figures in two adjacent scenes (ill. 45): the only thing that separates them is the Tree of the Knowledge of Good and Evil. Where Michelangelo should actually have characterized the contrast between the walled garden with the Fall to the left, and the bleak world into which the first human couple were expelled on the right, he does not provide the appropriate environment. In the scene of Adam and Eve driven from Paradise on the right, he quotes a monumental precedent from Florence – Masaccio's frescoes in the Brancacci Chapel, some of which at least he had partly sketched as a youth (ill. 7).

In the last three scenes, which originally formed the start of his work on the ceiling of the Sistine Chapel, the painter measures himself against quite different tendencies in the art of his time. The sequence of the story shows the importance which the systematic pre-existing format of the fields to be painted represented even to an artist of such stature: instead of following the chronological stations, Michelangelo surrounds the highly populated main event of *The Flood* (ill. 43) with two scenes which only come after. That is why it is apparently preceded by Noah's sacrifice in gratitude for having been saved, while the strange scene of Noah's drunkenness concludes the cycle in an altogether irritating manner. A study of classical reliefs and the compression of the figures into a large plastic group determine the two smaller pictures. The distant view from a shore rising slightly to the left, is used, in contrast, for the panorama of *The Flood* in a way which reveals training in Netherlandish painting.

This work at the latest reveals that Michelangelo did not intend to paint the whole ceiling of the Sistine Chapel on his own. He had had assistants come from Florence for this purpose who had climbed on the movable scaffolding with him. They may have thought of one or another of the images, particularly in the depiction of water and atmospheric distance. But the master quickly rid himself of these assistants in order to

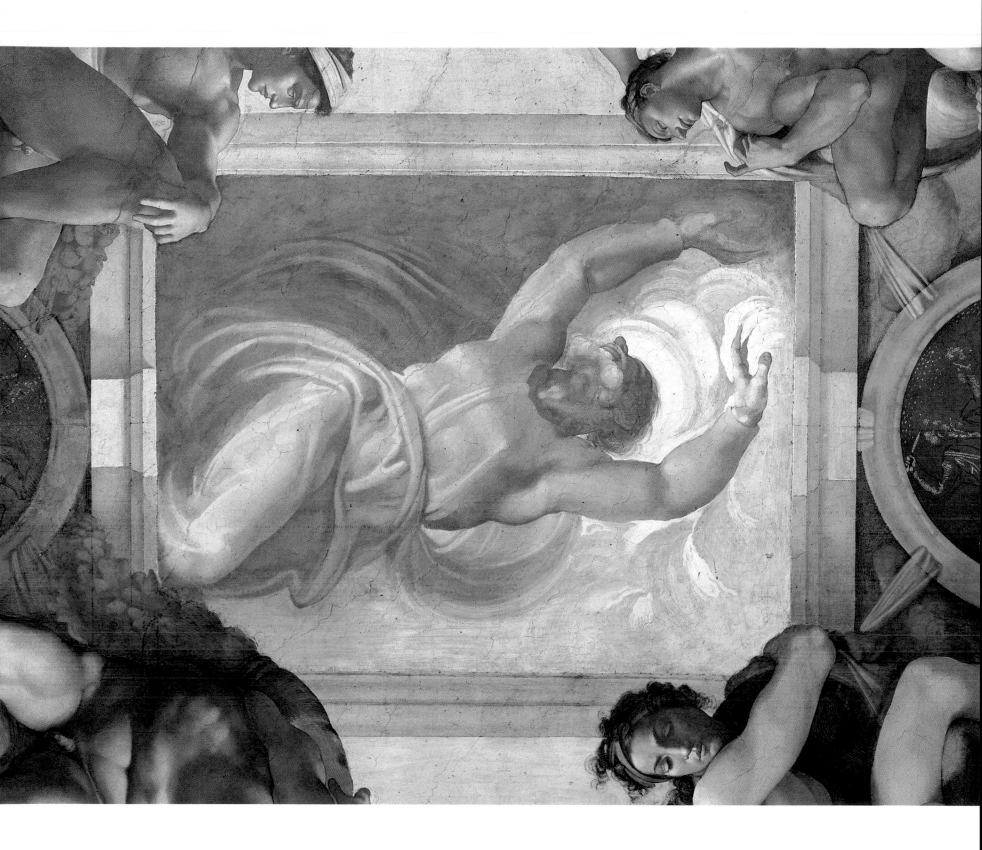

46 *The Separation of Light and Darkness* (detail ill. 34),
1511
180 x 260 cm

This picture, a product of only one day's work, illustrates
the actual beginning of creation. Michelangelo
approached the abstract subject matter by letting the
body of God the Father take shape at the point of
separation between light and darkness. The colors make
the extent to which this figure is responsible for the act of
Creation very clear: the darkness seems to come as a
grayish mass from God's garment, which itself logically
disappears into the darkness. Unlike those in the
Drunkenness of Noah (ill. 34), the *ignudi* are now large,
restless muscular figures.

47 *Ignudi above the Erythraean Sibyl* (detail ill. 34), 1509

Even the early biographers had difficulty with interpreting the meaning of the nude youths, and modern interpretations have not been able to assign a clear meaning to them either. That is why the term used by the artist himself, *ignudi* (the nudes), has found its way into art history. The pair depicted here is seated with sharply angled legs on the pedestal and is holding a medallion depicting the destruction of Baal by Jehu (2 Kings 10,25). Caravaggio (1571–1610) was interested in the stance of the youth on the left; he used it for his picture of victorious Cupid (Gemäldegalerie, Staatliche Museen zu Berlin – Preußischer Kulturbesitz, Berlin).

complete the monumental painting himself with only technical support. We know the names of Granacci (1469/77–1543), Giuliano Bugiardini (1474–1554) and Aristotile da Sangallo (1481–1551), without being able to distinguish with any certainty their share of the painting at the start of the work from that of the master.

Finally, scenes of the rescue of the people of Israel appear in the four corners of the ceiling like a terrible signal. Moses erects the bronze snake, David kills Goliath, Judith beheads Holofernes, and Haman is hanged after Esther has revealed his villainous plan (ill. 48). These pictures do not represent any clear temporal sequence either, for events jump from the corner to the right of the altar diagonally to the entrance wall, from there to the other side and diagonally back again to the altar wall, if we assume the story of Judith to have taken place under the Persian king Darius and that of Esther under his son Xerxes, that is around 500 and 480 BC. respectively. The painter uses these pictures to explore courageous compositional opportunities, something

which the most unusual shape of the fields alone made necessary.

A scaffolding constructed by the artist himself, which was first erected at the entrance and then at the altar end, enabled work to take place on the ceiling, the fields above the arches and the lunettes, even when mass was being said in the chapel. During the four years that it took to create the frescoes, Michelangelo complains in letters about the constant strain, including the physical strain, and his loneliness in Rome. The immense project of producing a whole ceiling fresco on his own also gave rise to jealousy and ridicule, so that pressure on the artist increased. It was a bitter irony for Michelangelo, who wanted to prove himself as a sculptor rather than as a painter, that it was almost only with the tools of the painter that he managed to complete any works at all. Julius II died in February 1513 without having made adequate provision for his tomb. But he did live to see the unveiling of the ceiling of the Sistine Chapel.

48 (opposite) *Punishment of Haman* (detail ill. 34), 1511

The *Punishment of Haman*, from the Book of Esther, is recounted in three physically separate episodes. With tremendous courage, Queen Esther, a Jew, informed King Ahasueros of a pogrom planned by Haman. On the right, the villain, clothed in yellow, can be seen leaving the royal chamber to procure garments for the Jew Mordechai who is sitting in the doorway. To the rear left, the event which until that time was the most frequently illustrated is depicted: Esther's accusation of Haman before Ahasueros. Haman's death is then shown with bold brevity at the front.

49 Tomb for Julius II: *Moses*, ca. 1515
Marble, h. 235 cm
San Pietro in Vincoli, Rome

Michelangelo depicts the hero who led the people out of
slavery in Egypt as an old man. One can still see the
strength endowed upon this man by his extremely
muscular arms. He has also retained a certain regal
tension which enables him to sit in an alert rather than a
lordly manner. He has retracted his left foot, ready to leap
up. Holding the Tablets with the Commandments under
his right arm, he looks to the left, grips his body painfully
and widens his eyes. Moses will have looked like this
when he saw death.

JULIUS II'S TOMB AFTER HIS DEATH

Hardly had Julius II died when his executors concluded
a new contract with Michelangelo on 6 May 1513
regarding the completion of the tomb (ill. 52). The artist
was contracted to finish the work within seven years,
and he did indeed devote himself primarily to this
task in the following years. His own position and the
situation of his relatives in Florence had changed,
however. The city had come under Medici rule again in
1512, and in the person of Leo X a member of the family
was even elected Pope in succession to Julius II in
the following year. But the Buonarrotis had declared
themselves for the republic, so that they had much to
fear in Florence. But in fact the Medici pope, who had
been acquainted with the artist from the time of Lorenzo
the Magnificent, quickly ensured that Michelangelo had
considerably less time than he had hoped to concern
himself with his favorite project.

Nevertheless, in the new pope's first few years in
office, a few monumental sculptures were created which
would make Michelangelo's relationship with Julius II
unforgettable. The program for the tomb was an un-
usual one and attempts to recognize and appreciate its
intellectual content have filled many volumes. Over-
life-size figures of slaves writing to release themselves
from their bonds were meant to represent the liberation
of the soul. Two of them were largely completed by the
sculptor in 1513, but they never reached the tomb (ills.
54, 55).

A present by the artist to a certain Strozzi from
Florence meant that they quickly came into the
possession of the French king Francis I, and from Paris
they went on to stimulate the imagination of artistic
spirits for centuries. One of them rears up against his
imprisonment (ill. 54) while the other, in sleep, is
reminiscent of death (ill. 55). Uncompleted slaves, some
of them only rough-hewn, one of them even with his
head still hidden in the stone, were set up as decoration
in the grottoes of the Boboli garden in Florence until in
recent times they were united with the *David* in the
Galleria dell'Accademia (ill. 30).

The master selected the marble for them in Carrara,
but the carving was largely carried out in Florence. Only
one of the statues of the planned ensemble, albeit the
most imposing, ever reached the tomb of the pope in
Rome (ill. 50). It is the over-life-size figure of the seated
Moses (ill. 49). Intended originally for the upper register
of the tomb, and placed even higher in the second
project, the figure today is irritating when viewed from
the same height, as its proportions are such that it was
intended to be seen from below. Nevertheless, it has
been famous ever since it was put on display, and copied
or varied by many artists.

It is particularly rewarding in view of the many
uncompleted works by Michelangelo to observe the
extraordinary perfection with which such a work stands
before us. It is polished like the *David* (ill. 22) and has
been given a linear structure which has an almost
abstract effect in some places. The powerful features are
far from being simply lifelike; beard and hair are
ornamental in a way which can only be grasped if the
enthusiasm which went into the work is also understood.

The colossal format and the attention to detail are
equally dramatic. This is particularly true of the horns,
which the Latin tradition gave to Moses because the
translator of the Bible, Jerome, misunderstood an
expression for the divine illumination of the forehead of
the hero. As if he had understood their deeper meaning,
Michelangelo makes the horns appear to express the
inner fire of the man in the light which strikes them first
when it falls on the statue.

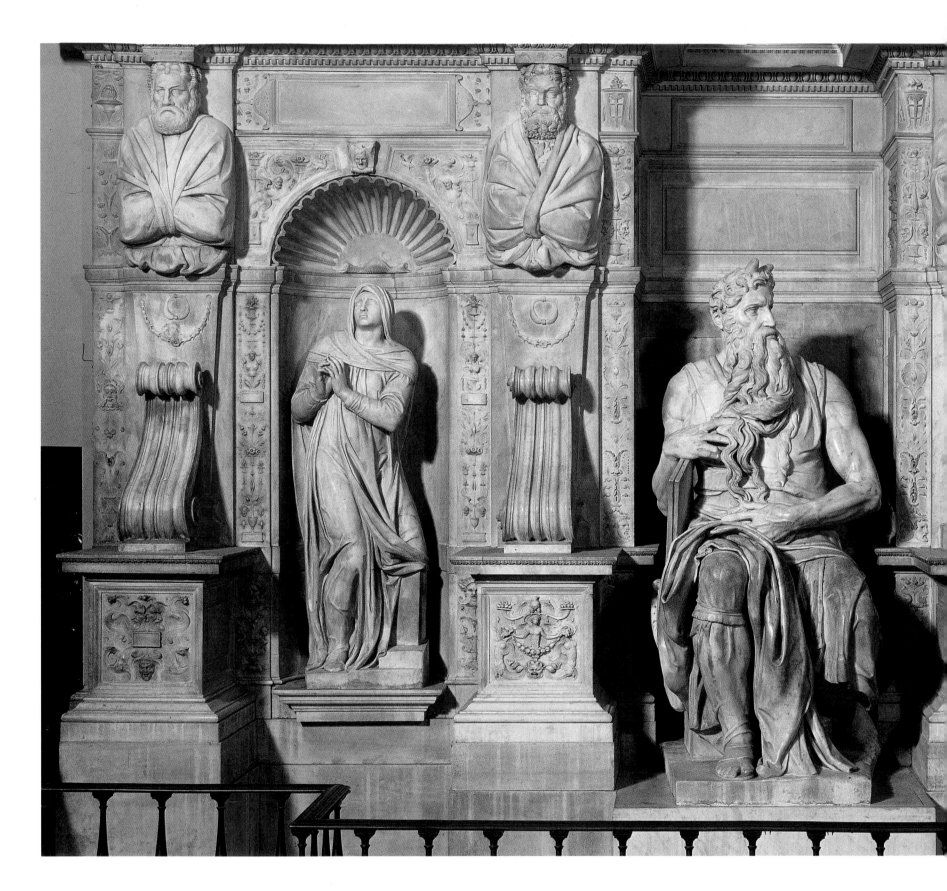

50 (above) Tomb for Julius II, lower level
Marble, ca. 1515 and 1532–1544
San Pietro in Vincoli, Rome

Following the agreement on the second commission, parts intended for use in construction were completed in Michelangelo's workshop in 1513 and found a place in the finished tomb. The tomb's central figure, *Moses*, was already finished in 1515. This monumental seated figure was the only part of the planned project to come to fruition: Saint Paul disappeared completely and the two slaves became the smaller standing figures of *Leah* and *Rachel,* which Michelangelo created with his own hands.

51 (opposite, top) Reconstruction of the first drawing for the tomb of Julius II, 1505

Early in 1505, Michelangelo started a project which was to occupy him for over 40 years. Pope Julius II, from the Rovere family, commissioned him to erect a free-standing tomb of undreamt-of proportions. It was to comprise nearly 40 statues and to be displayed in the choir of the new St Peter's basilica. But because the Pope made the plans for his tomb known, Michelangelo left Rome in disgust, regarding the project as his alone. After his return to Florence, he continued working on what he himself referred to as the "tragedy of the tomb".

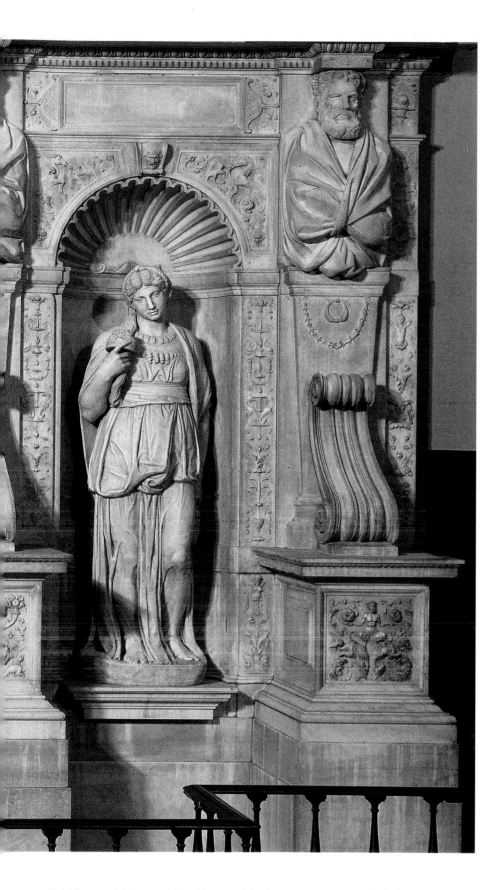

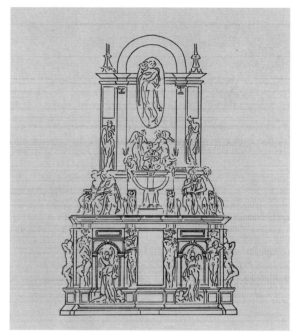

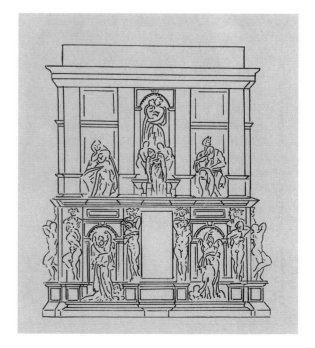

52 (right, center) Reconstruction of the second drawing for the tomb of Julius II, 1513

In 1513, the Rovere family agreed with the sculptor to construct the tomb against a wall, which was indeed later done. Although the revised version was on a considerably smaller scale than the original, plans were nonetheless made for a comprehensive array of figures crowned by the Madonna. Beneath her, there were to be four figures in the style of *Moses* (ill. 49) with the Apostle Paul beside him and on the opposite side, also seated, female figures from *vita activa* and *vita contemplativa*.

53 (right, bottom) Reconstruction of the third drawing for the tomb of Julius II, 1516

The artist was unable to implement the ambitious project of 1513, which is why a considerably reduced version was approved three years later. Now only 24 sculptures, 16 on the lower level and eight on the upper, were to adorn the tomb. The commission envisaged six years for the completion of this project. But the Medici Pope demanded that Michelangelo work on the façade of San Lorenzo (ill. 60) which brought this plan to nothing, too.

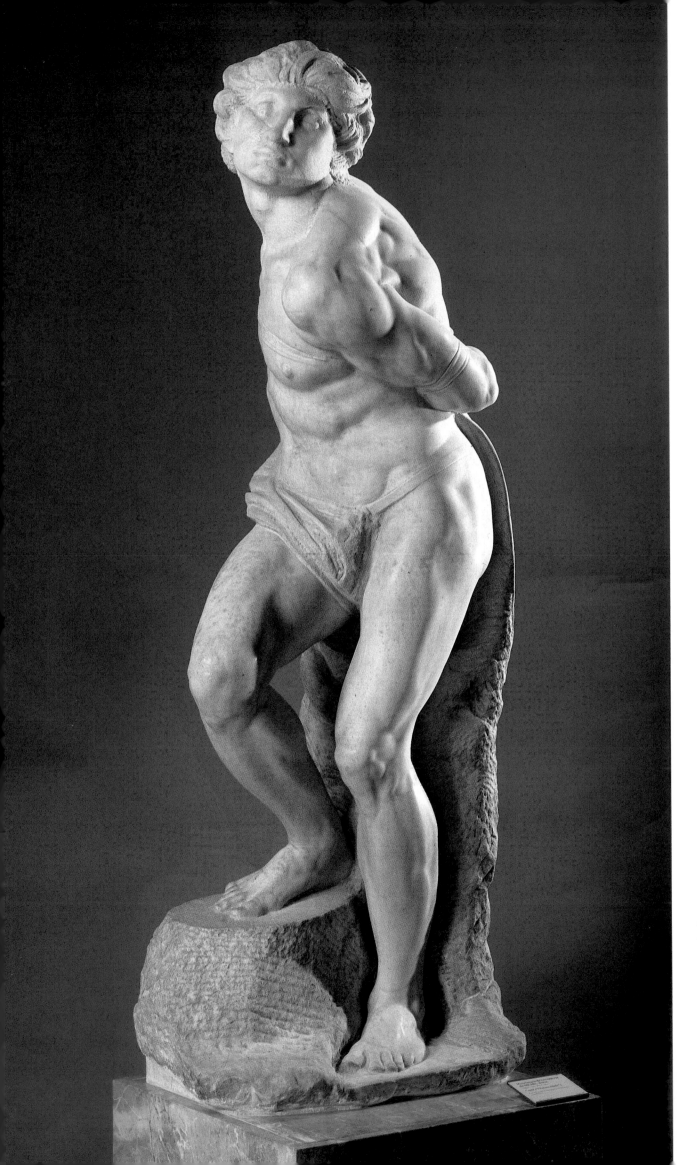

54 *Rebellious Slave*, 1513
Marble, h. 215 cm
Musée du Louvre, Paris

Of all of the so-called "slaves" which were intended to adorn Julius' tomb, the two now in Paris are the nearest to completion. In 1542, Michelangelo still intended to place them in the two corners which are now occupied by *Leah* and *Rachel* in San Pietro in Vincoli (ills. 101, 102). However, in 1544 he made a gift of the figures to a Florentine, Robert Strozzi, who was living in exile in Lyon and who in turn gave them to the French king, Francis I. This figure was never completed on account of an unattractive vein in the marble.

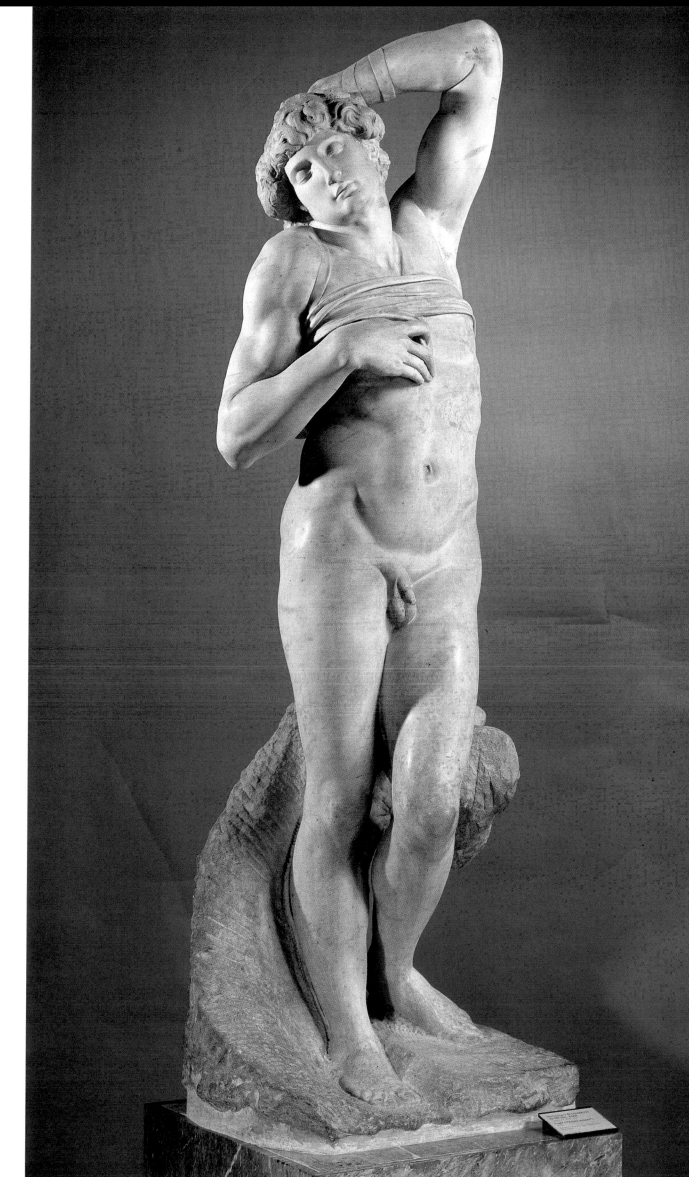

55 *Dying Slave*, ca. 1513
Marble, h. 229 cm
Musée du Louvre, Paris

Contrary to what its title suggests, this figure does not
represent a dying man, but a sleeping one. Like the
Rebellious Slave, this slave also has chains on his arm,
which have been loosed. Therefore, he is no longer the
prisoner of his body, if one wants to consider the slaves as
being souls imprisoned in their bodies. Behind him, the
roughly sketched outlines of a monkey can be seen, which
has caused some researchers to believe this slave to be the
incarnation of painting and the rebellious slave (ill. 54) to
symbolize architecture.

56 (left) *Head of Laocoön*
Drawing on plaster
San Lorenzo, Sagrestia Nuova, Florence

In the sanctuary of the chapel with Michelangelo's Medici graves, numerous traces of drawings have been found on the wall. In addition to architectural designs, this room contains items such as this head, which obviously cannot have been drawn by the artist with the famous classical sculpture in front of him. Instead, it demonstrates the powerful and profound impression wrought on Michelangelo by this statue group as he drew a memorial to them on the wall of the New Sacristy while reflecting on very different tasks far away from Rome.

ROME AND ANTIQUITY

It is wrong to assume that the Middle Ages were far removed from Antiquity. In fact the ancients were quoted more often than in any other time, for the statements by Greek and Roman writers were placed above people's own experience. Furthermore, the ancient works of art were made use of, and in architecture in particular there was great competition with the existing remains of a great age even if they appeared to be heathen, alien and dangerous.

The great change in the relationship with Antiquity came gradually. The famous Florentine poets of the mid-14th century, Petrarch and Boccaccio, began to look at the old literature in a new way. Classical coins were much in demand and it was already a profitable business even before 1400 to forge medallions for men of rank which were sold as antiquities. Small sculptures and archeological finds were also increasingly being collected. According to Condivi and Vasari, Michelangelo is said to have created a sleeping Cupid in his youth, which was sold in Rome as a classical

figure to Cardinal Riario. Two things are revealed by this anecdote: the unerring accuracy of the young sculptor on the one hand and the passion for the collection of antiquities in Rome in particular.

Similarly the damaged fragments of classical sculptures were no longer thrown in the gypsum furnace or their marble used for one's own work; rather they were preserved – even if only as garden decoration. The most impressive work, which fascinated Michelangelo particularly, was spared destruction perhaps because it was signed by its creator Apollonius. The piece was left as a torso (ill. 29).

Noble families such as the old Roman family of the Colonna owned such pieces and soon the popes also became fascinated by them. As early as 1432 a notable "torso" is mentioned as being in their possession. About 1500 it was given the place of honor in the Vatican Cortile delle Statue del Belvedere, which Julius II had specially redesigned from 1503.

At the time that Michelangelo first went to Rome,

57 (opposite) Hagesandros, Athanadoros and Polydoros
Laocoön group, ca. 50 BC
Marble, h. 242 cm (without base)
Vaticano, Palazzi Vaticani, Museo Pio-Clementino, Rome

Two stories have grown up around this group: Laocoön is said to have been punished by his god for breaking the law of chastity to which he was subject as a priest of Apollo and, as a result, having children. The story of the priest of Poseidon in Troy is better known, recounting as it does how the priest warned of the Wooden Horse and was silenced by serpents sent by his own god. There are very few sculptures from Antiquity which have borne witness to their era as eloquently as this group, which was found beside the Titus springs on the Esquiline in Rome in January 1506.

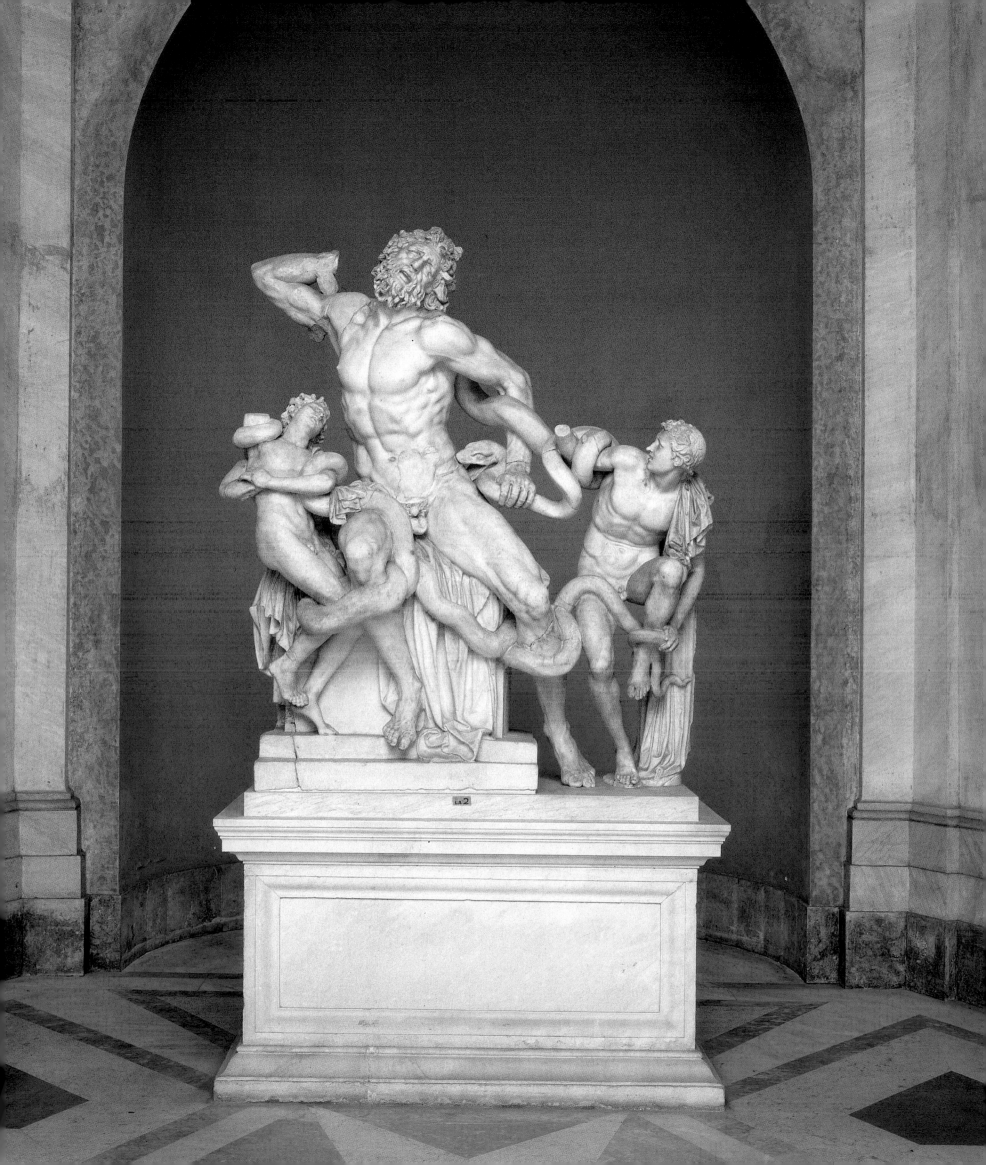

numerous fragments from Antiquity were being found in the course of large-scale building work. They were gathered and preserved. The preservation of historic monuments also proved to be a task for major artists, and from that time onwards the word of a master such as the great Florentine would keep many a piece from being destroyed.

Further sensational discoveries such as the *Apollo of Belvedere* also found their noble place in the Vatican. In 1506, the most complex piece made its appearance, at whose discovery Michelangelo was also present: the *Laocoön* (ill. 57), which Pliny mentions in his *Historia Naturalis* and which could now be seen as if by miracle. Additions were made to this piece but it was not forged. Pictures meant that its appearance was widely known. Theoretical debates discussed the expressive possibilities which were chosen by the Greek sculptors who had signed the piece. As late as the 18th century the German dramatist and critic Gotthold Ephraim Lessing placed his revolutionary treatise on the qualities of the various arts under the heading "Laocoön".

Michelangelo learnt about the shaping of body from the *Laocoön*, as he did from the *Torso of Belvedere* (ill. 29) and when he thought about the architecture and sculptures for the Medici tombs in the New Sacristy in Florence he put reminders of the *Laocoön* on the walls, as if he wanted to recall the head of the Trojan priest once more (ill. 56).

As an architect, too, the artist studied Antiquity intensively at the time in the 1530s when under Tommaso de' Cavallieri he worked on the planning of the Capitoline Hill and the erection of the equestrian statue of Marcus Aurelius. But not much was left of his design after the square was completed by Giacomo della Porta in 1573–1579.

58 *Bozzetto for Hercules and Cacus or Samson and the Philistines*, ca. 1525
Clay, h. 41 cm
Casa Buonarroti, Florence

Only a fragment of this outline for a 5m high colossus remains in existence. It was intended for the Piazza della Signoria as a counterpart for the *David* (ills. 21, 22). The *gonfaloniere* of Florence, Pietro Soderini, had commissioned the marble block, which was never to be completed, in 1508 after Michelangelo angrily cut all ties with Julius II. The artist resumed work on this figure around 1525, as demonstrated by this small outline. *Bozzetti* such as this have been preserved because in Michelangelo's day, the work preceding the finished product began to be appreciated together with the completed work of art.

59 *Risen Christ*, ca. 1518–1520
Marble, h. 205 cm
Santa Maria sopra Minerva, Rome

Although he was actually completely focused on the work
for the Julius tomb, Michelangelo completed this
sculpture at the request of the young patrician Metello
Vari. A black vein in the marble prevented a first
incomplete – and today lost – version from being
delivered to the client. The second version shown here
was sent by Michelangelo in 1521 from Florence to his
assistants in Rome. However, because their work was of
such a low standard and was beyond any rescue by the
Master himself, Vari was offered a third version, which he
politely declined.

In Florence under the Medici Popes Leo X and Clement VII

60 Sketch for the façade of San Lorenzo, ca. 1518
Black and red chalk on paper, 14 x 18 cm
Casa Buonarroti, Florence

In 1515, Pope Leo X called upon the artist's services in the competition for the commission for the façade of San Lorenzo in Florence. The similarity of the construction with the recently completed drawing of 1516 (ill. 53) for the Julius tomb is beyond doubt. Michelangelo was himself delighted with this drawing. The commission was agreed in January 1518 but annulled two years later by Leo X. The façade was never completed. To this day, the west side of the church has not progressed beyond the stark beginnings of a brick construction.

Initially, the unhappy project of the papal tomb for Julius II determined the course of Michelangelo's work under Leo X. Yet the Medici Pope Leo X clearly did not relish the idea that the great Florentine master should devote all his time to serving the posthumous reputation of a predecessor who had not been universally esteemed. Nevertheless, his rather softer character was much closer to the gentle manner of Raphael from Urbino than to Michelangelo's temperament. Thus he made every effort to retain the difficult Florentine in his service, but preferably far from Rome, in other words in Florence, where Michelangelo also preferred to be.

Several commissions resulted there. That to create a marble statue of the Risen Christ for Metello Vari in Rome did not go well (ill. 59). The ambitious project to give the coarse façade of the Medici family church, Brunelleschi's San Lorenzo right next to the palace, an appropriate facing (ill. 60) never came close to practical realization.

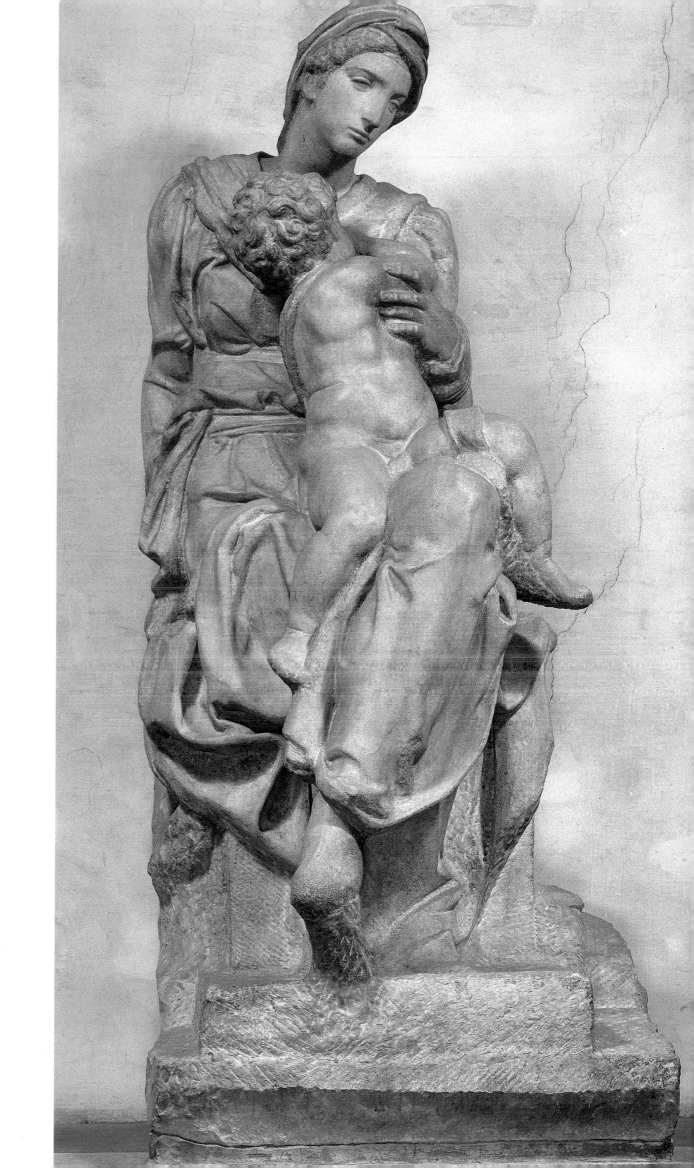

61 Tomb of Lorenzo the Magnificent: *Virgin and Child
(La Madonna Medici)* (detail ill. 62), ca. 1521–1534
Marble, h. 226 cm

The motif of the crossed legs, perceived as being offensive,
has always been a subject of debate. Michelangelo might
have seen the figure of a Muse seated in this position in
Venice in 1494. This motif is a response to the retracted
shoulder of Mary, demonstrating the interest displayed in
the figure of the interplay between movement and
countermovement. The position of the infant Jesus
should always be viewed in this light. While the lower
body is turned towards the front, the shoulder and head
bend back towards the mother, seeking both nourishment
and protection from the events destined for Him.

62 The Tomb of Lorenzo the Magnificent and his
brother Giuliano, tomb of the Duke of Nemours,
Giuliano de' Medici, 1521–1534
San Lorenzo, Sagrestia Nuova, Florence

The two walls of the square meet one another directly.
Although the architectural construction has been
organized in a uniform manner, the entrance wall, on the
right of this picture, displays a remarkable sobriety,
although it is here that the most significant members of
the House of Medici have found their final resting place.
Inscriptions are the only indications that Lorenzo the
Magnificent and his brother Giuliano lie here, whereas
the younger Giuliano has one of the most splendid tombs
in the history of art. Nevertheless, the tomb of the great
Medicis is adorned with Michelangelo's most important
image of the Madonna.

THE MEDICI CHAPEL

The project of a tomb for Michelangelo's first patron,
the chief magistrate Lorenzo the Magnificent, who died
in 1492, his brother Giuliano as well as the two dukes
Lorenzo of Nemours and Giuliano of Urbino remained
a noble fragment (ill. 62). The sepulchral chapel is
dedicated to the Resurrection of Christ, which is not
however expressed in the sculptural program. The
iconographic program only develops in the course of the
work, which had started in 1519 and was concluded
sufficiently in 1545 to allow mass to be said in the chapel
for the first time.

The initial talks about the project were held between
the artist and Cardinal Giuliano de' Medici, who was
also to become pope as Clement VII from 1523 to 1534,
after the short pontificate of the Dutchman Hadrian VI
(1522–1523). In this capacity he was to make greater
use of Michelangelo than Leo X had done.

With this place the house of Medici went back to

an old family tradition: San Lorenzo was the church
in direct proximity to the old city palace, which is
today known as the Palazzo Medici-Riccardi. The new
building had been erected in Florence by Cosimo
il Vecchio, the founder of Medici power. He was
buried in the Old Sacristy, as it is known, beneath a
funerary monument remarkable for its magnificence.
Symmetrically with the Old Sacristy, which is accessible
from the south arm, the New Sacristy was built in the
corresponding place to the north. It was decorated in a
Renaissance style, drawing on Michelangelo's designs,
which were in turn based on a creative interaction with
architectural ideas which Filippo Brunelleschi had
realized generations earlier in the Pazzi Chapel by Santa
Croce.

All four walls are given structure by a wide middle
field concluded on top by an arch flanked by small side
strips whose dimensions are determined by the width of
the door. The square main room is adjoined by a small
square sanctuary, which opens with the same wide arch

63, 64 (below, left and right) Tomb of Lorenzo the Magnificent: group of figures surrounding *Virgin and Child* (cf. ill. 62), 1521–1534
Marble
San Lorenzo, Sagrestia Nuova, Florence

The two *Magnifici* were to be commemorated in a double tomb on the entrance wall. However, only the group consisting of Mary with Cosmas and Damian was completed. The Madonna was sculpted by Michelangelo, but she was never completed. The Medici saints Cosmas and Damian stand at her sides. As the family's Italian name [*medici* = doctors] suggests, they were physicians. Using Michelangelo's models, they were sculpted by Giovanni Angelo Montorsoli (1507–1563) and Raffaello da Montelupo (1505–1566/67). A Resurrection was planned for the lunette above, which would have given expression to the thematic purpose.

65 (following double page, left) Tomb of Lorenzo the Magnificent: *Virgin and Child (La Madonna Medici)* (detail ill. 62), 1521–1534

The contrast between the mother, whose narrow face is imbued with a sense of foreboding and sorrow, and the plump infant lends greater intensity to the theme: whereas Mary manages with melancholy patience to look into the center of the room, the infant Christ turns round, seeking his mother's breast in an attitude of fear and panic. Thus, Michelangelo refuses to use his art to provide the religious prayer with a dignified counterpart. A revolutionary trait in the artist thereby comes to light: Michelangelo does not allow the obvious requirements of those around him to influence his work.

66 (following double page, right) *Virgin and Child*
Black and red chalk, 54.2 x 39.7 cm
Casa Buonarroti, Florence

Occasionally drawings can help to test, on a flat surface, the impression made by figures sculpted in stone. It is highly unlikely that this drawing was a preliminary study for the *Medici Madonna*. Instead, it was in all probability an attempt to express the relationship between mother and child in a similar manner. Here, Michelangelo employs techniques similar to those he uses when sculpting: the astonishing attention to detail invests the child with a striking physical presence while Mary is left in the background. Michelangelo then leaves this already great artistic achievement in its unfinished state.

67 (left) *Candelabrum Pedestal*, ca. 1531
Marble
San Lorenzo, Sagrestia Nuova, Florence

Two candelabra adorn the altar, one decorated with the
pelican to symbolize sacrifice and the other with the
phoenix to represent the Resurrection of Christ. The
arresting differences afforded by the various perspectives
of the sculptures can be best experienced from the
position of the priest, who stood behind the altar
according to the old Christian tradition. (The
candelabrum on the right was renewed in the eighteenth
century.)

68 (opposite) Tomb of Lorenzo: *Duke of Urbino*,
ca. 1525
Marble
San Lorenzo, Sagrestia Nuova, Florence

Even in the state in which the two tombs on the longer
walls of the New Sacristy were to remain, one can sense a
faint resemblance with the manner of representing the
prophets in the Sistine Chapel. A mighty figure sits in the
center, flanked by twin structures in the form of large
pilasters. Below, the form of a sarcophagus has been hewn
out of the stone, which is in fact only a depiction of a
receptacle for the bones of the dead: the actual burial
place is a crypt beneath the church floor. On the form of
the sarcophagus are allegorical figures. The surrounding
decorative bands in mask form below the seated rulers
(ills. 71, 72), the correspondingly decorated capitals, and
the candelabras (ill. 67) display a decorative form which
was specially developed for this commission, so that
architecture and sculpture are related in a unique way
here. Alongside the concept of the tombs in the niches,
Michelangelo initially toyed with the idea of erecting a
free-standing monument in the middle of the Sacristy.
Work on the marble blocks started in January 1521.

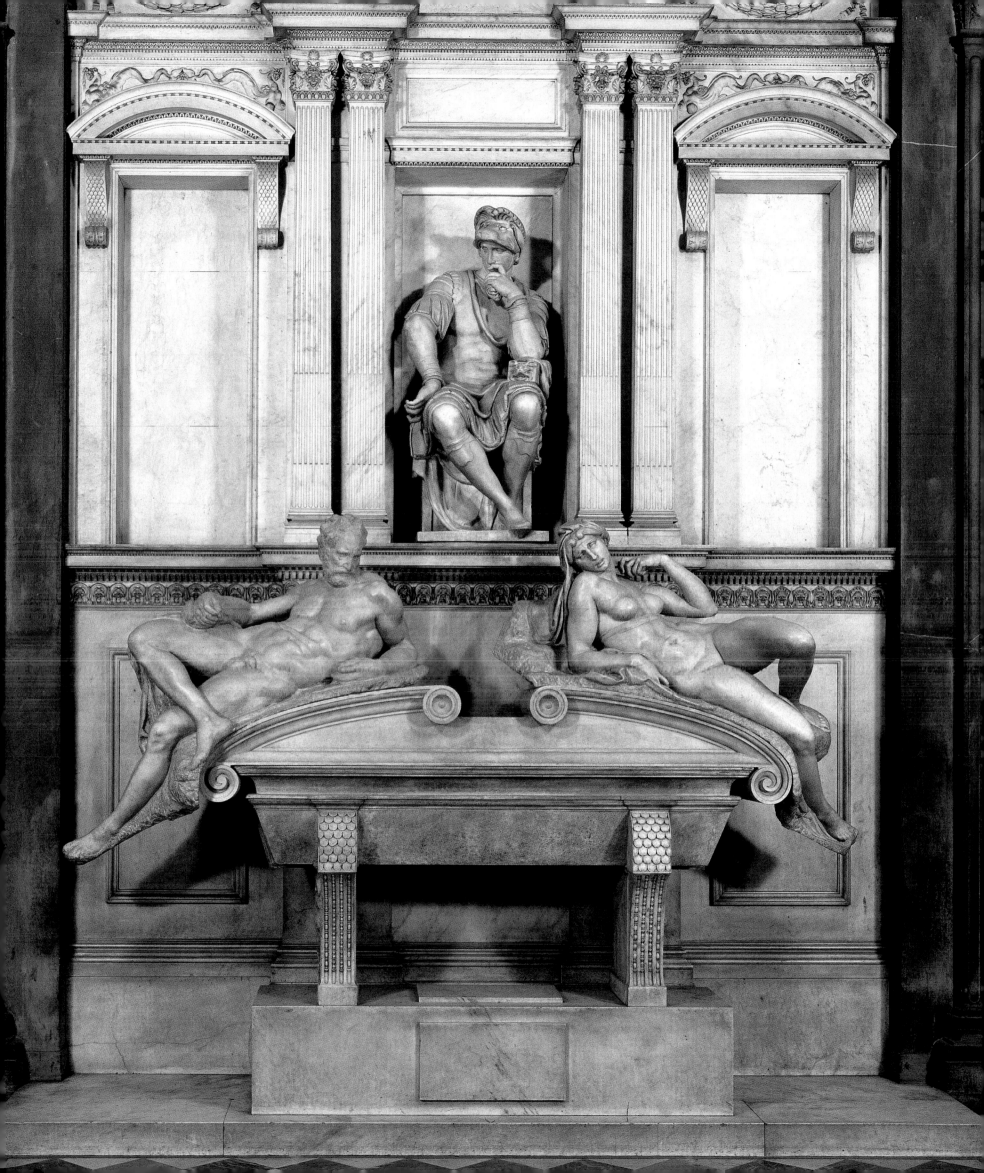

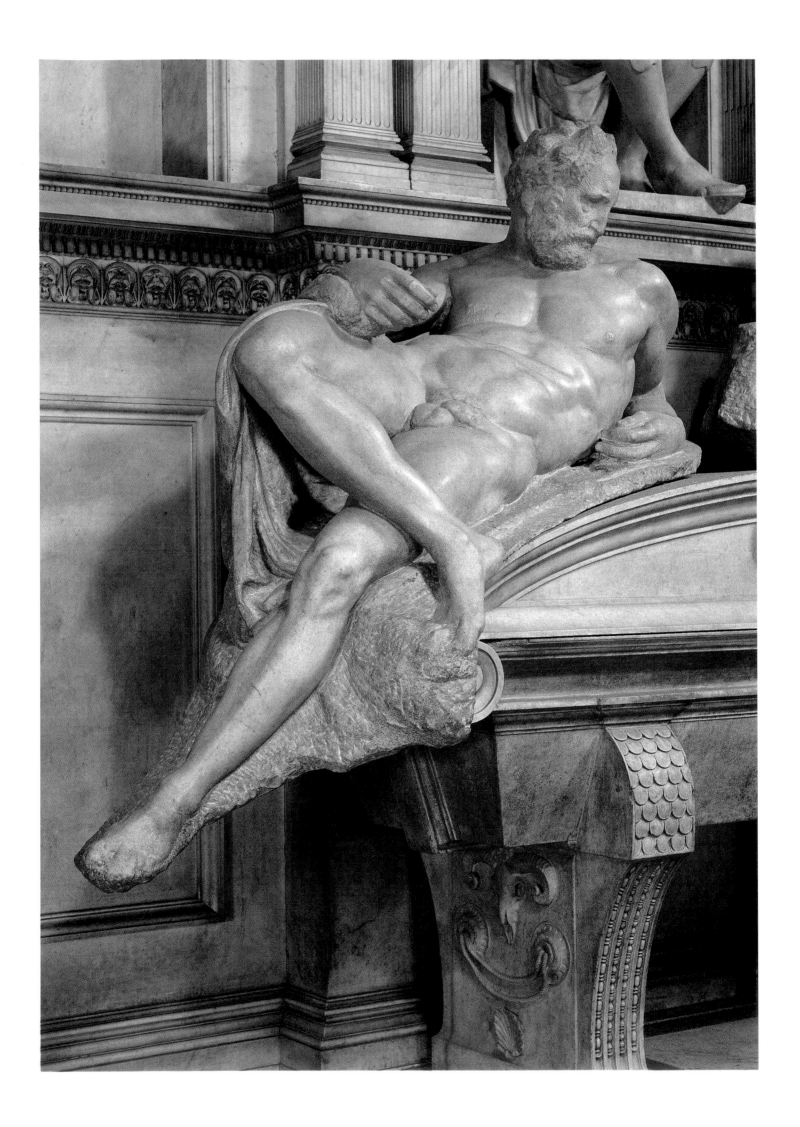

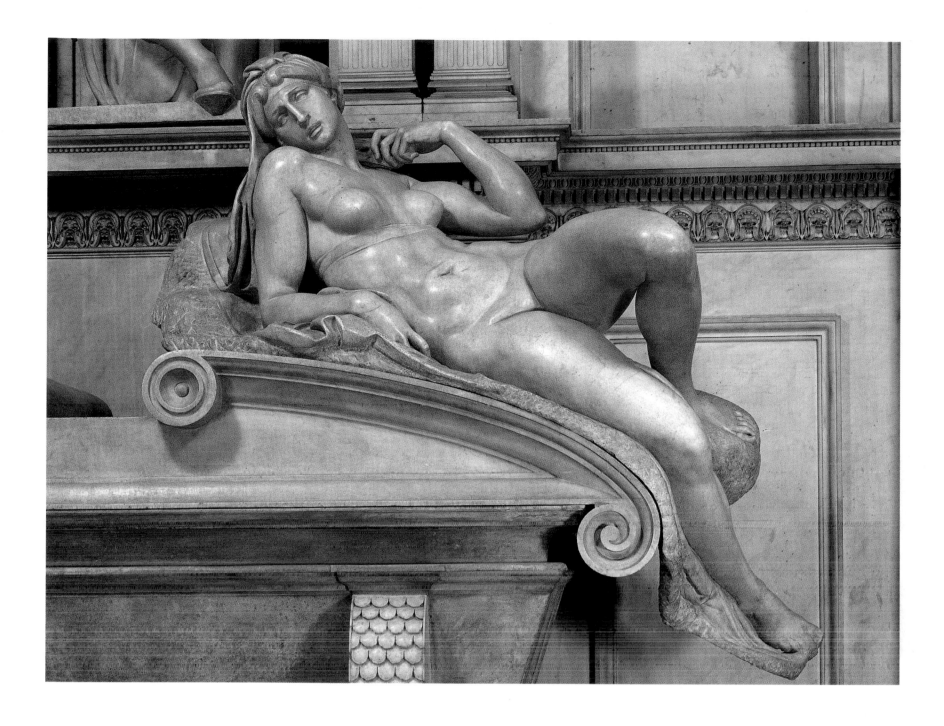

70 (above) *Dawn (Aurora)* (detail ill. 68), ca. 1524–1527
Marble, 206 cm long

Along with *Night* (ill. 73), *Dawn* is the only female nude Michelangelo ever sculpted. A youthfully smooth, yet powerful body turns towards *Day*, and thus also towards the observer. Her features are by no means serene: the dark eyes are deep set in their shadowy sockets. She wears a turban and a band around her chest in the style of slaves' garments.

69 (opposite) *Dusk (Crepuscolo)* (detail ill. 68),
ca. 1524–1531
Marble, 195 cm long

In the spirit of an allegory of Time, the deceased were coupled with figures representing the times of the day whose gender was determined by Italian grammar. The thoughtful figures of *Dusk* and *Dawn* are endowed with soft outlines as they gracefully adorn the edge of the sarcophagus. *Dusk* lies, featureless, with unfinished feet, hands and head. The principal inspiration for these reclining figures came from the river gods of Antiquity already depicted on the ceiling of the Sistine Chapel.

which gives structure to the side walls. Sculptural decoration was only executed on the side walls and the entrance wall opposite the altar so that the distribution today has an altogether unbalanced effect. It is restricted to the wide arched fields which are structured in two stories in three vertical axes for the individual tombs of the Dukes of Nemours (ill. 72) and Urbino (ill. 68), while the noblest tomb never received such decoration (ills. 62–64). It is opposite the altar and commemorates Lorenzo the Magnificent and his brother Giuliano, who was murdered in the Pazzi uprising. This is done with nothing but an inscription and three figures which, contrary to the aesthetics of the time, are placed against a blank white wall above a pedestal. At their center is a beautiful seated Madonna (ills. 61, 65). It is a thoughtful important work by Michelangelo, who left the saints to be executed by two assistants.

As with Julius' tomb in Rome, Michelangelo was not content with a simple representation of the deceased in

the case of the Medici in Florence either. The two deceased whose monuments were reasonably completed he turned into the exponents of different attitudes to life by forming Duke Giuliano wholly in the spirit of the *vita activa* (ill. 72) and Duke Lorenzo in the spirit of the *vita contemplativa* (ill. 71). In this context it is not important whether the quality assigned to each of the persons buried here really corresponded to their character.

There was never much evidence of anything of a sacred Christian character in the so-called New Sacristy: The altar space remained without decoration; the two Medici saints at the Madonna's side could just as well represent philosophers. Christ on the lap of his mother turns away from the main room. More significantly, however, these images do not deal with Christian death. The two deceased appear above the embodiment of Time on the two side walls; river gods were planned below but never progressed beyond life-sized models

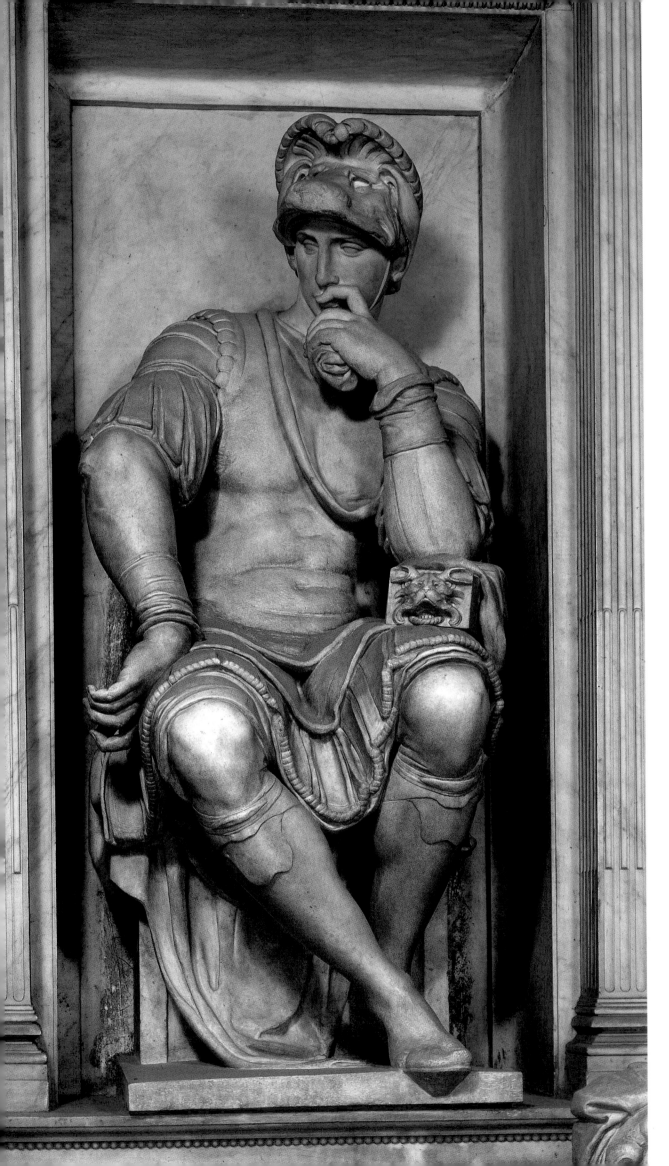

71 (left) Tomb of Lorenzo: *Duke of Urbino* (detail ill. 68),
ca. 1525
Marble, h. 178 cm

Like his counterpart, the *Duke of Nemours* (ill. 72), the *Duke of
Urbino* looks at the group around Mary (ill. 62). In so doing, he
turns to his patron saint, who is to intercede with the Mother of
God on his behalf. This is by no means a faithful depiction of
the era in which the Duke lived: an army leader from Antiquity
appears here, contemplating the embodiment of Contemplative
Life. Once again, the manner in which even the tiniest aspects
are perfectly executed is astonishing, displaying an obsessive
attention to the decorative detail which one would scarcely have
believed of the Michelangelo of the unfinished bosses.

72 (opposite) Tomb of Giuliano: *Duke of Nemours,* 1526–1531
Marble
San Lorenzo, Sagrestia Nuova, Florence

Unlike the thoughtful Lorenzo (ill. 71), Giuliano de' Medici,
who died in 1516, stretches his neck out to the group around
the Mother of God in a manner suggestive of his eagerness for
action (ill. 62). The command staff in his hands indicates that
he was nominated the *generalissimo* of the Church by his
brother, Pope Leo X, in 1516, the year he became Pope. This
ruler, who acquired his position as a duke thanks to his marriage
to Philiberta of Savoy, embodies *vita activa*.

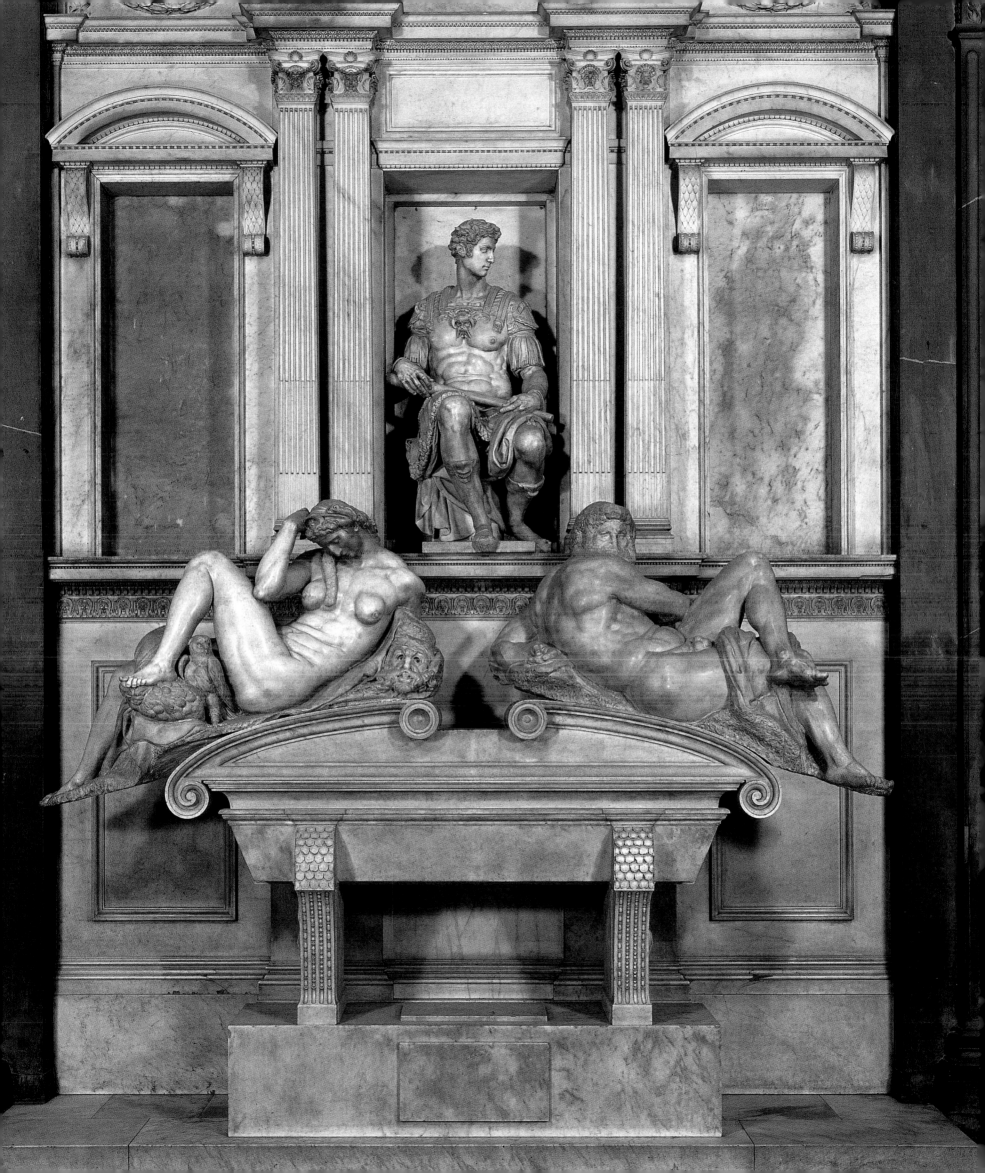

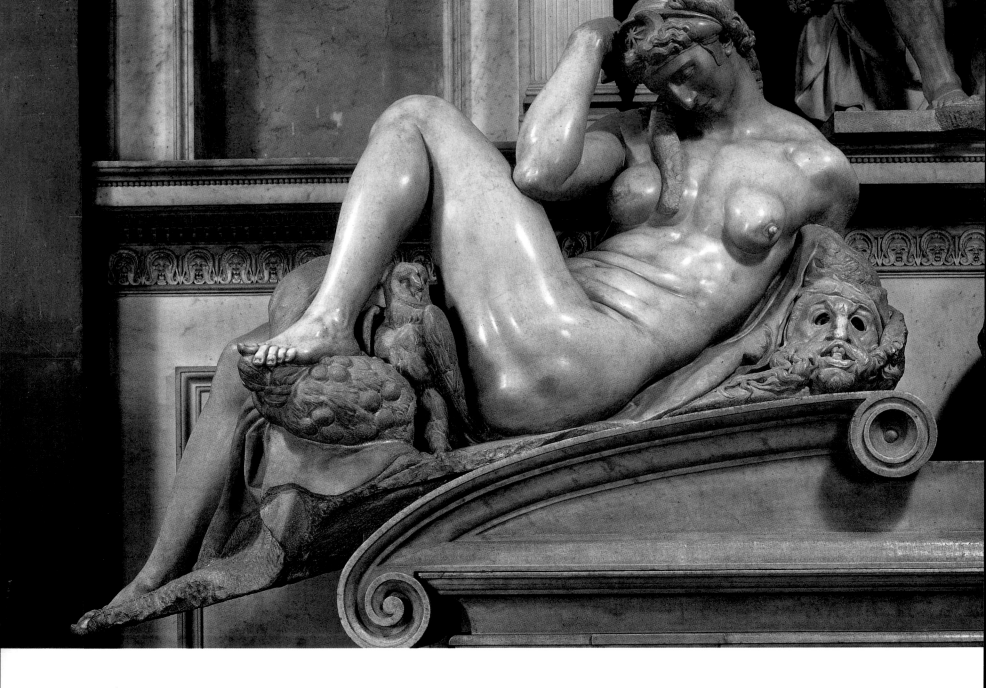

73 *Night* (detail ill. 72), ca. 1526–1531
194 cm long

The artist's representation of *Night* has her less at rest on her sloping plinth than actually pushing herself against the incline. In so doing, he takes every opportunity to endow the sculpture with straining muscles which are a sign of age in Michelangelo's work. Features which were probably borrowed from a "Leda" motif, appearing alongside her, the only figure lying down, can only offset the scandalous aspect of the work with difficulty. Night was said to be a fertile inspiration to the arts, and fertile generally. Yet, the position of the right arm allows the face to be shown in shadow, which leaves the figure shrouded in mystery.

(ill. 75). Their absence makes any interpretation difficult, not least because it is not clear what they were supposed to represent: did they embody the river Styx or Paradise, or, if there were four as on Gianlorenzo Bernini's (1598–1680) fountain with the four streams, did they represent the four continents known at the time? One thing at least is certain. We are dealing with a conception of time here which is not characterised by the canonical hours but which possesses a neoplatonic dimension of the kind which Michelangelo might have met in his youth at the Medici court of Lorenzo the Magnificent: Here time is victorious over everything

without the intercession of the Christian redeemer god.

But the structure is artistically coherent in itself for Michelangelo gave the contemplative Lorenzo the two twilight times of the day, *Dusk* (ill. 69) and *Dawn* (ill. 70), with a correspondingly thoughtful expression. But the active Giuliano is accompanied in this conception by *Night* (ill. 73) and *Day* (ill. 74), the one completed to the highest level of technical perfection with minute attributes, the other still largely rough-hewn around the head.

But that was not yet the end. River gods were also

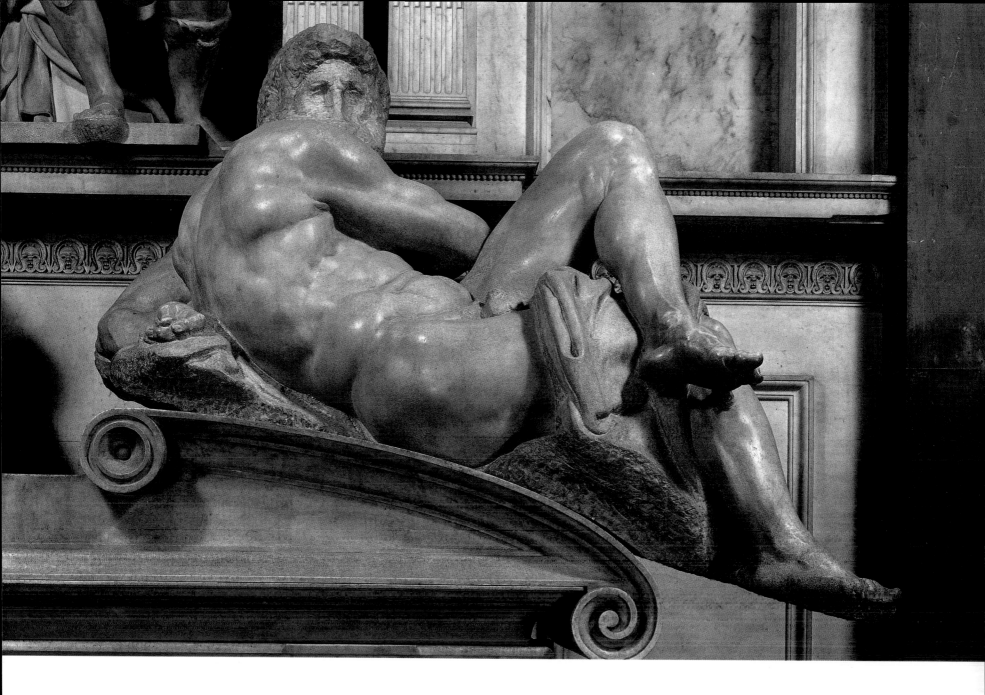

planned, who were to be positioned under the times of the day. They did not get beyond the kind of mighty clay models which the master had made for the other figures as well, in order to allow assistants to participate in the stonemason's work. The forms were revered to such an extent, that the *bozzetto* preserved in the Casa Buonarroti (ill. 75) was given a place in the New Sacristy in the 16th century. But then – and this is typical – it came, through noble intervention, into the possession of artists, where it remained much admired.

It is important to point out, in view of the various stages of completion of the sculptures, the detail with

which Michelangelo furnished them: in giving *Night* an owl and a mask (ill. 73) he achieves a minuteness of detail and a material effect which could not be bettered. The seated statues of the two deceased are treated in a similar fashion; for their armor he studied classical models and spared no effort to achieve material effects (ill. 71). Here the powerful main contours, inscribed deep into the stone, ensure that such obsession with accessories does not detract from the overall form.

All the sculptures for the Medici tombs have been worked to an astonishing degree, also on the reverse. The two statues with the images of the Dukes of

74 *Day* (detail ill. 72), ca. 1526–1531
285 cm long

The lower torso of this figure, whose face and right hand are only sculpted roughly, assumes a similar position to *Dusk* (ill. 69). However, its upper body is caught in a violent movement, which the sculptor has frozen at an almost painful moment. Its left arm is bent behind its back, while its right reaches beyond its left leg. Even in the absence of any supplementary work to explain what is being depicted, its position apparently forms a response to the gestures of the evocative figure of *Night* (ill. 73).

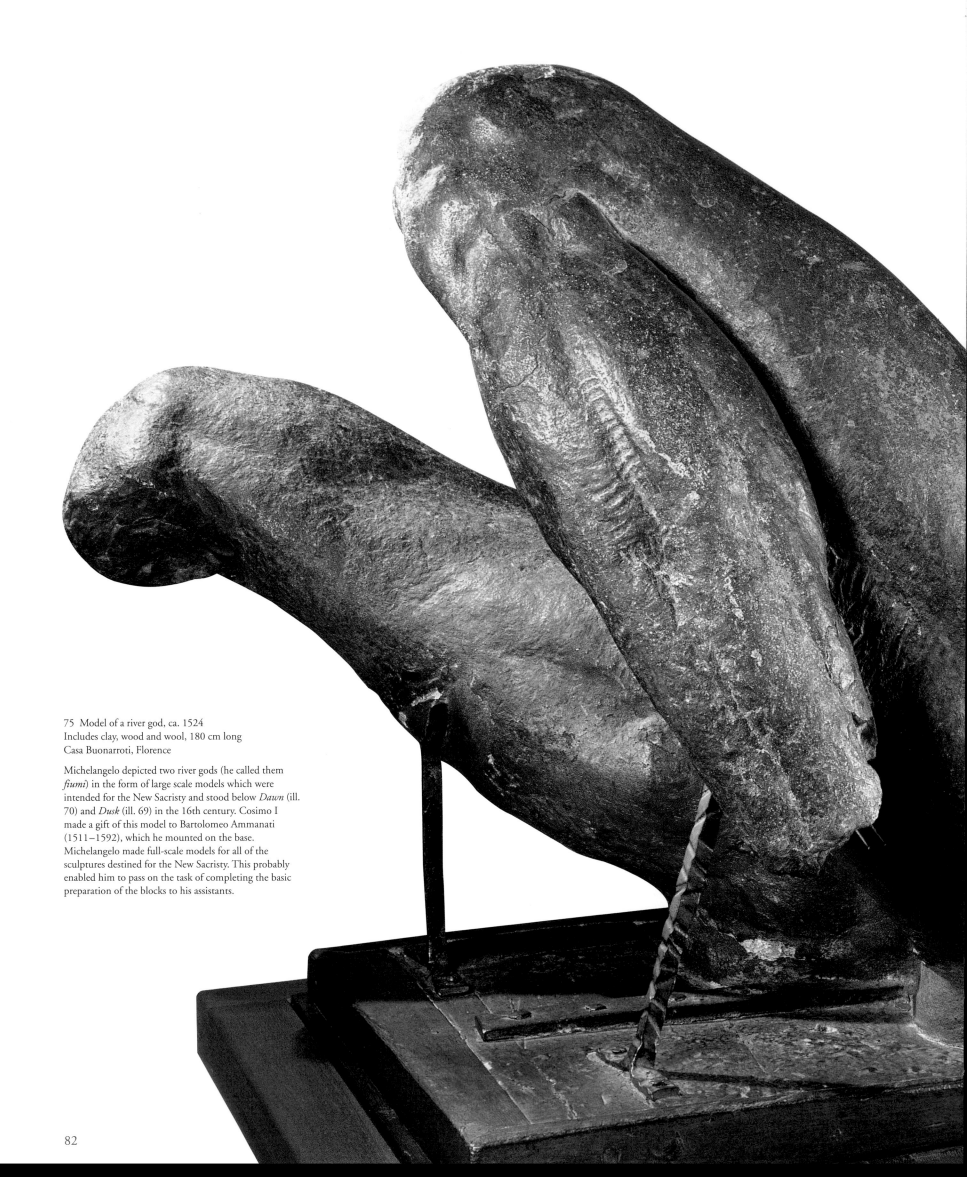

75 Model of a river god, ca. 1524
Includes clay, wood and wool, 180 cm long
Casa Buonarroti, Florence

Michelangelo depicted two river gods (he called them
fiumi) in the form of large scale models which were
intended for the New Sacristy and stood below *Dawn* (ill.
70) and *Dusk* (ill. 69) in the 16th century. Cosimo I
made a gift of this model to Bartolomeo Ammanati
(1511–1592), which he mounted on the base.
Michelangelo made full-scale models for all of the
sculptures destined for the New Sacristy. This probably
enabled him to pass on the task of completing the basic
preparation of the blocks to his assistants.

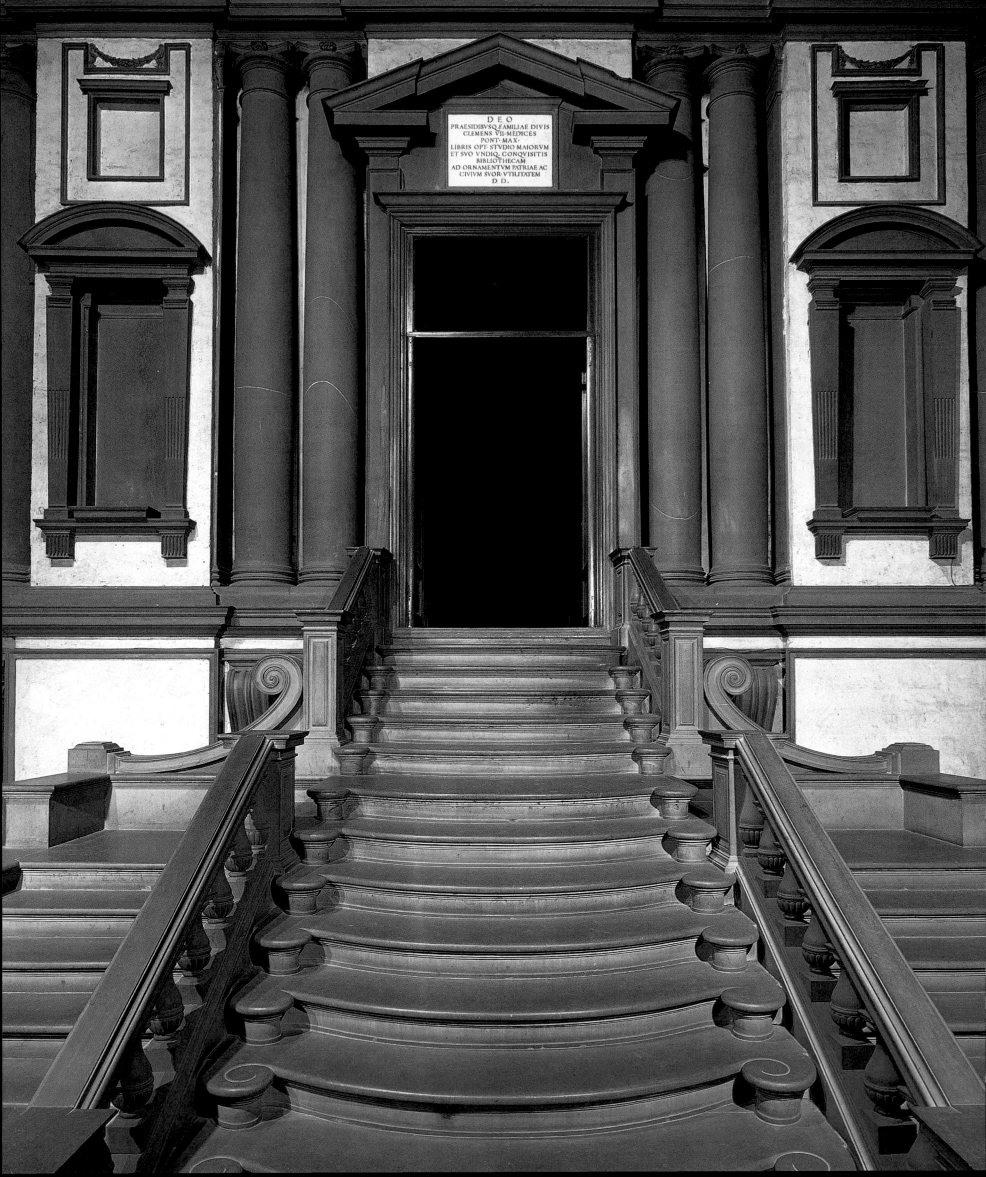

DEO
PRAESIDIBVSQ·FAMILIAE·DIVIS
CLEMENS·VII·MEDICES
PONT·MAX·
LIBRIS·OPT·STVDIO·MAIORVM
ET·SVO·VNDIQ·CONQVISITIS
BIBLIOTHECAM
AD·ORNAMENTVM·PATRIAE·AC
CIVIVM·SVOR·VTILITATEM
D·D·

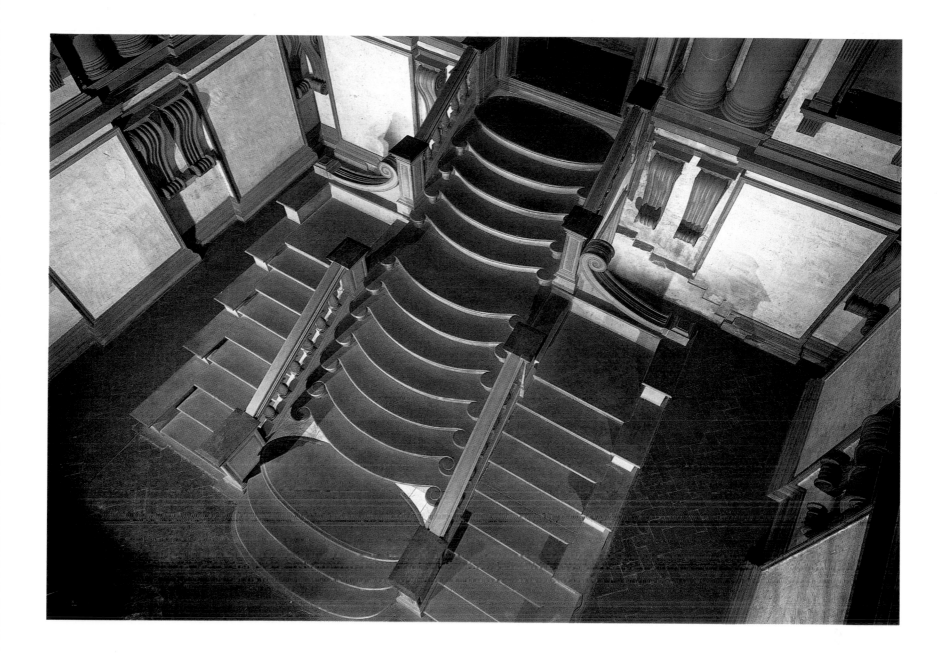

76 (opposite) Vestibule, from 1525
Biblioteca Laurenziana, Florence

In architectural terms, the vestibule represents the most
elaborate part of the edifice. It takes the form of a square
whose walls soar high above the observer. They are
divided into three branches, each of which is flanked on
the main story by pillars which are deep-set in the wall.
This leads to the peculiar result of twin pillars, deeply
recessed, which scarcely seem capable of bearing the ledge
above which the clerestory is situated. The richly gilded
and ornamented wooden ceiling obviates the necessity for
a vault.

77 (above) Vestibule: staircase (cf. ill. 76), from 1525
Biblioteca Laurenziana, Florence

There was originally supposed to be a double staircase
leading up to the reading room, but 1558 in Rome, the
aged artist altered the plans, which were carried out by
Bartolomeo Ammanati in the following years. Enormous
volutes, used purely as ornamentation, and double
columns erected in the recesses, are both elements far
removed from the classical stance of the Renaissance. This
staircase, with its interplay of oval forms, is one of the
most refined examples of Michelangelo's work in the field
of architecture.

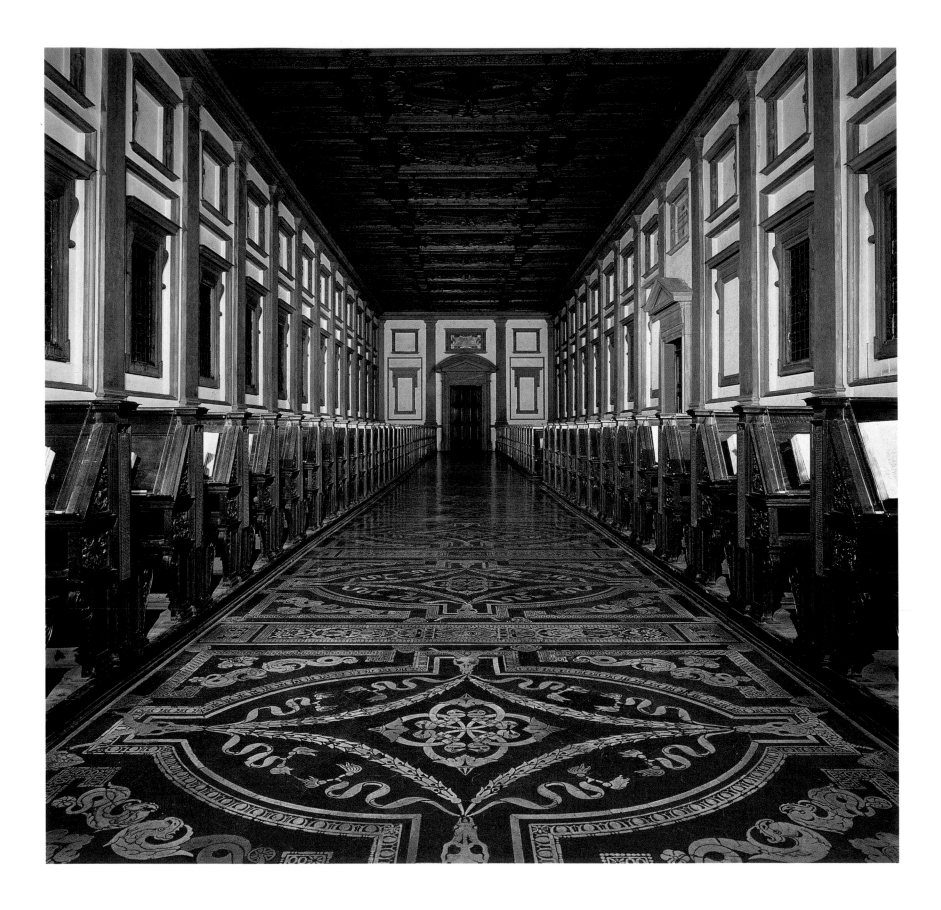

78 Reading Room, from 1524
Biblioteca Laurenziana, Florence

The Medici library consists of a single room in the shape
of a narrow rectangle, thus mirroring the medieval
tradition of monastic libraries. It seemed highly
appropriate to follow this tradition in view of the fact that
the Biblioteca Laurenziana is situated in the east wing of a
cloister. Inside, the bolted down benches provided room
for readers and books, because under the desks there was
storage room for the chained volumes, which was also a
medieval tradition.

Nemours and Urbino have even been formed, with incredible care, to be viewable from all sides as if they had been planned, right up to their completion, as free-standing.

Among the Florentine works of Michelangelo the architect which can be experienced in their essential outline today, in addition to those in the New Sacristy, is another which is also part of the San Lorenzo complex. To the south, the transept is adjoined by the long building of the Medici library, consisting of vestibule and library chamber. It is still referred to as the Laurentian library (Biblioteca Laurenziana) after the patron saint of the church (ills. 76–79). The collection contains treasures of classical literature and philosophy collected by Lorenzo the Magnificent. To house them in a worthy building was a project which like so many others was dogged by its patrons' ambitious plans and lack of funds. An inscription in the reading room reveals that it was only opened in 1571 after a long construction period while the final completion of the vestibule had to wait until 1904.

Together with the New Sacristy, the design of the Laurentian library with its alternating light surfaces and dark structural elements in *pietra serena* gives an impression of Michelangelo's architecture in the 1520s, albeit that the artist continued to intervene in the building work in his later years, even while he was in Rome. The purpose of the building itself demands a simple structure with a flat relief. Here the artist tried out effects, particularly as regarded its height, which are difficult to reproduce in a photograph (ill. 76). Mannerist traits appear at an early stage when double pillars are used for the vertical separation of the axes, which are not only recessed deeply into the wall, but above which the cornice recedes concavely. (ills. 76, 77). The collision of individual wall motifs in the corners of the room is the result of Michelangelo's thorough harmonization of the exterior and interior of the building (ill. 77). For where pilasters or consoles almost intersect in the corners, the edges of the external building are finished off with individual pillars.

79 Reading Room: benches with illuminated manuscripts (cf. ill. 78), from 1524

The Bibiloteca Laurenziana owes its fame to the medieval and early Renaissance manuscripts housed there. The ground floor of the library contained the volumes once obtained by Cosimo il Vecchio for the monastery of San Marco. After the unrest caused by the religious conflicts in Florence, which had already culminated in the leadership of the Dominican Prior Savonarola and his dreadful end in the 1490s, it was only the second Medici Pope, Clement VII, who ensured that the books would be kept once again in a splendid room in Florence with Michelangelo as its architect.

80 (left) Drawing for the fortifications of the Porta al Prato d'Ognissanti, 1529
Pen with traces of red chalk on paper, 41 x 57 cm
Casa Buonarroti, Florence

In political terms, Michelangelo was an enigmatic personality. Although he was trained in the House of Medici, he was, after the family's expulsion from Florence in 1526, to become the head of fortification works in the last phase of the republican government. But his plans for fortification were never realized, since the Medicis succeeded in returning in 1530. Unlike other Republicans, there were no reprisals in store for Michelangelo after the Medicis regained power. It was more important for them that the artist resume his work.

MICHELANGELO AND THE FLORENTINE REPUBLIC FROM 1527 TO 1530

The papacy of Clement VII was characterized by epoch-making ructions. The Reformation, which had started under Leo X, took hold and large regions abandoned Rome. The Habsburg Charles V, elected emperor after a deep political crisis and a supporter of the old Church, turned out to be a terrible ally, for his unruly troops attacked Rome in 1527 and looted the city in that never-to-be-forgotten horrific episode which was to enter the history books as the "Sack of Rome".

The weakness of the Pope and the general conditions encouraged those forces in Florence who were opposed to the Medici to shake off the rule of the family once more for a short while. In 1527 Republican rule was established again, in which Michelangelo was also involved.

On 10 January the artist was elected to the Council of Nine responsible for war and was entrusted with the construction of the fortifications. Drawings (ill. 80) provide evidence of his work for the republic, but his impressive projects were never executed. The artist also displayed political instinct during the short turbulent time of his commitment, for he clearly had a presentiment of the treason which would subject the city to the Medici again in 1530. He waited, hidden in San Lorenzo, until he could be certain, after a remarkably

81 (opposite) Study for the face of Leda, ca. 1530
Red chalk on paper, 35.6 x 27 cm
Galleria degli Uffizi, Gabinetto dei Disegni e delle Stampe, Florence

Leda was one of the lovers of Zeus who were unable to receive the god in his true form. Therefore, he made love to her as a swan, and their children were the heavenly twins Castor and Pollux and the beautiful Helen. Like Leonardo (1452–1519) before him, Michelangelo attempted to give artistic expression to this myth. However, the compositions of the two figures have only been preserved in freely varying copies. This one shows the somewhat unmoved features of Leda, appearing in exquisite detail, and the *Night* of the Medici tombs (ill. 73) throws some light on the entire figure.

82 *David-Apollo*, ca. 1525–1530
Marble, h. 146 cm
Museo Nazionale del Bargello, Florence

Probably created for Baccio Valori, the sculpture displays
the traits of the Florentine style from the era of the
Medici tombs. This, however, is only true of the
conception, because this work also remained unfinished.
Vasari spoke of an Apollo, but in the inventories of the
Medici, in whose possession the figure remained until the
end of the 16th century, reference is made to a David. It
is generally assumed that the figure was sculpted as a
David for the Medici tombs, only to be adapted to
become an Apollo for Valori.

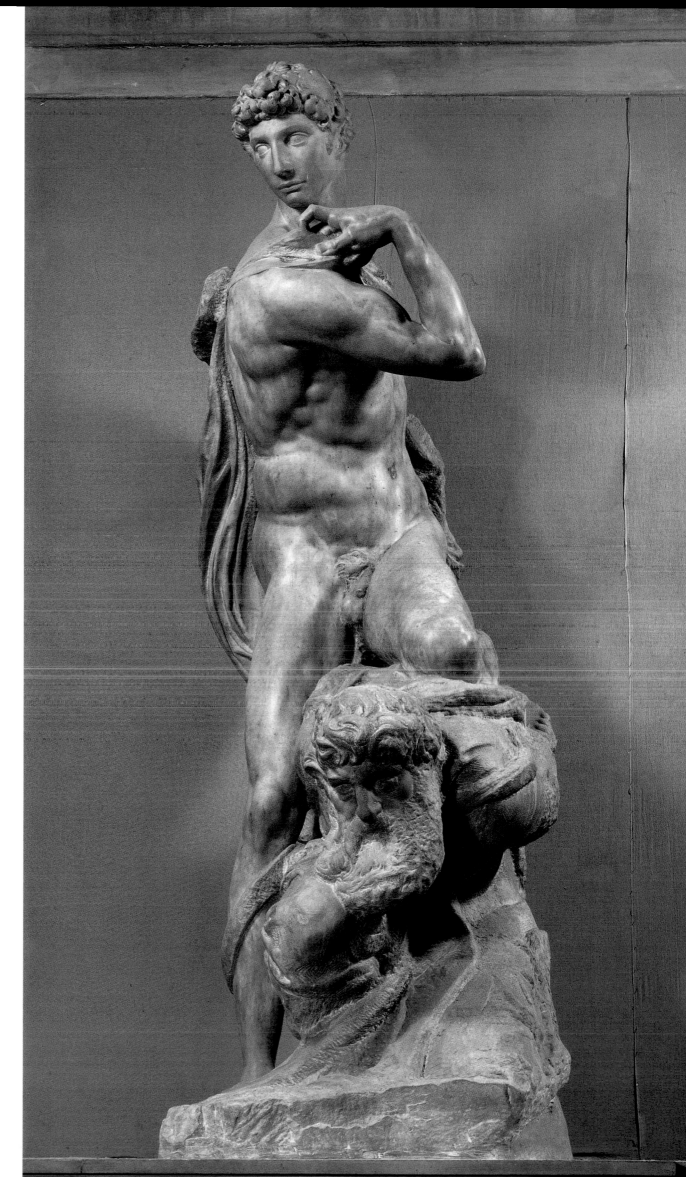

83 *Victory*, ca. 1532–1534
Marble, h. 261 cm
Palazzo Vecchio, Florence

This figure was certainly intended for the tomb of Julius
II (ill. 51), but there is controversy surrounding the date.
In its present state, a particular source of delight is the fact
that the youthful and beautiful victor is almost
completely finished whereas his ageing, defeated
opponent is only indicated in rough terms, which
emphasizes the sculpture's theme. Since the figure was not
used in the tomb, Vasari asserts that some considered
using it for Michelangelo's own tomb after his death.

84 (left) *Victory:* right hand (detail ill. 83),
ca. 1532–1534

The expressively formed hands of the figures were already
a feature on the *Dying Slave* (ill. 55) and *Moses* (ill. 49).
The hands of *Victory* are also formed in particular detail:
The left hand with the index finger spread away from the
other fingers takes hold of the cloth while the right hand
grips the clasp in a gesture which is an unlikely one but
therefore all the more impressive. The tension contained
in the power of *Victory* is depicted to the fingertips. At the
same time the specific artistic interest in the hand is an
expression of the importance which painters and sculptors
from the high Renaissance onwards accorded to their own
hands in the creative process. Since that time art experts
refer to different hands when they are discussing the
elements by different artists in works which have been
preserved.

short time, of the favor of the Medici pope, and thus
also of the restored family.

The artist had little time for smaller commissions
because, with the exception of this short episode, he had
become the court artist both in Rome and in Florence
in the service of the pope and the Medici palace. In these
years Michelangelo once more turned his attention to
the project of putting the second patron of Florence,
Hercules, next to the Old Testament hero *David* at
the gate of the Palazzo Vecchio. An impressive clay
bozzetto provides evidence of this (ill. 58). But then the
intentions of the artist were not so clear after all, for
the group of figures which might represent Hercules as
the vanquisher of Cacus can also be understood as the
biblical Samson smiting a Philistine.

In 1530 he created the composition of *Leda and the
Swan*, which received much attention (ill. 81), for the
Duke of Ferrara. It has, however, been lost. But a
mysterious piece from the same year has been preserved,
half David, half Apollo, which was not made for the
ruling family (ill. 82).

Growing autonomy means that it becomes difficult
to assign even monumental sculptures to specific
projects. Since the artist was contractually and inwardly
bound to Julius' tomb, he kept the mighty slaves in
Florence, two of which were almost completed but never
reached their destination (ills. 54, 55). When the tomb
was set up in 1592, these two works were removed to
start their journey to France, while the *Victory* group of
figures, which was also largely complete, remained in
Florence (ill. 83). His contemporaries are said to have
considered putting this work, as an image in which evil
is overcome, on the artist's grave.

This work marks a decisive step in the development
of art: nearly everything which Michelangelo had
created thus far was guided by the basic surface and
the tectonics of the body, whose axes may be moved
in the process of pondering without losing their
fundamentally architectural quality. With the exception
of the *Bacchus* (ill. 20), all the earlier figures have a main
view. But *Victory* breaks with important conventions
which the great Michelangelo also applied to himself.
There is no longer a view which allows the whole
group to be understood at one glance. Instead, the
movement rotates from the cowering figure of the
vanquished via the almost naked limbs of the victor
up to a tiny head which is once again twisted out of its
axis, giving a non-organic effect when seen from the
wrong angle (ill. 85). The immensely muscular
shoulders above all make the head very irritating, so that
one might almost think that Michelangelo had at a late
stage carved it from a head which was originally much
more massive.

The change of meaning of the work can also make
us ponder. It contains early indications of the way later
ages will deal with sculpture. An anecdotally concrete
meaning which would give a name to the young man
and his bearded victim is not thought to exist. As victor
on the tomb of Julius the figure embodies a virtue. As a
single group above the artist's tomb it might stand for
the victory of eternal life over death. But in the main
hall of the Florentine Palazzo Vecchio, where the group
stands today among moderately good battle scenes, it
embodies the essence of military victory, which the artist
could only have intended as a symbol for something
spiritual.

85 (opposite) *Victory:* side view (cf. ill. 83),
ca. 1532–1534

Like the *Slaves* (ills. 54, 55), *Victory* represents the
incarnation of virtue, which defeats vice, thereby
liberating the soul from the fetters of the body.
Michelangelo breaks decisively with the tradition of
composing a figure with one view alone in mind. If the
Julius tomb was planned as free standing in his first
drawing, then Michelangelo's *Victory* can be observed
from all sides and offers a variety of views, none of which
are in any way "inferior" to the others.

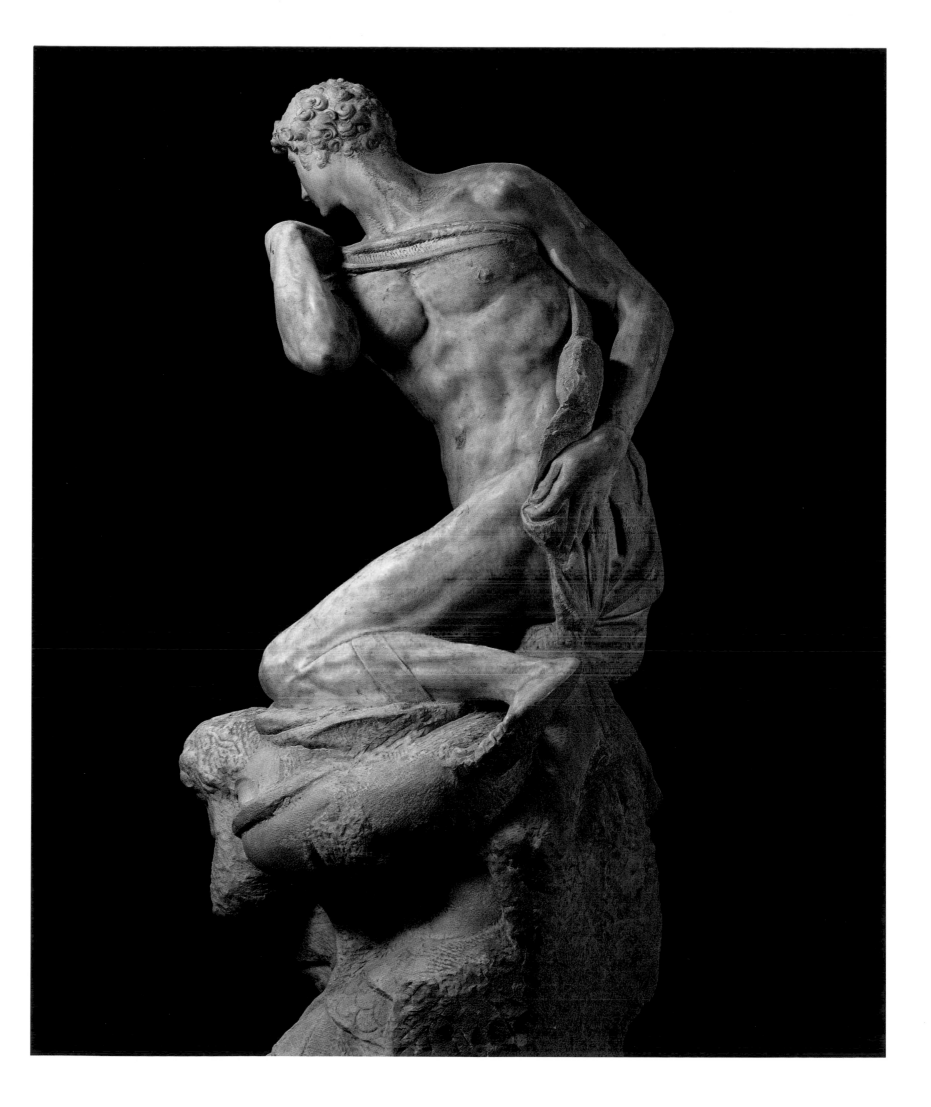

BACK IN ROME UNDER THE FARNESE POPE PAUL III

86 *The Fall of Phaeton: Zeus* (detail ill. 89), 1533

Hurling bolts of lightning, the god sits rather uneasily on an eagle carrying him on outstreched wings. The bird is drawn with just a few strokes. The second version on this theme shows Zeus in an altered position.

87 (opposite) *Ideal Face,* between 1512 and 1530
Red chalk on paper, 20.3 x 16.5 cm
Galleria degli Uffizi, Gabinetto dei Disegni e delle Stampe (Testa n.2F), Florence

Individual or presentation drawings such as this, were done without any recognizable theme, as is the case with the *teste divine* (divine heads). This picture is normally interpreted as the head of a young woman, but the presentation leaves room for speculation that it is an androgynous youth. The imaginative head covering and the body are merely hinted at, while the interplay of light and shadow on the throat and forehead is fully executed.

After the death of Clement VII, Michelangelo broke off all work on the Medici tombs in Florence and also left the dome of the New Sacristy uncompleted. In Rome as in Florence, Michelangelo was tied into a culture in which selected members of noble society exchanged sonnets and honored one another in works of art (ills. 87, 89, 91, 98). It is assumed that some of the ideas of the artist crystallized in these circles. The extent to which the painter and sculptor from Florence was able to overcome the social barriers is, nevertheless, rather surprising.

The artist increasingly discovered picture-like drawings. There are fifteen versions of the *Risen Christ* (ill. 88) of which one is lost; all of them probably originated in 1532/33. It is surprising that neither Condivi nor Vasari mention a commission on this subject. Possibly these sheets were preparatory sketches for an altar work in the Chigi chapel in S. Maria della Pace for which Michelangelo's protégé Sebastiano del Piombo signed a contract in August 1530. The endeavor to find own solutions independently of pictorial traditions becomes understandable if we remember that the Chigi chapel contains the masterly frescoes of the

Prophets and Sibyls by the great Raphael around the altar niche. However, Sebastiano never carried out this commission.

Even without having been turned into a painting, Michelangelo's resurrection sketches display a virtuoso handling of the medium. Christ's posture appears to have caused particular problems at various stages of completion of the sketch. At issue was the way in which the transcendental nature of the event could be made comprehensible in the action of the human body.

Sketches became noble gifts and in particular measure pledges of friendship, such as the portrait sketches, unique in the degree of their completion, of the young Andrea Quaratesi (London, British Museum). Michelangelo was a friend of this Florentine family; he knew Andrea, born around 1512, from when he was a child. From 1532 onwards, a much deeper relationship linked the ageing artist with the beautiful Roman noble Tommaso de' Cavalieri, a friendship which remained intact until the death of the artist. Vasari reports that Tommaso had also been honoured with a portrait sketch which has, however, been lost. In the first two years in particular, Michelangelo's affection for the young man was more passionate than is known of any other of the artist's friendships.

If Michelangelo had not felt particularly happy in Rome up to that point, his dealings with the confident and educated patrician meant a great deal to him. Apart from the sonnets which the artist composed – he dedicated about thirty to sixty to him – as did Tommaso, sketches also became a means of communication for Michelangelo. A *Ganymede* (only preserved as a copy) and a *Titus* (Windsor Castle) transpose their joint conversation into a different medium which carries an additional message to the verbal one. The three preserved versions of the *Fall of Phaeton* (ill. 89) do not represent the illustration of a classical myth but deal with ideas which provide deep insight into the philosophy of Marsilio Ficino and assume thorough reading of, for example, Landino's commentary on Dante's "Divine Comedy" both by the artist and the person whom he is addressing.

Individual large compositions are more difficult to interpret, such as the monumental *Epiphany* sheet

88 (above) *Resurrection of Christ*, ca. 1530
Red chalk on paper, 15.2 x 17.1 cm
Musée du Louvre, Département des Arts Graphiques,
Paris

This picture, probably not drawn for a commission, is a
rarity in Italian art in that it depicts the exact moment
that Christ rises from the tomb. Although it is only a
drawing, the arresting contrast between the soldiers.
either cowering at the tomb or fleeing in horror, and
Christ at the moment of his Resurrection is still
unmistakable. Without leaving the realms of the natural,
the upwards movement towards the light symbolizes the
Resurrection of the Redeemer.

89 (opposite) *The Fall of Phaeton*, 1533
Black chalk on paper, 31.3 x 21.7 cm
British Museum (Wilde 55), London

Zeus appears at the top of this picture, ready to strike
down Phaeton with a thunderbolt. Phaeton had borrowed
the sun chariot from his father Helios, lost control of the
steeds, then fell from the heavens into the Eridanus. The
river god of the Eridanus is shown, as are Phaeton's sisters
who had harnessed the horses and were consequently,
according to Ovid's "Metamorphoses", transformed into
poplars. Three copies of this composition remain. They
are an expression of the friendship with the young
patrician Tommaso Cavalieri, who was described by his
contemporaries as being uncommonly beautiful.

(ill. 91), which does not, however, show the veneration of the Wise Men celebrated on Epiphany (6 January), as the traditional title might lead us to assume. A seated woman in the center of the sheet is being addressed by a second woman with an argumentative gesture of the left hand; the former turns towards the latter but reaches back with her left hand towards an old man sitting in the background. A naked boy is hiding between the legs of the main figure while a second one is standing next to her to the right. The hint of a fur cloak being worn by the standing boy suggests a depiction associated with the Holy Family. That would mean that it is Anne or Elisabeth and Mary in the picture, with step-father Joseph in the background, as well as the Christ child with John the Baptist who as a child already wears a hair shirt in anticipation of his hermit's existence in the desert.

Nevertheless, the woman on the left is not as old as Mary's mother Anne or the ancient Elisabeth. This interpretation is also weakened by the appearance of further heads above her and next to Joseph. This has led to the assumption that the legend of Joseph's children from his first marriage played a part in this depiction. This thought would also explain the name, *Epiphany*, which alludes to a theologian from the late classical period, Saint Epiphanius. It was his view that Christ's brothers and sisters, mentioned in the Gospels, were the children of Joseph, whose marriage to the Virgin was never consummated. This might be indicated by Mary's fierce rejection of the old man.

Independently of such interpretations, Michelangelo appears to pick up an artistic tradition here which includes two major works by Leonardo da Vinci, the Anne cartoon in the National Gallery in London and the large tableau in the Louvre. These pictures were created in the context of a cult of Anne which was promoted by the Popes since Sixtus IV around 1475 which granted special pardon of sins if certain prayers were said in front of a picture of Anna. In contrast to compositional sketches, which can vary in size, cartoons are the same size as the later painting. Cartoons were originally pale models for tapestries which frequently were not even carried out by the artist responsible for the work. But after Leonardo's and Raffael's cartoons for the Vatican tapestries, depicting scenes from the Acts of the Apostles, these designs were valued and collected as works of art in their own right. Michelangelo's design for the *Battle of Cascina* (27, 28) too takes the form of a cartoon which prepares the later fresco. Marks on the *Epiphany* sheet (ills. 90, 91) indicate that pricks were made in the drawing to trace the contours through to the medium for the painting. The hard folds have had a negative impact on its state of preservation but show that the paper was folded for storage, whereas such a drawing would not have lasted until today as a drawing on the wall.

90, 91 *Epiphany* (and detail), ca. 1534–1564
Black chalk on paper, 232.7 x 165.6 cm
British Museum (Wilde 75), London

There can scarcely be a connection between the subject depicted here and the title in the inventory of Michelangelo's legacy: instead of the veneration of the Wise Men from the Orient, two women with two children meet here, with an older man joining them from the left. Presumably, it is the ageing Elizabeth and the Mother of God shown here, with the infant John and Christ playing at their feet. The card was a present to Michelangelo's biographer Condivi, whose oil painting which was to be completed later hangs in the Casa Buonarroti today. At one time, the painting was ascribed to Michelangelo's own hand.

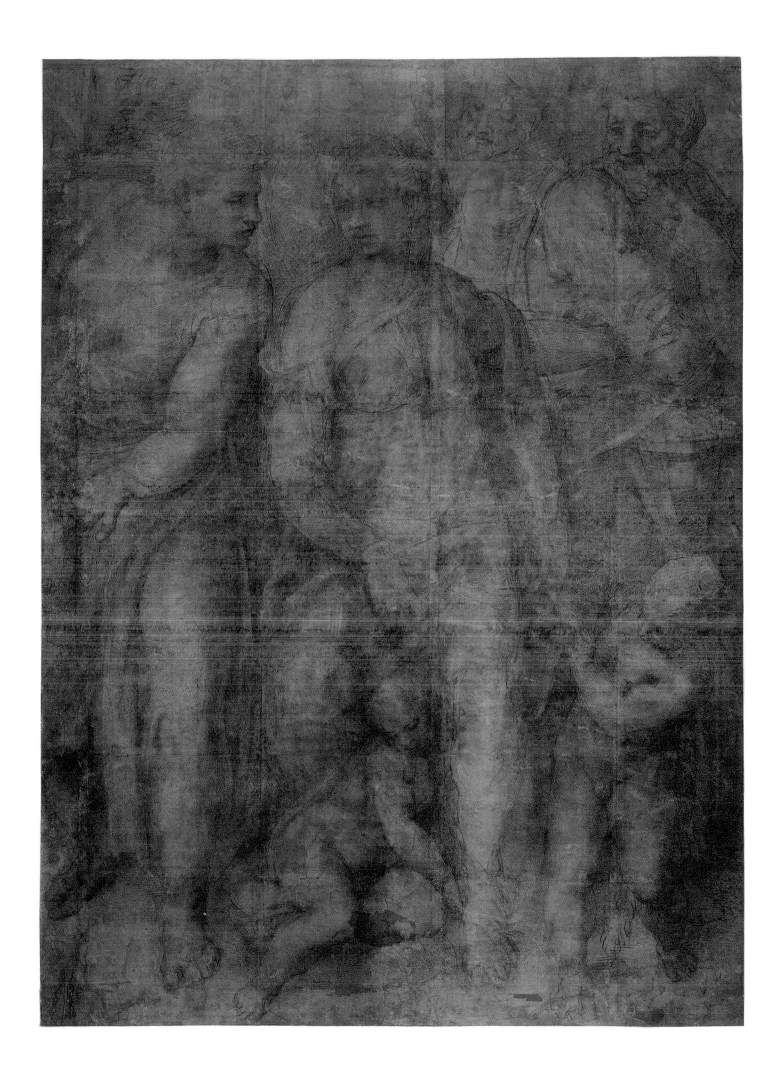

THE LAST JUDGEMENT IN THE SISTINE CHAPEL

Tradition has it that Michelangelo, resident in Rome again since the early 1530s, agreed to his last monumental contribution to the arts not in Rome but in Tuscany. In the small village of San Miniato the artist is said to have decided on the plan to create the *Resurrection of Christ* (ill. 88) and the *Last Judgement* on the end walls of the Sistine Chapel during a meeting with the Medici Pope Clement VII on 22 September 1533. That is why a first sketch for the colossal painting, which was not finished until 1541, has been dated to the following year, i.e. 1534 (ill. 92).

These plans were only realized a few years after Clement VII had died and his successor Paul III Farnese had been elected pope. Two windows had to be walled up because the whole of the altar wall was to be used for the fresco. During this work the start of the cycle dating from shortly after 1481, which is still preserved on the side walls, was destroyed, as were the lunettes painted by Michelangelo himself (ill. 33).

The wall had to be carefully prepared. In order to prevent the picture being dirtied too quickly by candle smoke and dust, the plaster was extended outwards a little at the top so that the field was slightly concave. There were profound disputes about the technique. Sebastian del Piombo (ca. 1485–1547), a close friend of the old Michelangelo, had prepared the surface for a kind of oil painting against the wishes of the master.

Michelangelo broke with him for ever and had the wall completely replastered and prepared anew because he insisted on painting only in the traditional fresco technique.

In artistic terms, the colossal painting was a revelation with far-reaching consequences; no painter could ignore the prescriptions which Michelangelo offered here. As late as the end of the 19th century, the French sculptor Auguste Rodin (1840–1917) modelled his own *Gates of Hell* on the Sistine fresco (ill. 93). But in many respects Michelangelo breached the barriers of readability and iconographic convention, as well as decency, in this picture. The naked body is the main focus of his art to such an extent that he is presumptuous enough to show even the most modest saint completely unclothed. In addition, he ignores long-standing traditions. Angels are deprived of their wings so that, now, muscular human entities in the two lunettes at the top to the side carry the instruments of the Passion (left: cross and crown of thorns; right: scourging post) and similar beings in the center below call with trumpets for the resurrection of the body.

The Judge by no means has the familiar features of Christ. But for the wounds in his side, hands and feet, the figure would reveal nothing of its identity, for Jesus here appears without beard and with unheard of muscular strength (ill. 95). He approaches from the depths of space in a bright yellow mandorla and lacks the vocabulary of blessing and damnation. Anyone who looks attentively at the painting will quickly notice that the monumental figure of Christ seems to project beyond the picture surface, as if penetrating far into the space of the chapel in front of the crowds in the picture.

There is no sign here of the usual judgement scenario: The apostles should be enthroned in judgement alongside Christ and should not crowd around the Apparition. Mary neglects her most important task in that she does not appear to intercede before the Judge but nestles into the contours of her Son (ill. 95). The Baptist appears on the same side, not to intercede either, but full of astonishment about the figure of light which has penetrated the picture. Finally, St Peter is given a role which is not at all appropriate to him in this context, in that he intervenes in a violent dispute with vehement gestures.

The instruments of the Passion, at first sight lacking any direct relationship to the figure of Christ presiding over the Last Judgement, but conceived in a position directly below, are held by athletic angels. The Gospel (Matthew 24, 30) only refers to a sign which has been interpreted as a cross; but according to the same text the "Son of Man" approaches on the clouds of the sky; the chosen ones really do seem to come from one end of the heavens to the other. The saints, closely crowded in a semicircle round Christ sitting in judgement are

93 (opposite) *The Last Judgement*, 1537–1541
Fresco, 13.7 x 12.2 m
Vaticano, Palazzi Vaticani, Cappella Sistina, Rome

Since restoration has been completed, we can once again see how Michelangelo developed this composition on an outstandingly arresting shade of blue. One must realize that a considerable transformation has taken place, because almost all of the figures were originally naked, with the result that the effect of the dense figure relief was not dissimilar to the early *Battle of the Centaurs* (ill. 4). It is a far from easy task to disentangle the mass of souls on their ascent to Heaven, the souls of the Damned as they plummet towards Hell, the angels whose sounding trumpets signal the resurrection of the dead and the saints gathering around Christ. Indeed, the observer will initially only have the impression of a plethora of bodies, characterized by the extreme plasticity of their depiction.

92 (left) First draft for *The Last Judgement*, ca. 1534
Pencil on paper, 41.8 x 28.8 cm
Casa Buonarroti, Florence

The idea of commissioning Michelangelo with a *Last Judgement* on the altar wall of the Sistine Chapel goes back to Clement VII, although the altar was dedicated to the Virgin Mary. But work on it was only to begin under his successor, Paul III, in 1536. The artist, who was now 60, soon broke with the standard traditions in iconography. Instead of having the Judge in the center, surrounded by intercessors, and of separating the Saved on the left from the Damned on the right, he elects to focus the observer's attention on the ascent of the Saved and, even more forcefully, on the terrible fall of the Damned.

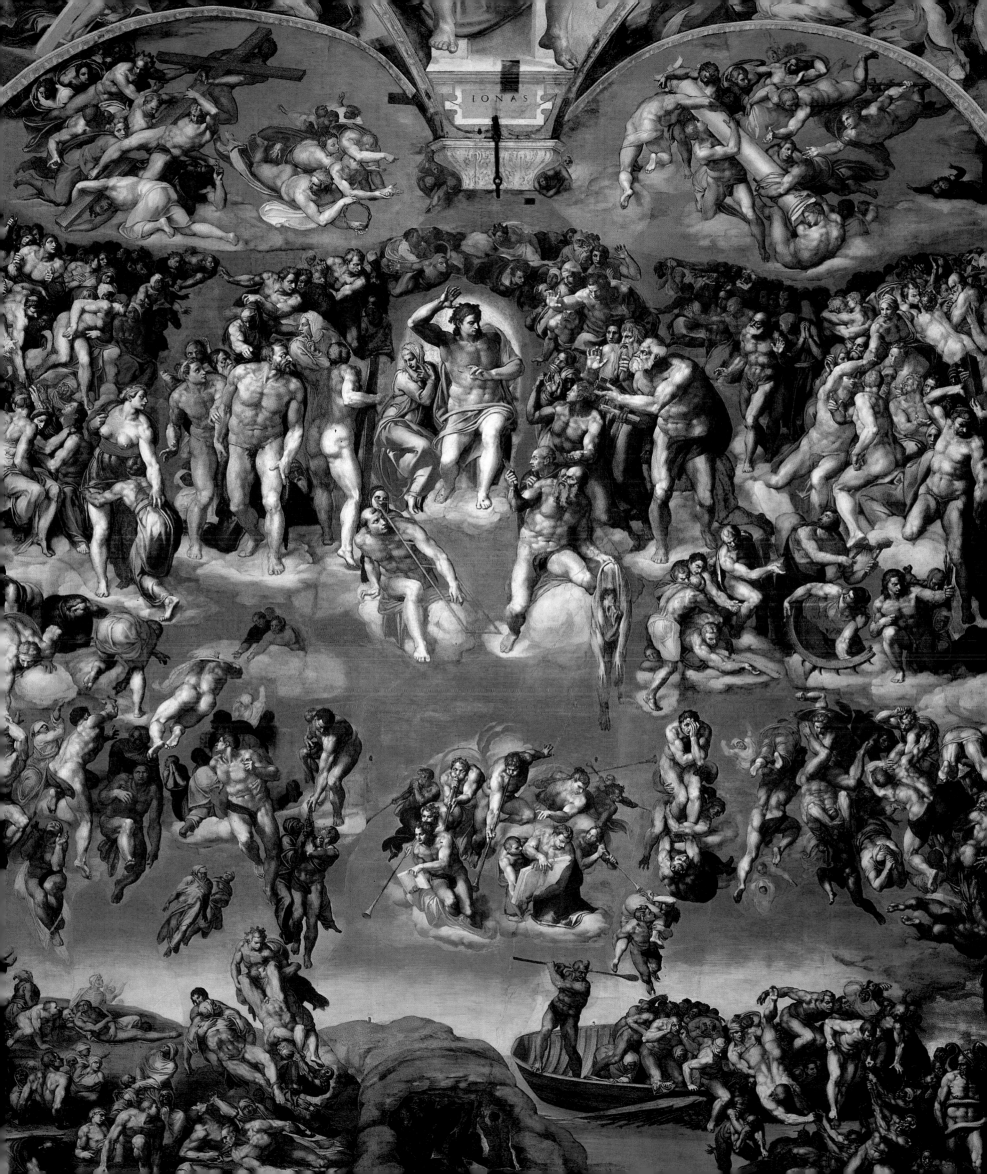

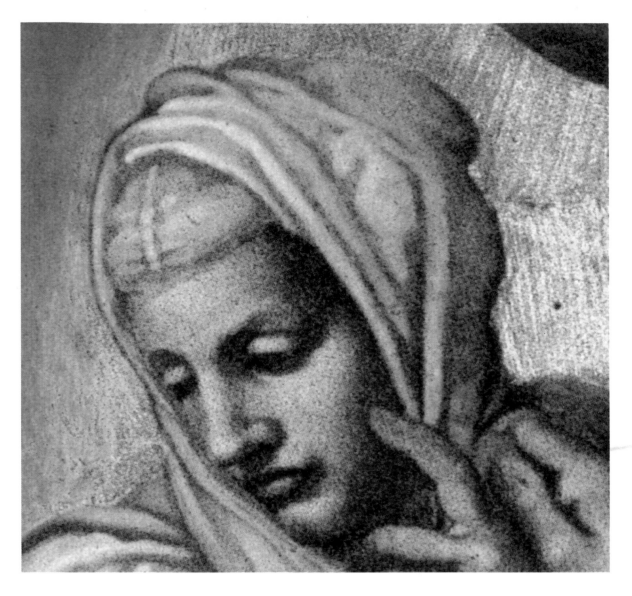

94 *The Last Judgement:* Mary (detail ill. 93), 1537–1541

With half closed eyes, Mary turns away from Christ sitting in judgement. She is depicted in melancholy youthful beauty so that she appears more like the sister or lover of her son, as if both of them formed the male and female parts of a whole.

difficult to identify because they are naked. Only very few of them possess any attributes.

If Michelangelo presents a new interpretation of the Gospels in the heavenly sphere, there is little evidence of the Biblical sources in the events on earth, even if words of Ezekiel (Ezekiel 37) can perhaps be recognized in the resurrection process itself, when the flesh is newly formed around the bones. There is a spectacular depiction of Hell with Charon the ferryman over the Styx to Hades and King Minos as evil judge in the Underworld (ill. 98). The Christian subject is thus permeated by elements of mythology on the one hand as well as being inspired by Dante's "Divine Comedy".

The new fresco was unveiled on the eve of All Saints, 1541, and clearly met the approval of the Farnese pope. Praise and criticism were about equal to start with. There was opposition not only among the theologians and clergy, but also among art lovers. The Venetian Ludovico

Dolce accused the picture of consisting of monotonous groups of musclemen. But while he denied that this picture showed any sort of *varietà*, this, the unprecedented inventive variety of the work, is precisely what was praised by Giorgio Vasari.

Critics who saw heretical obscenities in the painting soon won the upper hand, and so it was that Daniele de Volterra (1509–1566) was commissioned to paint over the obviously bodily details following a decree by the Council of Trent in 1564. As a pupil and admirer of the aged Michelangelo he restrained himself nobly, so that his intervention only introduced a little too much color to the colossal painting. There was a reluctance to breach the decision of the Council even in the most recent restoration work, so that the nakedness remains covered. Here it has to be remembered that some figures, like St Catherine, caused such outrage that Daniele de Volterra had to paint them completely anew on fresh plaster.

95 (opposite) *The Last Judgement:* Christ and Mary (detail ill. 93), 1537–1541

Christ appears without a beard and is unrecognizable, since he bears little resemblance to his traditional iconic depiction. His gesture is reminiscent of that of the Zeus of the Phaeton drawing (ill. 89). In his unblemished youthful beauty, he incarnates the ideals of a traditional belief that sees the beautiful body as a reflection of divine perfection. Michelangelo does not give Mary her traditional role as the most important intercessor, but instead has her sitting behind her son in an attitude which is timid, yet also composed. Instead, it is John the Baptist and the Apostles who speak with the Judge.

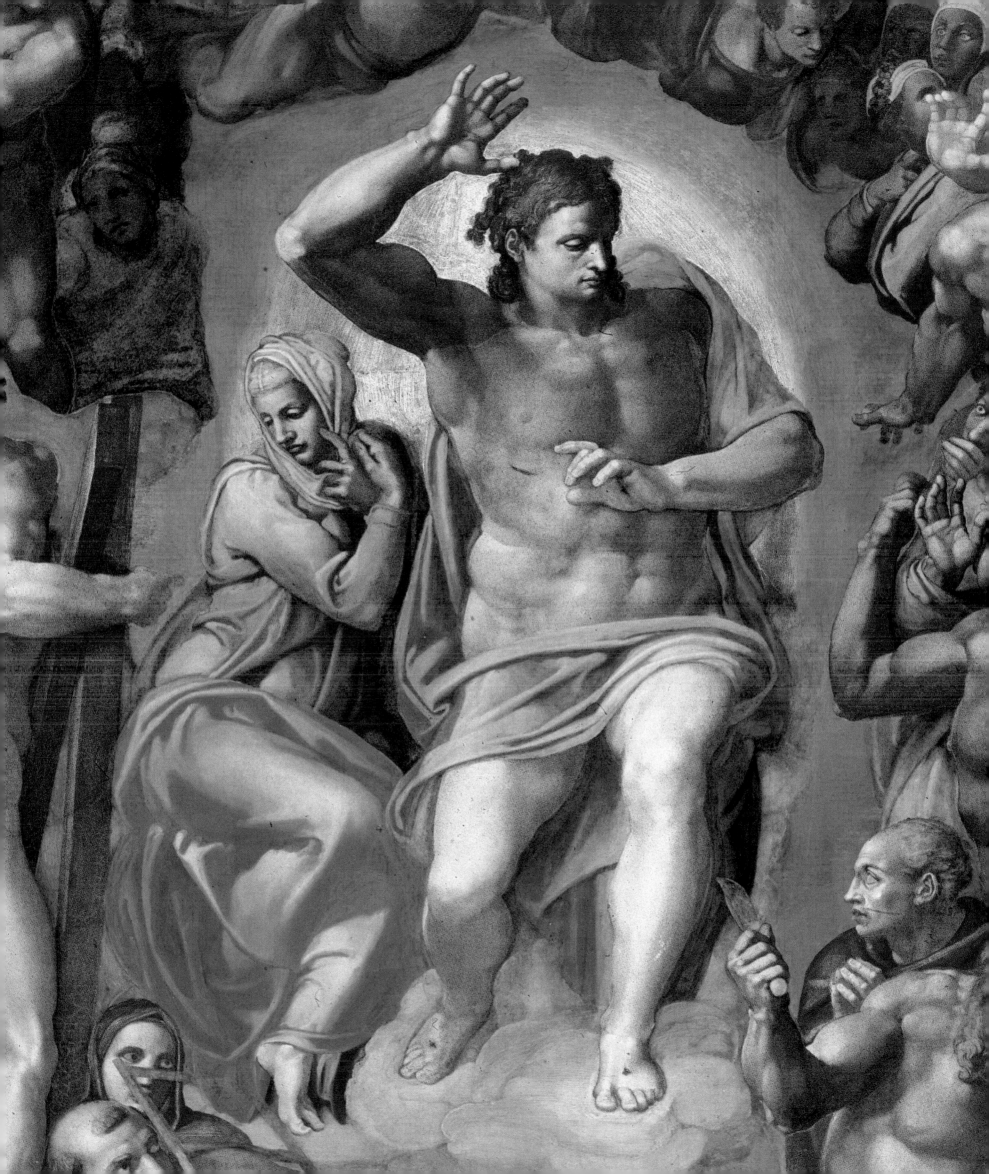

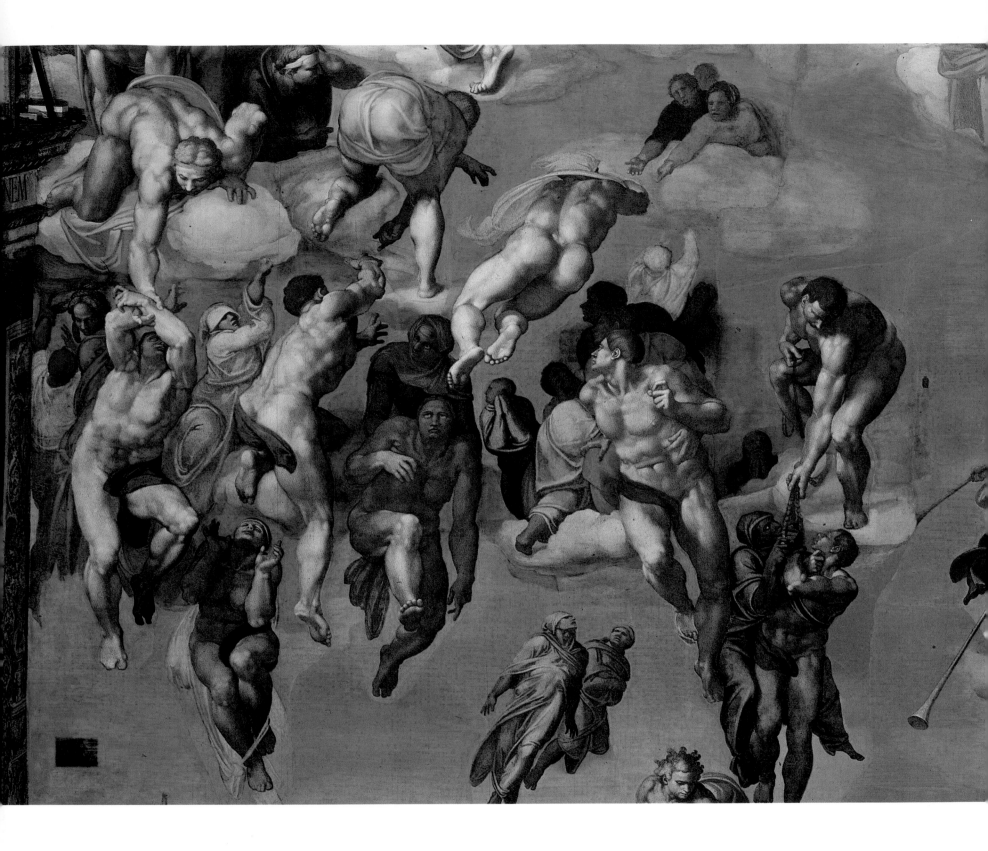

96 (above) *The Last Judgement: the Redeemed*
(detail ill. 93), 1537–1541

The human race rise up laboriously out of a desolate
landscape towards the Last Day, without any real
understanding of the events taking place. Still partially
wrapped in shrouds, they have none of the certitude of
salvation possessed by the Blessed in older depictions of
the Day of Judgement. Uncertain of which direction to
take, the Blessed explore the depths of the space with the
turns of their bodies. They help one another, but there are
no winged angels to lead them.

97 (opposite) *The Last Judgement: the Damned*
(detail ill. 93), 1537–1541

Horned devils and serpents drive the whirling mass of the
Damned down into Hell. A still full gold pouch and keys
hang around the neck of the miser. But here,
transgression and punishment are processes which take
place within the individual, as demonstrated so
powerfully by the top left figure which had impressed
Rodin so much. Michelangelo's decision not to use a
frame makes the fresco seem like a view of another world
which continues behind the Chapel's walls.

98 (following double page) *The Last Judgement:*
the Boat of Charon (detail ill. 93), 1537–1541

Devils and damned souls gather below around two
mythological figures. Charon can be seen on the left,
driving the lost souls out of his boat and into Hell, and to
the right is the figure of King Minos with the donkey's
ears. Snakes are wound around him and Vasari states that
he has been given the features of Biagio da Cesena, the
Pope's Master of Ceremonies. Cesena is said to have
complained about the inappropriate nudity of the figures,
with the result that Michelangelo, in his disgust, found a
place for his portrait amongst the devils in the
underworld. Paul III rejected any further complaints
"because he had no jurisdiction in Hell".

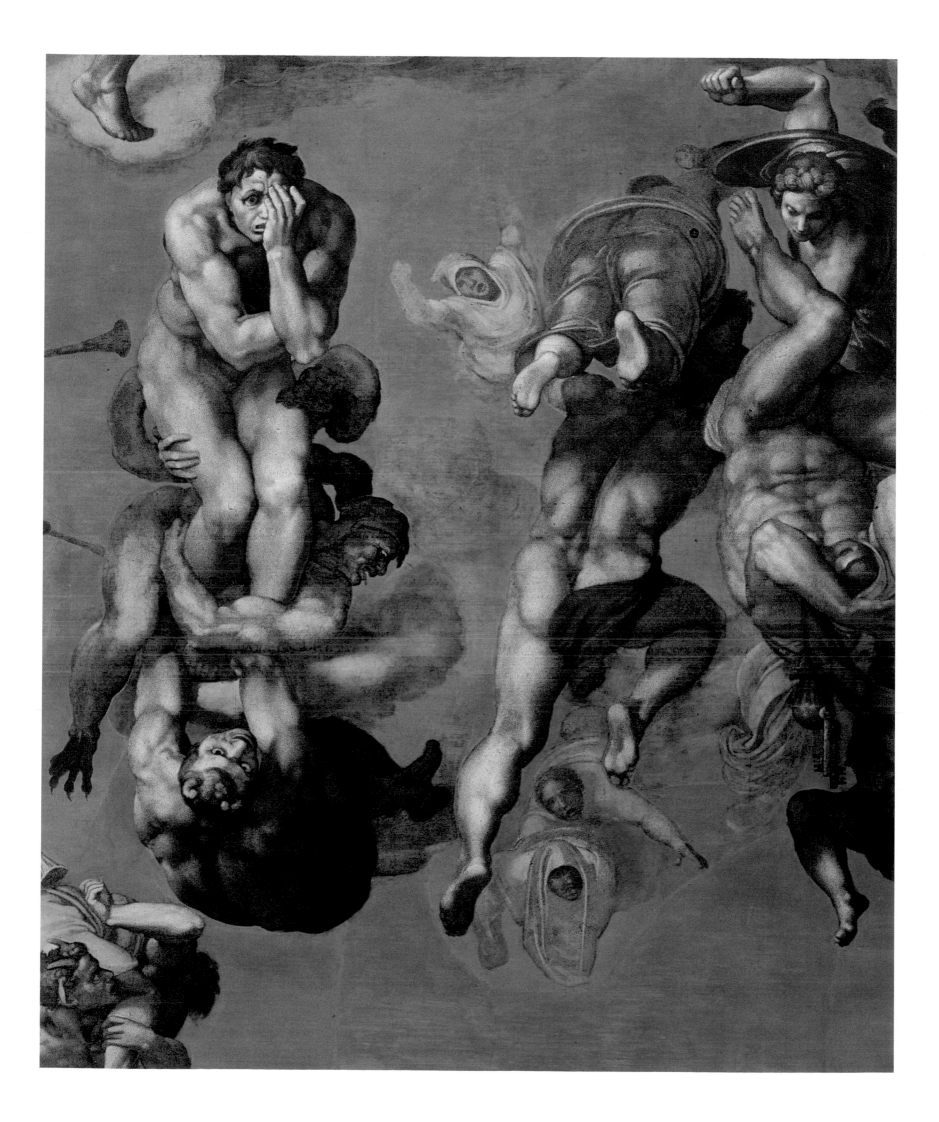

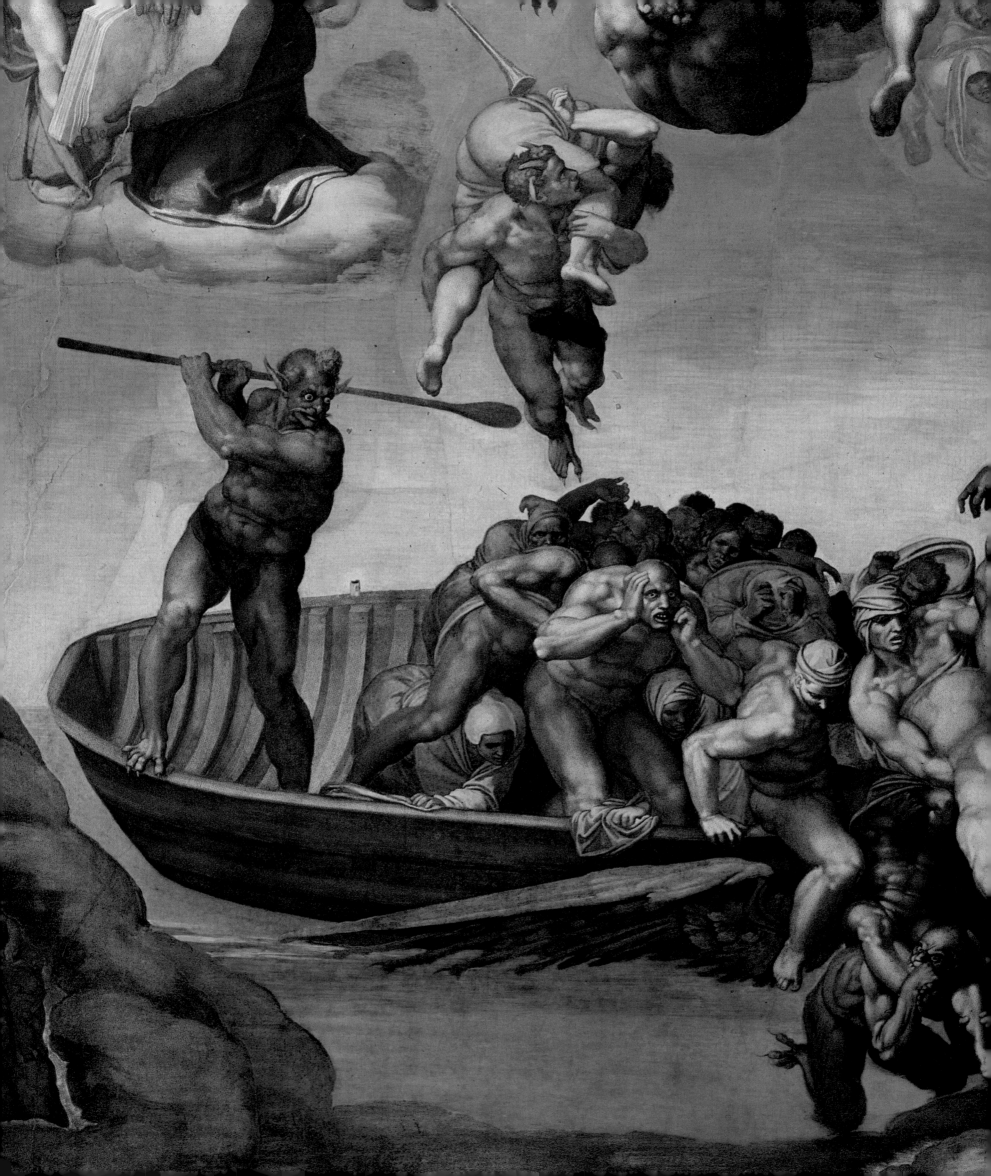

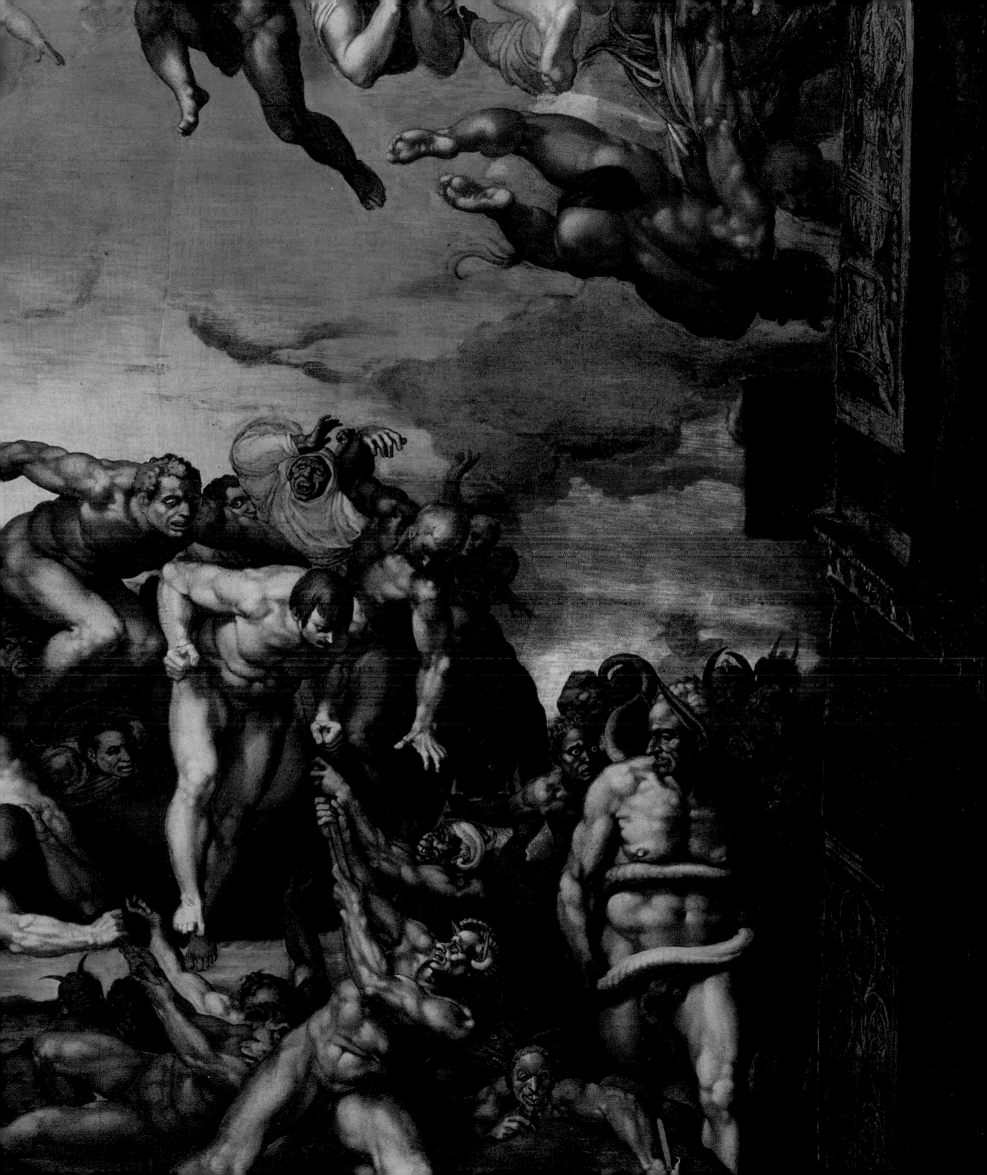

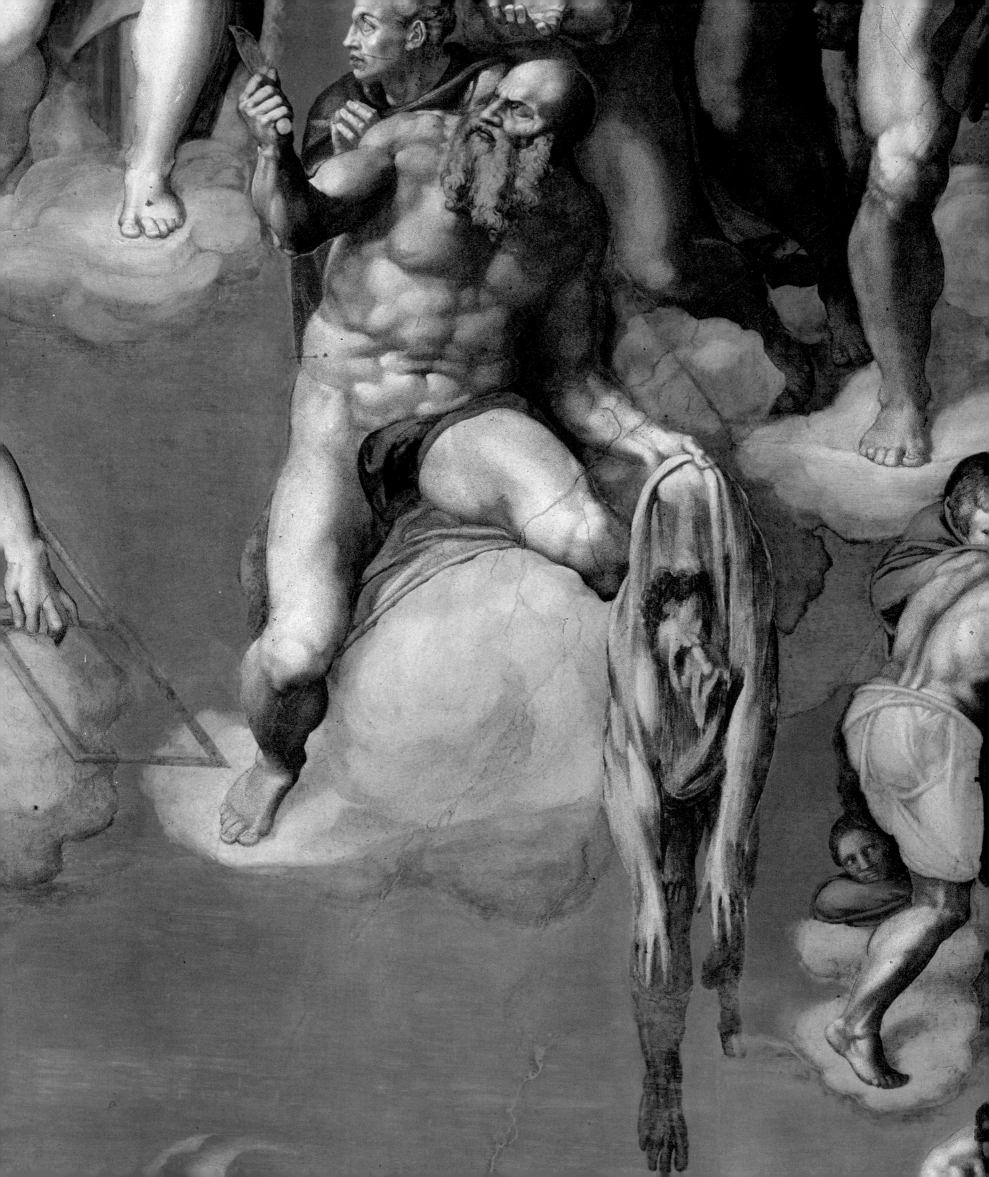

Splits in the Church in the 14th century led to the exile of the popes to Avignon and in the 15th century to the election of rival popes who excommunicated one another. This Great Schism was set aside by a Council of the Roman Church in Basel, Constance, then Ferrara and Florence, in which not only clerics but also temporal powers were represented. Together with the theologians, a way out of the crisis of the Church was sought. Under pressure from the Council, on which all hope rested, the Pope returned to Rome. But from then onwards the main concern of the incumbent of the Holy See was to win back the sovereignty of the Church.

The Reformation broke out in 1517 under Leo X. But just two years later, following the death of Emperor Maximilian I, the imperial crown was at stake. Under those circumstances the Habsburg heir, Charles, did not want to take decisive action against Luther's protector, the rich Elector of Saxony, for that might have helped the French king on to the imperial throne. That is also the reason why a new Council was out of the question, particularly as neither Leo X nor his successor wished to have one. Such an assembly would have caused confusion in imperial politics and endangered the power of the popes as the Reformation intended.

The clerics did not meet until more than a generation after Luther nailed his theses to the church door in 1517, and thus far too late for the unity of western Christendom, on the southern edge of the Alps in what is today the Italian town of Trento. This spot was agreed by the Emperor and the Pope because Italian was spoken there but it belonged to the Holy Roman Empire of the German Nation. Since representatives from Protestant lands did not turn up, the Council was not about reconciliation, as was the original intention, but about the reconstruction of the old Church. The "Catholic Reform" or, from a Protestant perspective, the "Counter Reformation" had its origins in this Council, the Council of

Trent, which had cemented papal omnipotence for centuries. After the magnificent rule of the great Renaissance popes, above all Julius II and Leo X, who surrounded themselves with art and artists, it is no surprise that one section of the Council of Trent was given the task of reformulating and regulating the role of art in the Church. The debate was given urgency by a work of Michelangelo's. His *Last Judgement* (ill. 93) in the Sistine Chapel was the object of contention. He depicted Christ sitting in judgement on the world as a Herculean figure, paying no attention to the most sacred image of Jesus, the *Vera Icon* of the Savior with hair parted in the middle, slim face and beard (ill. 95). His other figures were even worse, since he had subjected not only the Damned, but also the saints, to his ideal of the monumental body.

In a world in which nakedness was the devil's work, many a devout churchman was unable to understand how the Pope in Rome of all people could celebrate mass under one of the wildest pictures of challenging nudity. The election of popes was to take place under this work – that was outrageous, could not be allowed to continue. Change was resolved on 21 January 1564 in Trent and implemented soon after in Rome. A painter was commissioned to cover with great restraint – much too great restraint for many a Cardinal arriving from distant lands – those parts which Michelangelo considered to be a natural part of the human figure. Luckily for art, the choice fell on Daniele da Volterra, an admirer of Michelangelo. The master himself never saw the result, he died less than one month later.

Not even the radical restoration of our days has dared to tamper with this over-painting. The conclusion of the Council of Trent led to a period of unchallenged omnipotence for an institution, the papacy, which had initially protected Michelangelo's work. But that did not help his daring in the *Last Judgement*. Nakedness was sacrificed to the modesty of the Church.

99 *The Last Judgement:* Bartholomew with the artist's self-portrait on the flayed skin (detail ill. 93), 1537–1541

Michelangelo left his self-portrait on the flayed skin of the martyr. His misshapen nose – the result of a break – can be detected in the twisted features. In spite of all criticism, the religious intention of the artist is clear here, as he gives expression to his hope for redemption and renewal with the means he knew best. After this restored fresco was unveiled, John Paul II gave the correct interpretation of Michelangelo's intentions by speaking of " a theology of the human body."

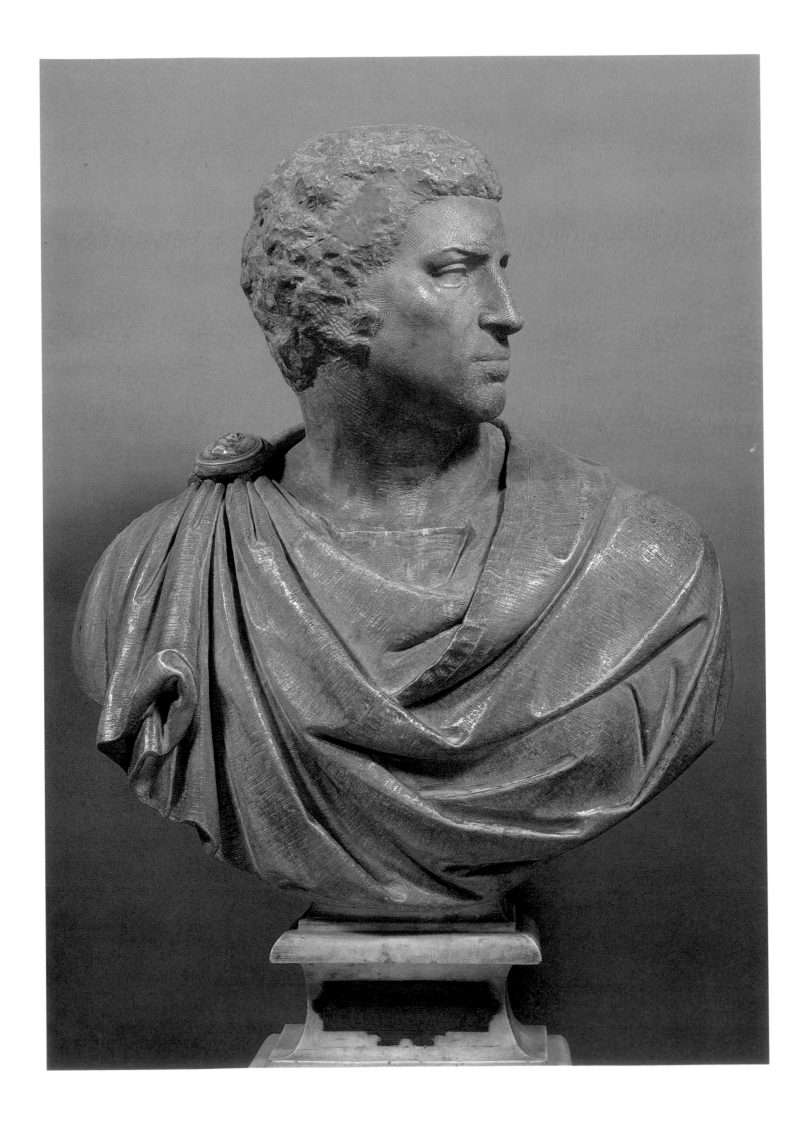

BRUTUS AND THE ERECTION OF JULIUS' TOMB

Although the epoch was characterized by reference back to classical times, Michelangelo seldom created a subject from Antiquity in monumental format. There is the early statue of *Bacchus* (ill. 20), a lost one of Amor and an Apollo, which could, however, also be a *David* (ill. 82). Beyond this the only other piece apart from the lost pictures of Hercules and Leda worth naming is an over-life-size bust of *Brutus*, which refers either to the good hero who killed the last Roman king or to the murderer of Caesar (ill. 100) who was assigned to deepest hell by the Middle Ages. According to Vasari, the bust was created for Cardinal Niccolò Ridolfi through the intermediary Donato Gianotti. Gianotti, like Ridolfi, had to leave Florence after the reinstatement of the Medici in 1530. Lorenzino de' Medici, who had murdered his cousin Alessandro in 1537, was celebrated as the "new Brutus" by the supporters of a Florentine republic. In this sense this bust must be seen as a political statement in Michelangelo's creative work.

With its abrupt turn of the head this imposing piece recalls the attitude of Moses, who finally found his place in 1545 above the papal tomb in St Peter's (ill. 49). Of course Julius II was now denied a burial in St Peter's, although he had started its construction. The tomb was built in San Pietro in Vincoli, an important pilgrimage and relic church in which the chains were preserved from which the angel of the Lord had freed St Peter (ill. 103). At this stage both the pope's heirs and the artist were only interested in bringing the project to an conclusion, particularly as Paul III had immediately commissioned Michelangelo to begin the frescoes in the Cappella Paolina (ills. 107, 108) after the work on the *Last Judgement* had been completed.

Julius's tomb typified for the following centuries the problems associated with building papal tombs. The time in office of Julius II as head of the Church was too short to carry out such an ambitious project. That is why his legacy to his family included the duty to complete the monument. In fact the figures made by the hand of the master were largely completed with *Moses* (ill. 49), *Victory* (ill. 83) and the *Slaves* (ill. 54, 55), but with the exception of the Old Testament hero none of them fitted into the planned design. Although decorative elements for the monument from the earlier designs of 1505 and 1513 could be used in the first storey, the decoration in the upper register is considerably plainer.

On 20 August 1542, a final contract with the Pope's heir, Guidobaldo, the Duke of Urbino, annulled the agreement from 1532, in accordance with which Michelangelo would supply only the *Moses* while the rest of the work would be left to assistants (Raffaelo da Montelupo). Michelangelo also took on the execution of two religious allegories which were originally to be completed by Montelupo. That is why the master himself created the active and the contemplative life which take the place of the slaves in the tomb which was finally built (ill.103). *Rachel* or the allegory of the *vita contemplativa* (ill. 102) is kneeling with her left leg on a pedestal; slightly turned to the left, she faces upward in prayer where she sees the divinity in all certainty. The play of the folds in the garment of *Leah* or the *vita activa* (ill. 101) is even more restrained, while her contemplative stance contradicts the subject matter only on a superficial level. The active element here does not mean vigorous activity in the world but active love. Leah holds a laurel wreath in her left hand and in her right hand an object the interpretation of which is disputed; it might be a mirror or it could be a diadem, even if the object does not fit the considerably larger head of the figure.

Both sculptures marked a decisive change in Michelangelo's life which was linked with the Marchioness of Pescara, Vittoria Colonna (1492–1547), a spiritual friend of his later years. The late work of the artist stood under her influence.

Vittoria Colonna, the widow of Ferdinand Pescara, met Michelangelo in 1537. Until her death they were united by an intimate friendship in which letters, sonnets and drawings were exchanged. The plain nature of the drawings which Michelangelo prepared for her is interesting (ill. 105). They will have spoken about Christ's Passion and in doing so, developed a spirituality which focused on the basic idea of mercy and redemption. It has been shown that some of the great exemplary pictorial ideas of the Baroque period were developed in this, if anything private, circle. The personal element thus crosses the borders of internal communication and becomes accessible to an educated public.

100 *Brutus*, ca. 1538
Marble, h. 74 cm (94 cm with base)
Museo Nazionale del Bargello, Florence

The observer is confronted with massive broad shoulders under a classical cape. The form energetically turns its head into a sharp profile, thereby evoking classical associations, whereas the observer is imbued with the sensation that the form is somewhat clumsy when walking around it. The inscription on the plinth, originating either from Gianotti or Cardinal Bembo, explains why the work remained unfinished: "Dum Bruti effigiem sculptor de marmore ducit / In mentem sceleris venit er abstinuit" (When the sculptor wrought the image of Brutus from the marble, the memory of the latter's crime was awakened and impeded him from continuing.)

101 Tomb of Julius II: *Leah* (*vita activa*) (detail ill. 103), ca. 1542
Marble, h. 197 cm

The conception of the two female forms now flanking *Moses* differ
from him to such an extent that one can scarcely believe they came
from the same artist. *Rachel* and *Leah* illustrate Michelangelo's
espousal of the Catholic reform movement as embodied by Vittoria
Colonna and his relationship with Faith and expectation of personal
redemption.

102 Tomb of Julius II: *Rachel* (*vita contemplativa*) (detail ill. 103),
ca. 1542
Marble, h. 209 cm

According to Condivi, inspiration for the statues was provided by
"Purgatory" from Dante's "Divine Comedy". The two figures stand
alongside *Moses* instead of the two slaves (ills. 54, 55). In comparison
with the *capitani* of the Medici graves (ills. 71, 72) which embody the
active and passive facets of life, the figures of *Rachel* and *Leah* bear
witness to the change wrought within Michelangelo. *Rachel* as the
representation of Faith and *Leah* of active Love display their spiritual
positions as decorative figures endowed with scant presence in their
recesses.

103 (opposite) Tomb of Julius II, 1545
Marble
San Pietro in Vincoli, Rome

Although the early plans were still rooted in basic classical
ideas such as the imprisonment of the soul in the body,
the Julius tomb with *Leah* and *Rachel* as it was eventually
to be accomplished has a predominantly Christian
content. The power and grandeur that the tomb was
supposed to command are now made evident by the
figure of *Moses* as he sits in the center, and whose vital
presence overshadows the two women. The actual result is
regrettably far removed from the ambitious projects of
previous years. This is especially true of the recumbent
figure of the Pope whose apparel motif, especially,
underneath the weak head seems to have been
accomplished by the master in a somewhat rigid,
formulaic manner.

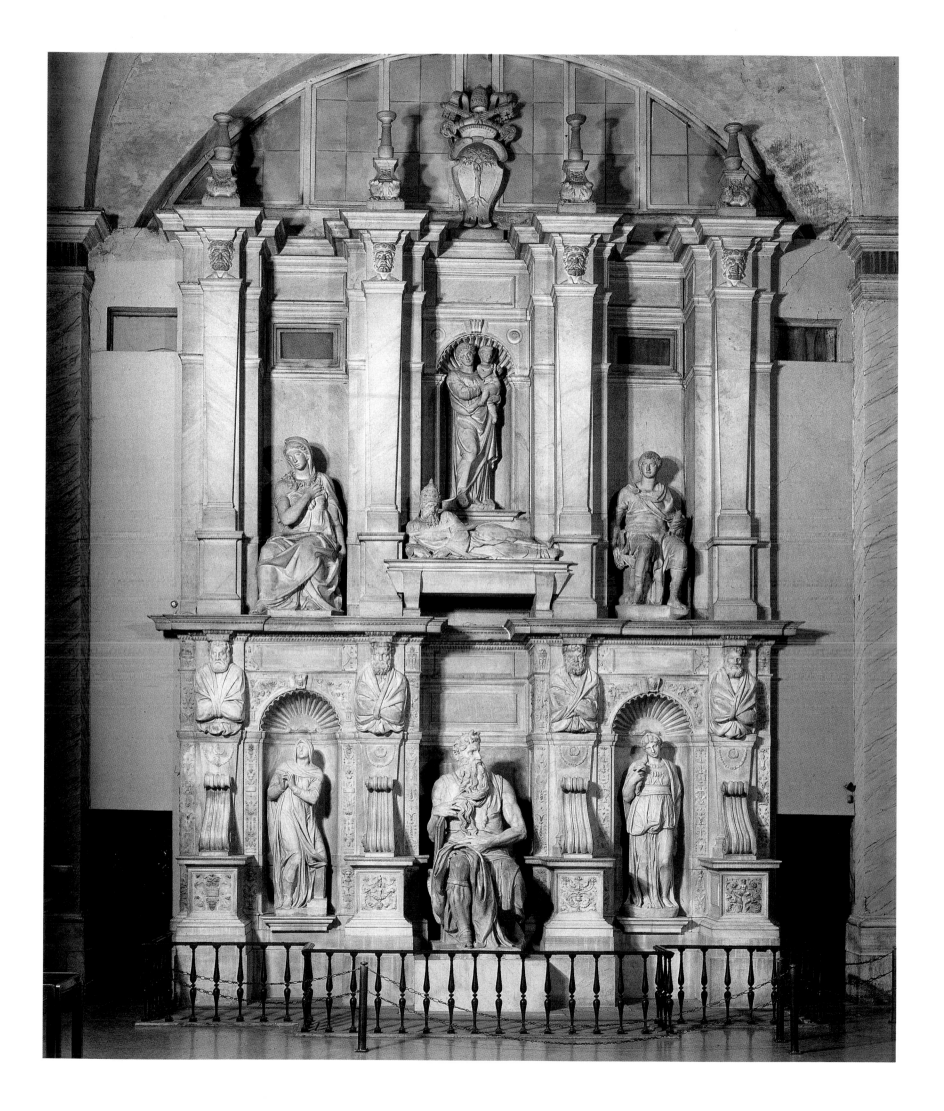

Three compositions were created altogether for the pious poetess: *Christ and the Samaritan woman* (only known from painted copies), a *Crucified Christ* (British Museum, London – not accepted by all experts as authentic) and a *Pietà* (ill. 105). Arrangements must have been made within Michelangelo's workshop to bring copies of such drawings, which might also have served as templates for paintings in the studio, into circulation. The *Pietà* in particular enjoyed great popularity among fellow artists; Giulio Bonasona made an engraving of it. Condivi described an unusually formed cross, whose shape no longer appears on the drawing kept in Boston, as a particularly important component of the composition. The sheet was clearly trimmed. Thus it is no longer clear that Michelangelo

depicted a forked cross like the plague crosses in conscious use of the medieval tradition.

Mary raises her arms towards heaven in sorrow without reference to her dead son on her lap. Two angels hold Christ's arms and elbows so that they point downwards in the same way that Mary's arms point upwards. Christ lies horizontally between the legs of his mother; in order to ensure that the legs are bent, the cross must stand on a clod of earth higher than the usual level. That this is a highly unusual arrangement for a *Pietà* is made clear by an earlier group sculpture in St Peter's (ill. 12). Specialists like to see in the version for Vittoria Colonna a copy of the depiction of the Trinity in the so-called *God the Father Pietà* as it was common north of the Alps.

104, 105 *Pietà* for Vittoria Colonna (and detail), 1538–1540
Black chalk on paper, 29.5 x 19.5
Isabella Stuart Gardner Museum, Boston

The artist's acquaintance with Vittoria Colonna had a profound impact on him. His resultant identification with the Catholic Reform was manifested in the religious subject matter of his work. Michelangelo created this *Pietà*, a *Crucified Christ*, and, according to Vasari, an oil painting *Christ and the Samaritan*. The words from Dante's "Divine Comedy" are written on the upright of the Cross, "Non vi si pensa quanto sangue costa" (Man does not know the value of blood).

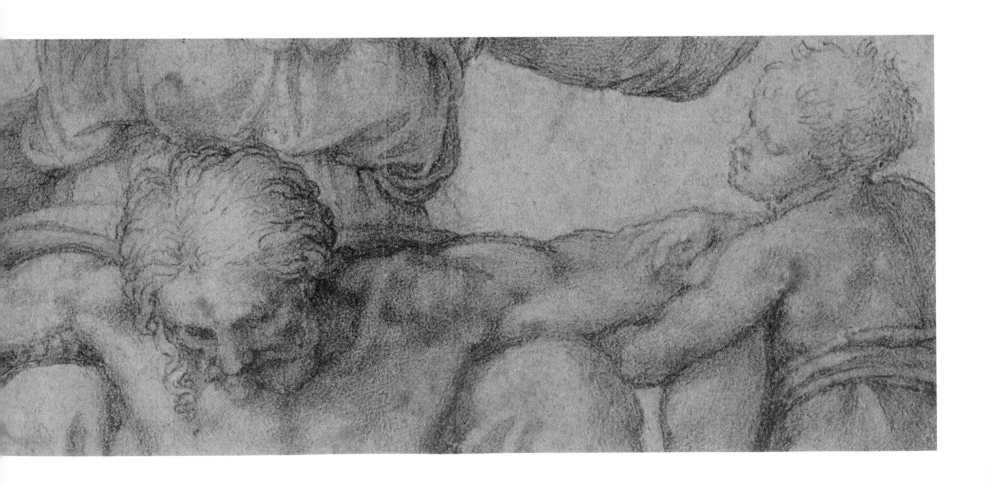

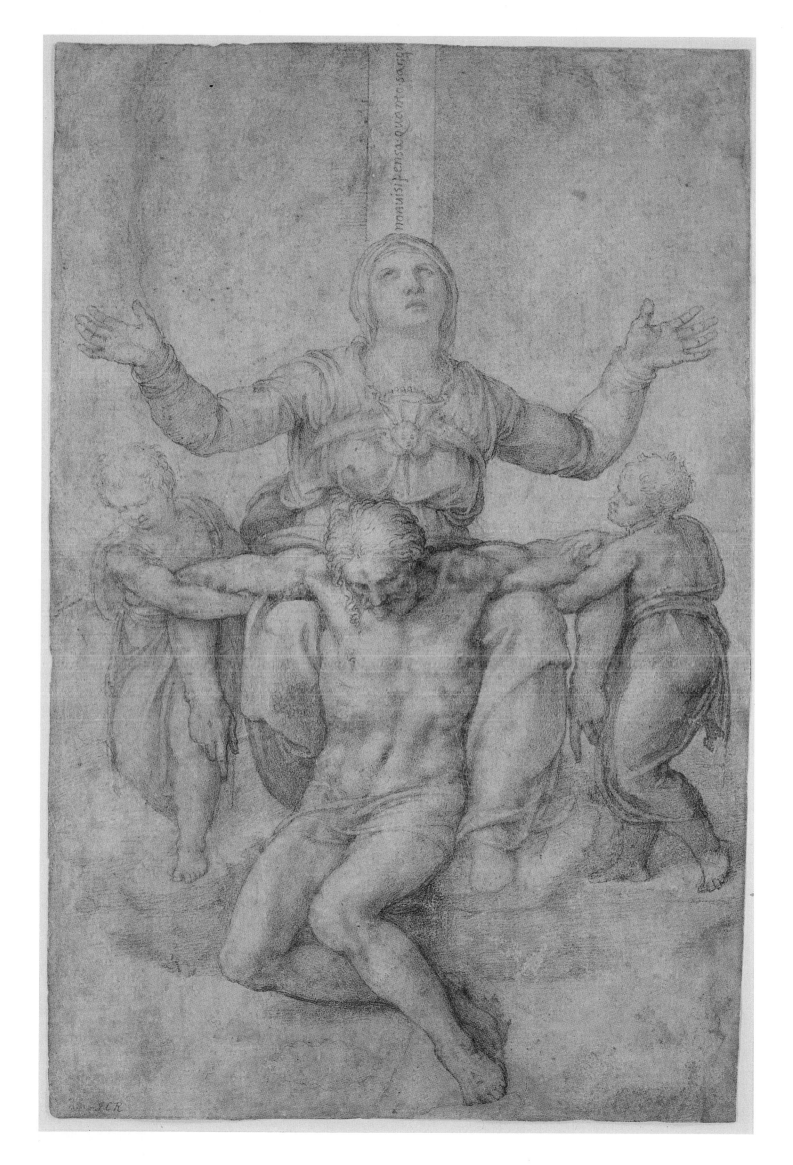

THE CAPPELLA PAOLINA AND THE CONSTRUCTION OF ST PETER'S

106 Apse of St Peter's
San Pietro in Vaticano, Rome

Michelangelo's greatest construction task in the non-secular domain was the rebuilding of St Peter's. Plans had already been drawn up by many important architects: after the death of Bramante (ca. 1444–1514), Raphael took over (1483–1520) and was himself succeeded by Antonio da Sangallo the Younger. (1485–1546). After his death, construction was entrusted to Michelangelo. The west side was built under his supervision, but the breathtaking structure of the exterior can only be seen from the Vatican gardens and is therefore not for general view.

Like the frescoes in the Sistine Chapel (ills. 33–48), the paintings for Paul III were executed reluctantly. After all, for the whole of his life Michelangelo considered himself to be a sculptor; he signed many of his contracts "Michelangelo scultore". Once he had been appointed building supervisor for St Peter's, which, curiously, only happened eleven years after he had been appointed "First sculptor, painter and architect to the Vatican", he proudly called himself an architect. The construction of the Cappella Paolina under the supervision of Antonio da Sangallo the Younger (1485–1546) became necessary because the sacramental chapel had fallen victim to the construction of the Sala Regia and the steps to the Cortile del Maresciallo. The room was originally lit by two large semi-circular windows of which one was walled up in 1609 by Carlo Maderna (1556–1629) when St Peter's was enlarged by the addition of a nave.

The middle fields of the side walls, divided by pilasters, contain the frescoes (ill. 107, 108). These last paintings represented a great deal of effort for an artist who was 75 years old on their completion. Strangely isolated, Saul lies like a classical river god in the middle of the circular composition (ill.107) from which the soldiers are fearfully moving away. The conversion of the apostle is depicted as an intimate imaginary dialogue with Christ floating above him. Only a bystander gently supports the man who has sunk to the ground.

Yet the reaction of the bystanders to the events plays an important role in both compositions. In the *Conversion of St Paul* it is the dispersal at the bottom and the concentration towards the center at the top, while in the *Crucifixion of St Peter* it is a woman looking out from the lower edge which challenges the observer to look. In the same way as with the *Last Judgement* (ill. 93), the picture space represents a section of an infinite panorama. It is uncertain whether there was a change of plan before the *Crucifixion of Saint Peter* (ill. 108) was started, for the counterpart of the *Conversion of St Paul* should actually be the "presentation of the keys" to St Peter.

But this composition led to an interesting development. Michelangelo da Caravaggio (1571–1610), who also had to juxtapose the conversion of St. Paul with the crucifixion of St. Peter for the Cerasi chapel in S. Maria del Popolo, harked back in the first version of his *Conversion* to the composition of his Florentine namesake: He too has St. Paul covering his eyes, which see God under closed eyelids, with his hands. Caravaggio restricts himself to the main group, and although his *Crucifixion of St. Peter* shows the raising of the cross in reverse, it is tempting to see Michelangelo's conception in his apostle.

An enlargement of the venerable St Peter's was considered for the first time under Nicholas V, but key parts of the old church were to be preserved. The foundation stone for the new building was laid on 18 April 1506 under the architect Donato Bramante. It must have been a great comfort to Michelangelo after his life as an outsider that he was appointed the building superintendent when, as a 72-year-old, his strength was on the wane and he was no longer able to wield hammer and chisel or to paint large walls at speed *al fresco*. For he had really been in dispute with all his predecessors, including Bramante, whom he thought wanted to ruin him at the time that he was painting the ceiling of the Sistine Chapel, and Sangallo, from whom he became alienated after a violent dispute. After an initial reluctance for reasons of modesty, he finally devoted himself to the task with energy because as an artist he felt superior to the professional architects of the building lodge. This building represented the culmination of all the dreams of the Roman Renaissance. Julius II wanted to realize himself in the building, it was to contain his unique tomb which was, however, simply embarrassing in the form in which it was finally completed (ill. 103).

Above all, however, the key question presented itself with St Peter's which had also been the focus of Michelangelo's art. Once again it was the question of the colossal dimension in an unprecedented task: the construction was immeasurably large and not based

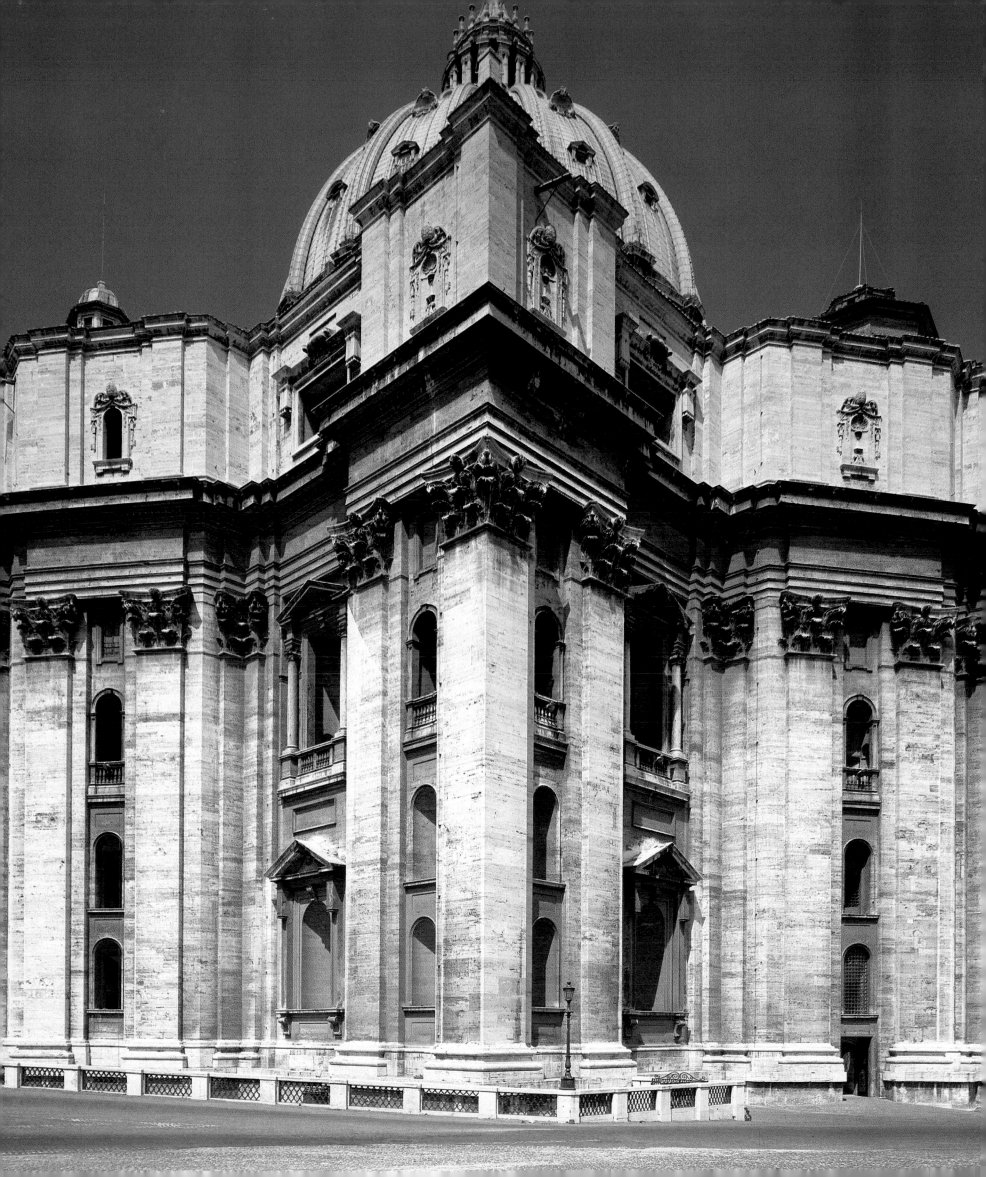

107 *Conversion of Saint Paul*, ca. 1542–1545
Fresco, 625 x 661 cm
Vaticano, Palazzi Vaticani, Cappella Paolina, Rome

When he was still called Saul, Paul initially encountered
Christianity as a cruel persecutor. He was stopped by
Christ on the road to Damascus. Thrown from his horse,
the army leader was then asked why he was persecuting
him. This fresco afforded Michelangelo the opportunity
of painting mass scenes with soldiers, the only one of its
kind to have survived. It is said that Michelangelo's own
features can be seen in the face of the Apostle, as if it was
the artist's wish to depict his own religious conversion.

108 *Crucifixion of Saint Peter*, ca. 1545–1550
Fresco, 625 x 662 cm
Vaticano, Palazzi Vaticani, Cappella Paolina, Rome

Here, we see Michelangelo's habitual lack of interest in
ornamenting his paintings with detailed landscapes.
While at the same time the depiction of a town was
necessary for the *Conversion of Saint Paul*, since the future
Apostle was on the road to Damascus, the *Crucifixion of
Saint Peter* takes place in barren surroundings. The horses
required by iconographic tradition are the only animals to
take a prominent place in Michelangelo's painting.

109 (left) *The Conversion of Saint Paul:* Christ (detail ill. 107), 1542–1545

Although ringed by many angels without wings, yet clearly separated from them in his aureole, Christ turns to Saul. With his left hand he points to the city of Damascus on the horizon.

on any pattern from the Middle Ages or the early Renaissance. Starting from Bramante's design of 1506, which proposed a purely centrally-planned building like his *Tempietto*, the basilica form had been abandoned in favor of what was considered the more ideal circular form. As long as Michelangelo was responsible for St Peter's, no one could guess that this project too would turn into a basilica in the following century. Today, still dominating the building, a mighty dome covers the grave of St Peter, but leading up to it a basilica with a nave and two aisles was built in the early 17th century.

After the death of Sangallo (1485–1546), Michelangelo succeeded in cleaning up the constantly changing plans of his predecessors, stopping construction of the internal gallery and creating additional sources of light (ill. 106). If a short time before Sangallo's model appeared to have represented the final basis for further progress, Michelangelo's changes led to resistance and disputes with the architects involved, whom Michelangelo described as the *Setta Sangallesca* ("Sangallo clique"). For this reason, Paul III wrote a papal brief in October 1549 giving the artist and architect sole responsibility for the building plans.

But now the dome and the mighty foundations for it had to be built (ills. 112–115), and here Bramante's basic conception had to be adhered to. That also meant for Michelangelo that he had to measure himself against the great models from his own city: Filippo Brunelleschi

had taken the first step in the direction of new daring techniques which had not been tried in this form since Antiquity. But the master of the early Renaissance still used vault sections which could not hide their origin in Gothic sectional construction both internally and externally. The task was to overcome this division of the overall structure and at the same time to pursue an ideal geometry which preferred the circle and all correspondingly precise forms. This brought Michelangelo into conflict with the statics, so that his plans for the mightiest dome ever could not be followed by the architects, Giacomo della Porta (ca. 1537–1602) and Domenico Fontana (1543–1607), who were finally entrusted with its execution. They had to make the classical circular form more pointed in the years from 1588–1590 and design a higher lantern.

111 (opposite) Porta Pia, 1561
Rome

In 1561, Pius IV commissioned the artist to create a majestic entry for the Via Nomentana as it enters the Eternal City from the north. Although the edifice we see today does not completely correspond to the artist's intention, this monument provides the one physical example of an aspect of the artist which otherwise all but exclusively existed on paper: Michelangelo saw his task in a universal framework which included giving a city its face.

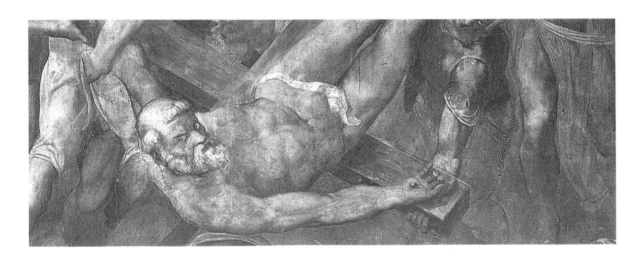

110 *Crucifixion of Saint Peter:* Peter (detail ill. 108), 1542–1545

With an almost defiantly challenging look, the apostle Peter turns towards and looks at the observer. Peter had demanded to be crucified upside down since he was not worthy of the death which Christ had suffered.

113 (opposite) Dome of St. Peter's, 1546–1564
San Pietro in Vaticano, Rome

Michelangelo certainly had the wonderful external effect
of the Dome of Florence Cathedral in mind as he
designed this dome, conceiving its outside view to the last
detail. He was also able to follow its construction from
1554–1557 until the drum was in place. Its entire
conception is only documented by the 1569 engraving by
Etienne Dupérac. It was only after the artist's death that
the dome was elongated, a total of 8–9 m being added to
its height, with the result that it could be seen from far
off. It was completed by Giacomo della Porta (ca.
1537–1602) and Domenico Fontana (1543–1607) in
1588–1590.

112 (above) Wooden model of dome of St Peter's,
ca. 1561
Lime wood, Tempera, 500 x 400 x 200 cm
San Pietro in Vaticano, Rome

In keeping with his conviction that architecture must
originate from sculpture and painting, Michelangelo
initially produced a clay model in order to test the
plasticity afforded by his architectural creation.
Subsequently, this wooden model was made by a
carpenter. Alterations were made to the model in the
course of the century, probably by Giacomo della Porta
(ca. 1537–1602), who modified the external structure,
and by Luigi Vanvitelli (1700–1773), who carefully
copied damage encountered by the real dome onto the
model.

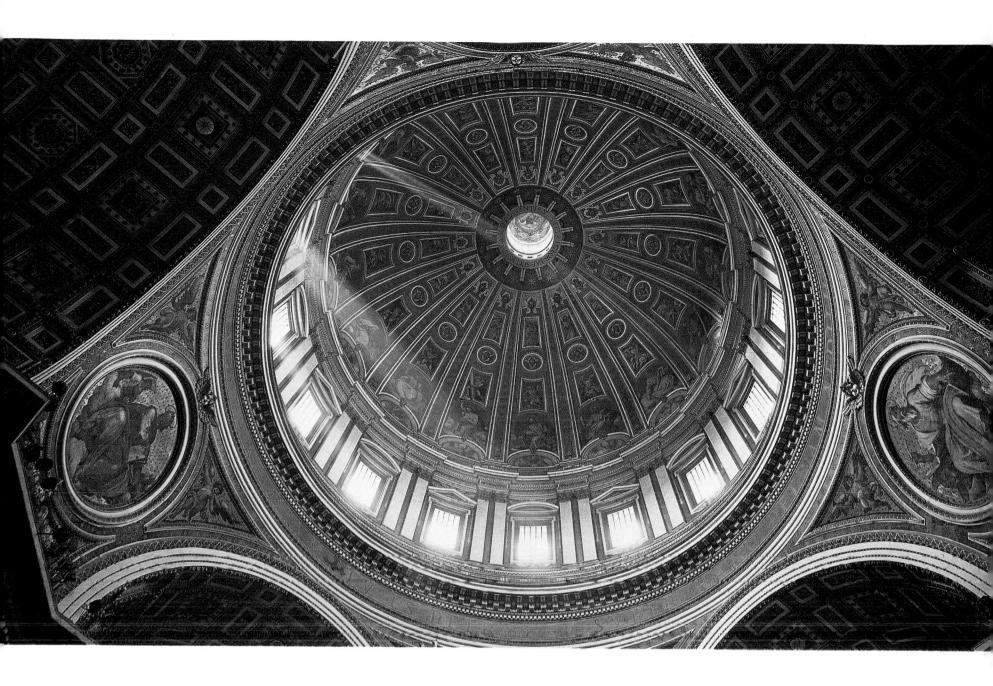

114 (opposite) Dome
San Pietro in Vaticano, Rome

The huge twin columns in front of the pilasters reaching
out to either side mark the outer casing of the drum and
direct the gaze along the right-angled entablature and
attica to the dome's ribs. A harmonious balance is
achieved in the relationship between weight and support.
Great advances were made in construction in the years of
Michelangelo's supervision of the project of rebuilding St
Peter's. One of the principal reasons for this was there
were now sufficient resources available thanks to the
Spanish gold obtained in America. It is not certain if
Michelangelo was responsible for the erection of the
smaller side domes. They were incorporated in the present
construction of Giacomo della Porta (ca. 1537–1602)
following the design of the principal dome.

115 (above) Interior of Dome
San Pietro in Vaticano, Rome

The diameter of the Dome (41.5 m) was designed to
match the diameter of the 42.7 m of the Pantheon.
Michelangelo monitored construction personally as far as
the wall frieze of the drum with the twin pilasters. Sixteen
ribs were to extend from the pilasters to support the
dome. The intermediate chambers tapering upwards are
filled with alternating rectangles and tondi. The
overwhelming height has not lost any of its power to
impress even today. This effect was not necessarily
reinforced by the mosaics inspired by the 1605 drawings
of the Cavalier d'Arpino.

LAST WORKS OF THE PASSION

116 *Pietà*, started before 1550
Marble, h. 226 cm
Museo dell'Opera del Duomo, Florence

Without being commissioned to do so, Michelangelo worked on depictions of the *Pietà*. In a moment of despair, the artist struck off the left arm and leg of Christ. His pupil, Tiberio Calcagni (1532–1565) continued the work, completed Mary Magdalene, restored the missing arm and prepared a replacement for the leg, as shown by the groove on the base. After Calcagni's death, work was never resumed on the group. Michelangelo gave it to his servant Antonio in 1561.

117 (following double page, left) *Crucified Christ with Mary and John*, 1545–1550
Black chalk and white paint used for corrective purposes, 41.3 x 28.6 cm
British Museum (Wilde 81), London

This drawing comes from a series in which Michelangelo towards the end of his life sought to depict the Crucified Christ. They might have been viewed as a preparation of a sculpture. The position of the Crucified Christ's head is not yet clear and the other figures (presumably Mary and John) only appear in a rough state as they are stricken with grief.

118 (following double page, right) *Crucified Christ between Mary and John*, 1545–1550
Black chalk and white paint, used for corrective purposes, 41.2 x 27.9 cm
British Museum (Wilde 82), London

The unclothed figure clings to the dead Christ, apparently seeking protection, while the male figure on the left looks upwards with an expansive gesture of grief. Like ill. 117, this drawing bears witness to Michelangelo's mystical search for God undertaken in his advanced years.

At the end of his long life, Michelangelo concentrated almost exclusively on the dead Christ. The subject of the dead Christ on the cross, and even more so the lament of Mary, the *Pietà*, fascinated his artistic imagination. In the end it is difficult to decide whether Michelangelo's life has influenced us so strongly in its legendary features that thoughts of death expressed in this way do not surprise us a great deal. Since he appears to have carried out all these works without being commissioned to do so, they can be taken as evidence of the spirituality of the artist.

Although Michelangelo was one of the first after Andrea Mantegna in Mantua (1430/31–1506) to plan his own tomb, it has become part of our idea of the life of the genius that such an endeavor should end in tragedy. Michelangelo had planned to use the *Pietà* (ill. 116), which is kept today in the museum of Florence Cathedral, for his grave in S. Maria Maggiore in Rome. The figure of Nicodemus is considered to be a self-portrait of the artist (ill. 116) who, by identifying himself in this way on his own tomb, saw himself as helping to take Christ from the cross and assisting in His entombment. Another dimension is added if the wish for intimate closeness to the Redeemer is seen as being founded in the latter waiting for his grave on that of the artist.

The idea of the Man of Sorrows merges in this monumental composition with the station of Christ being taken from the cross. As in the drawing for Vittoria Colonna, Christ's body is arranged vertically, with Mary and Mary Magdalene almost assuming the roles of the angels in the former (ill. 105). Mary Magdalene, completed by Calcagni, spoils the effect of the group as a whole by her smaller proportions and polished finish since the unfinished surface fits the subject particularly well. Michelangelo himself vented his anger on the work by knocking off Christ's left leg. It is difficult to imagine how it would have rested on Mary's thigh so that in this respect too its unfinished, indeed fragmentary state supports the statement which it makes.

If one thinks of the *Pietà* by the twenty-three-year-old in St. Peter's (ills. 12, 18), it is noticeable how much the idea of the Mother of God has changed in his artistic

thinking. The ideally beautiful, still youthful woman in quiet sorrow has turned into a loving mother marked by pain (ill. 116). But the group was rejected; flaws in the marble and irritation about the position of the dead Christ drove Michelangelo not only to knock off the leg, but also the left arm. Since adding pieces to sculptures was out of the question for him, he gave the unfinished block which was to decorate his grave as a present to his servant, according to Vasari.

A series of drawings dealing with the crucified Christ disengage themselves from the tradition of iconographic representation. Contrary to the convention of the time, Michelangelo harks back with this forked cross to the medieval *crucifix dolorosi* (ill. 117), that is the expressive pain-filled cross, as previously with the *Pietà* for Vittoria Colonna (ill. 105). The supplementary figures, which must be Mary and St. John, are very far removed from traditional iconographic representation. Their movements express pain and horror as human temporal feelings and yet they are removed from time. It is not only mourning for the sacrifice made by the Son of Man which is being reformulated, the aspect of comfort protected in child-like trust through redemption is presented in a deeply shocking and moving way (ill. 118).

As in the *Pietà* in the Cathedral (ill. 116), Christ in the *Palestrina Pietà* still has the band with which he was lowered from the cross about his chest (ill. 120). The artist's obsession with the body is clearly evident in the section of the unfinished sculpture between the band and the loin cloth, Mary's right hand projects powerfully. Here the proportions become curiously unbalanced. Christ's legs, much too thin and angled to the right, almost grow back into the block (ill. 119).

The vertical order of the figures already played a role in the drawing for Vittoria Colonna (ill. 105); it is, however, counterbalanced horizontally by the angled arms which are mirrored as if around an axis. The *Pietà Rondanini* takes up this idea (ill. 121) and takes it to its conclusion. Mary stands on a stone in order to be able to hold the long body of her dead son (ill. 122) who leans against her at a slight angle. As with the late drawings, Michelangelo makes use of medieval patterns, and awakens associations with the pictures of the God the

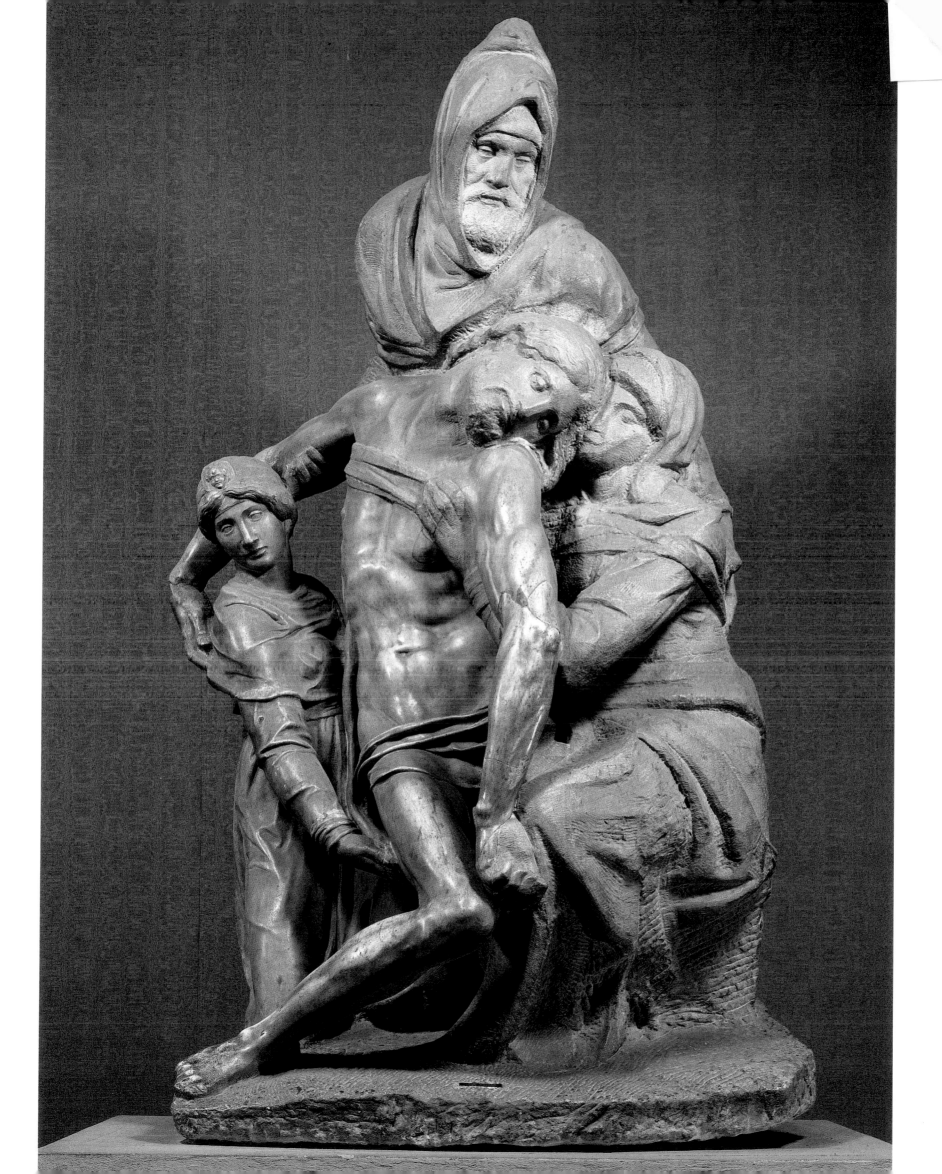

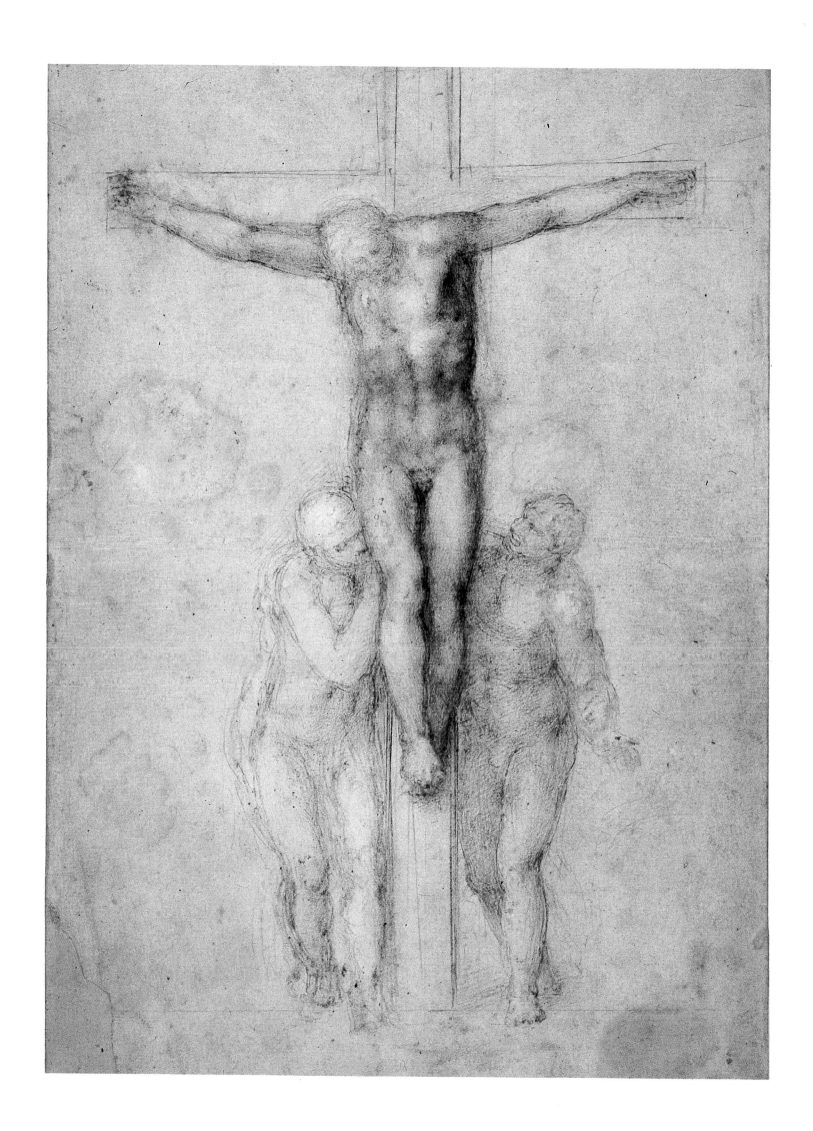

Father Pietà from north of the Alps such as those by the Master of Flémalle.

Clearly a fragment from a powerfully formed smashed version, there was insufficient stone to complete the changes in the block with the erratically rising stump of Christ's muscular right arm, so that the work process remained visible as a constant wrestling for expression. Turning his back radically on the basic idea of using the body pictorially, mother and son melt into a symbol of helplessness which is neutralized by inner love.

The unfinished work of art of the *Pietà Rondanini*, which Michelangelo was working on in the final days of his life, shows his passionate endeavor for perfection at the end of a richly creative life. It should not be understood as an end in itself, however, but represents for posterity an important element of a truly artistic spirit. Only Michelangelo's exceptional position as an artist allowed such an astonishing marble block to be preserved.

On 18 February 1564, Michelangelo Buonarroti died in Rome at the age of almost 89 in the presence of Daniele da Volterra, Tommaso Cavalieri and Diomede Leoni and was buried on the following day in SS. Apostoli; it was the wish of the Pope that he should later be given a tomb in St. Peter's. But his final wish was fulfilled by his nephew Lionardo, who had the body of the artist secretly transported to his native city of Florence, wrapped in bales of cloth like a piece of merchandise. Michelangelo's "second escape to Florence" ended on 14 March at his eternal resting place in S. Croce, where he was given a rather banal tomb designed by Vasari.

119, 120 *Palestrina Pietà* (and detail), ca. 1555
Marble, h. 253 cm
Galleria dell'Accademia, Florence

The group of figures, named after the place they were originally kept is mentioned in a contemporary report. It remained incomplete and it is difficult to ascertain which secondary figure is depicted. The group was not sculpted from fresh marble but from a workpiece from a Roman architrave, as can still be seen clearly on the rear side.

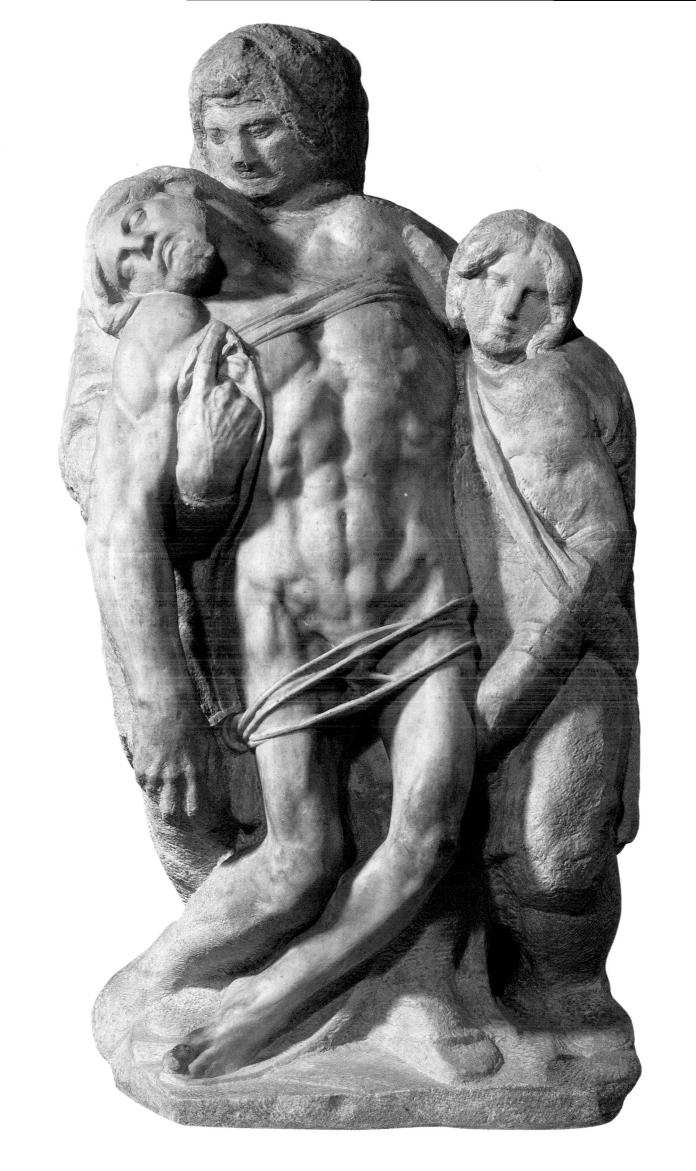

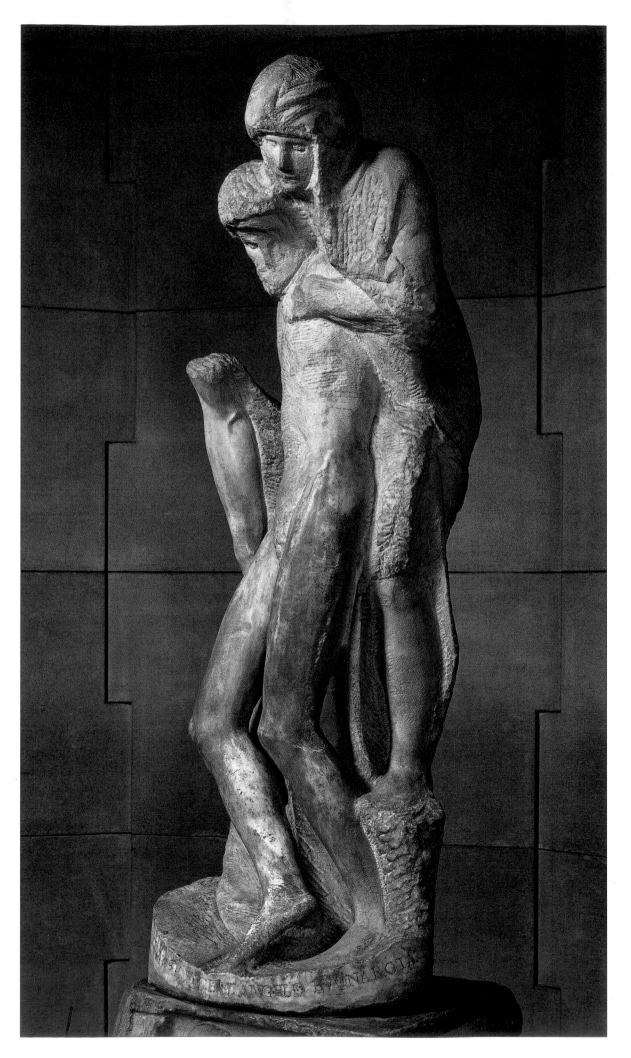

121, 122 *Rondanini Pietà* (and detail), 1552–1564
Marble, h. 195 cm
Museo del Castello Sforzesco, Milan

Probably started before the *Pietà* in Florence, the present
state demonstrates the extent to which the artist had
wrestled with the composition – the stationary, completed
and much more muscular right arm of Christ belongs to
an earlier version. The astonishing attempt of the Mother
of God to hold her dead son upright follows preliminary
stages completed in the northern Alps. It was an attempt
which forced the artist to make several corrections. The
group was supposed to stand beside the originally broader
form at a higher angle, as the still visible eye on Christ's
forehead indicates.
More so than all of the other late works, the sculpture was
intended for view from one perspective. However,
Michelangelo takes care to show that Mary is smaller than
her son and must therefore stand on a raised surface. He is
so engrossed in his inspiration that he takes the daring step
of breaking with all traditions of depicting Mary's dress
and robes her in a short garment. Her naked leg is shown
up to her knee, which was polished as early as the initial
stages, as was the overly long leg of Christ.

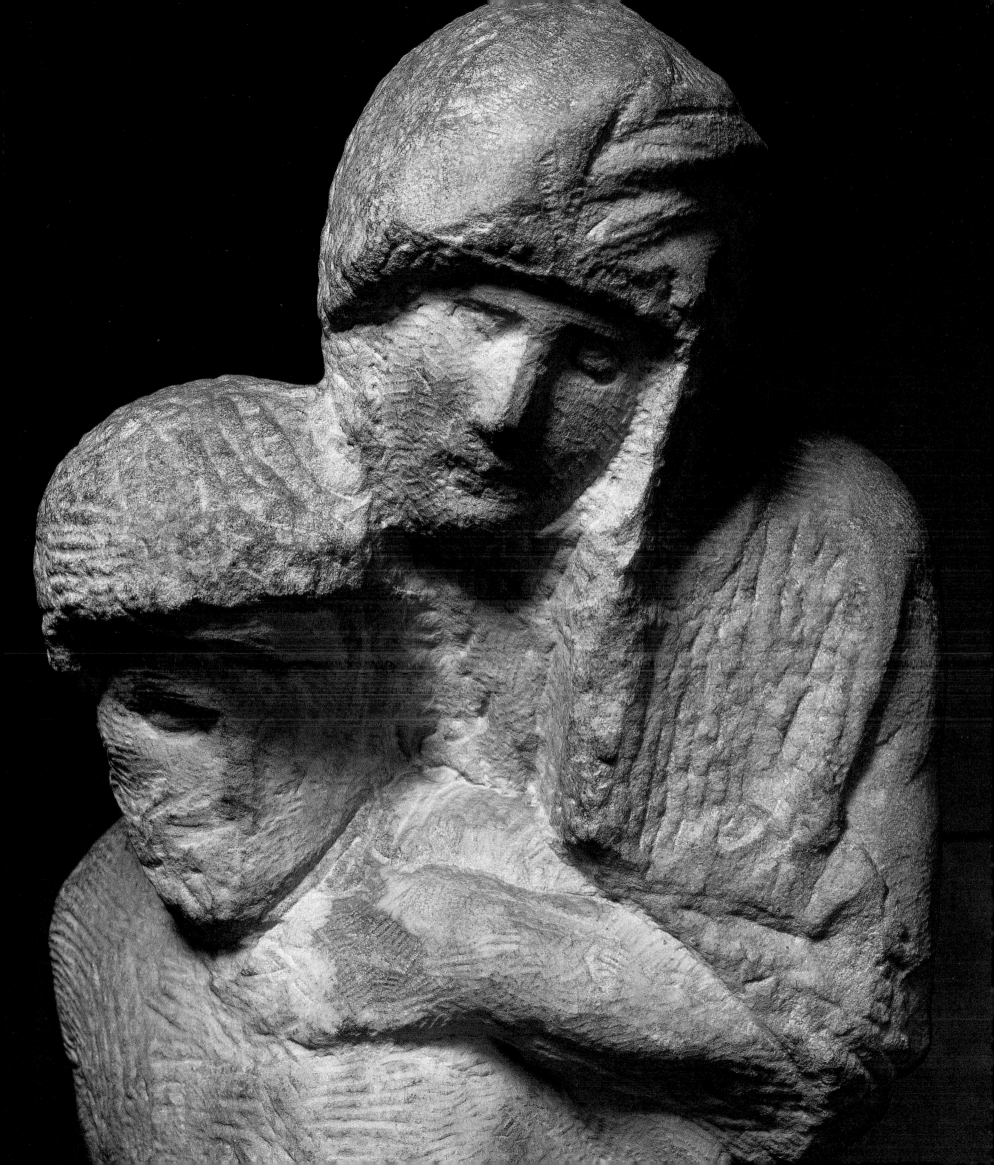

CHRONOLOGY

1475 6 March: born in Caprese near Sansepolcro.

1488 1 April: start of three-year apprenticeship with Domenico and David Ghirlandaio; at the end of the year (?) transfer to Bertoldo at the Medici gardens near San Marco.

1492 8 April: Lorenzo de' Medici dies.

1494 October: Michelangelo leaves Florence because of the imminent invasion by Charles VIII; he travels to Venice and Bologna.

1496 25 June: arrival in Rome.

1498 27 August: contract for the *Pietà* in St. Peter's.

1501 May (?): return to Florence. 16 August: contract for marble *David*.

1503 24 April: contract for statues of the twelve Apostles for Florence cathedral.

1504 March: the marble *David* is completed. November/December: start of work on full-size cartoon for the *Battle of Cascina*.

1505 Spring: Julius II calls on Michelangelo to return to Rome and commissions him to execute his tomb.

1506 17 April: secret return to Florence. End of November: summoned to Bologna by Pope to make a bronze statue of him.

1508 End of February: return to Florence. Spring: Called to Rome by the Pope and commissioned to paint the vault of the Sistine Chapel.

1510 Early September: half of frescoes completed, followed by a long break in the work.

1512 31 October: frescoes on the ceiling of the Sistine Chapel unveiled.

1513 21 February: Julius II dies. 11 March: election of Leo X. 6 May: new contract with the Pope's heirs for the tomb of Julius II.

1515 Leo X confers the title of "Count Palatine" on Michelangelo's family.

1516 8 July: third contract for Julius' tomb. Michelangelo returns to Florence. September: visit to Carrara to choose the marble for Julius' tomb. December: commission from Leo X to design the façade of San Lorenzo in Florence.

1520 10 March: responsibility for quarrying and supply of the marble for the façade of San Lorenzo is removed from Michelangelo. November: planning for the Medici Chapel starts.

1521 1 December: Leo X dies. The new Pope, Hadrian VI, does not employ the artist.

1523 19 November: election of Clement VII.

1524 January: intensive work on the Medici Chapel. Commission to build the library of San Lorenzo.

1527 6 May: Sack of Rome. 17 May: the Medici leave Florence.

1528 Autumn, to summer 1529: active part in the preparations for the defence of Florence against the Medici.

1529 10 January: Michelangelo is elected a member of the "Nove della Milizia" of the Republic of Florence.

1530 12 August: capitulation of the Republic of Florence and return of the Medici. October/November: work on the Medici Chapel.

1532 29 April: fourth contract for Julius' tomb. August: back in Rome. Michelangelo's friendship with Tommaso de Cavalieri begins at the end of the year.

1534 August/September (?): last stay in Florence. 25 September: Clement VII dies. 13 October: election of Paul III.

1536 November: start of work on the fresco of the *Last Judgement* in the Sistine Chapel.

1536 or end of 1538 His friendship with Vittoria Colonna begins.

1538 Planning for erection of *Marcus Aurelius* on the Campidoglio.

1541 31 October: fresco of the *Last Judgement* unveiled in the Sistine Chapel.

1542 20 August: fifth contract for Julius' tomb. Autumn: work starts on the Cappella Paolina.

1545 February: completion of Julius' tomb.

1546 October: takes on building supervision of St. Peter's and the Palazzo Farnese.

1547 25 February: Vittoria Colonna dies.

1549 10 November: Paul III dies; his successor Julius III keeps Michelangelo in all his offices, although he loses them temporarily in 1555 during the pontificate of Marcellus II.

1550 The frescoes in the Cappella Paolina are completed. The first edition of Vasari's "Vita" is published.

1564 21 January: The Council of Trent decides to have the *Last Judgement* partially repainted. 18 February: Michelangelo dies.

GLOSSARY

allegory (Gk. *allegorein*, "say differently"), a work of art which represents some abstract quality or idea, either by means of a single figure (personification) or by grouping objects and figures together. Renaissance allegories make frequent allusions both to both Greek and Roman legends and literature, and also to the wealth of Christian **allegorical** stories and symbols developed during the Middle Ages.

al fresco See **fresco**

al secco See **fresco**

Attic, in architecture or sculpture, in the style of ancient Athens; characterized by purity and simplicity.

attribute (Lat. *attributum*, "added"), a symbolic object which is conventionally used to identify a particular person, usually a saint. In the case of martyrs, it is usually the nature of their martyrdom.

baluster, one of the small posts that support a rail.

baptistery (Gk. *baptisterion*, "wash basin"), from the 4th to the 15th centuries, a small building, usually separate from the main church, in which baptisms were performed. They were often circular or hexagonal, and dedicated to St John the Baptist. A well-known example is the Baptistry of the Duomo, the cathedral of Florence.

Baroque (Port. *barocco*, "an irregular pearl or stone"), the period in art history from about 1600 to about 1750. In this sense the term covers a wide range of styles and artists. In painting and sculpture there were three main forms of Baroque: (1) sumptuous display, a style associated with the Catholic Counter Reformation and the absolutist courts of Europe (Bernini, Rubens); (2) dramatic realism (Caravaggio); and (3) everyday realism, a development seen in particular in Holland (Rembrandt, Vermeer). In architecture, there was an emphasis on expressiveness and grandeur, achieved through scale, the dramatic use of light and shadow, and increasingly elaborate decoration. In a more limited sense the term Baroque often refers to the first of these categories.

basilica (Gk. *basilike stoa*, "king's hall"), in Roman architecture a long colonnaded hall used as a court, a market or as a place for assemblies. The early Christians adopted this form of building for their churches, the first Christian basilicas being long halls with a nave flanked by colonnaded side aisles, and with an apse at the eastern end. With the addition of other features, in particular the transept, the basilica became the traditional Christian church.

bozzetto (It.), a small scale preparatory model of a sculpture.

candelabra, sing. **candelabrum** (It. *candela*, "candle"), a large, usually decorated, candlestick with several branches or arms.

capitani (It.) "captains" – here a reference to the sculpted figures of Lorenzo and Giuliano de' Medici, who in their funerary chapel in the church of San Lorenzo in Florence are presented as army leaders of classical Antiquity.

cartoon (It. *cartone*, "pasteboard"), a full-scale preparatory drawing for a painting, tapestry, or fresco. In fresco painting, the design was transferred to the wall by making small holes along the contour lines and then powdering them with charcoal in order to leave an outline on the surface to be painted.

Centaurs, in Greek mythology, creatures who were half horse, half man. In Renaissance art they were often seen as symbolic of the darker, passionate side of human nature, or of lawless barbarism. See **Lapiths**.

classical Antiquity, ancient Greece and Rome. The classical world played a profoundly important role in the Renaissance, with Italian scholars, writers, and artists seeing their own period as the rebirth (the "renaissance") of classical values after the Middle Ages. The classical world was considered the golden age for the arts, literature, philosophy, and politics. Concepts of the classical, however, changed greatly from one period to the next. Roman literature provided the starting point in the 14th century, scholars patiently finding, editing and translating a wide range of texts. In the 15th century Greek literature, philosophy and art – together with the close study of the remains of Roman buildings and sculptures – expanded the concept of the classical and ensured it remained a vital source of ideas and inspiration.

console, in classical architecture, an ornamental bracket carved (in profile) in an S-shape.

contrapposto (It. "placed opposite"), an asymmetrical pose in which the one part of the body is counter-balanced by another about the body's central axis. Ancient Greek sculptures developed contrapposto by creating figures who stand with their weight on one leg, the movement of the hips to one side being balanced by a counter movement of the torso. Contrapposto was revived during the Renaissance and frequently used by Mannerist artists, who developed a greater range of contrapposto poses.

cornice, in architecture, a projecting moulding that runs around the top of a building or the wall of room.

Council of Trent, a 16th-century council of the Roman Catholic Church convened to reform the Church, and in particular to develop measures to combat the spread of Protestantism. It set about clarifying doctrine and placed a new emphasis on teaching, missionary work, and the use of the arts in promoting the Church's message.

Counter Reformation, 16th- and 17th-century reform movement in the Roman Catholic Church. Prompted initially by internal criticism, it was given greater momentum by the emergence of Protestantism. The Counter Reformation led to a new emphasis on teaching, missionary work, and the suppression of heresy. In Catholic countries there was the deliberate cultivation of the arts in supporting the Church's message, with works both explicitly illustrating doctrine and also aiming to make a direct appeal to the emotions. Among the major artists of the Counter Reformation were Bernini, Rubens, and Caravaggio.

crucifixus dolorosus (Lat. "sorrowful crucifixion"), a depiction of the crucifixion that stresses the pain and anguish of Jesus (rather than the promise of salvation that is implicit in Jesus' sacrifice).

Deposition, in art, a representation of the body of Christ being taken down from the Cross.

diadem (Gr. *diadein*, "to bind") a crown or headband worn as a sign of royalty.

divinità and *terribilità* (It.) "divinity" and "terribleness" (awesomeness) the terms contemporaries used to describe the power, intensity, and spiritual profundity of Michelangelo's personality and art.

Dominicans (Lat. *Ordo Praedicatorum,* Order of Preachers), a Roman Catholic order of mendicant friars founded by St. Dominic in 1216 to spread the faith through preaching and teaching. The Dominicans were one of the most influential religious orders in the later Middle Ages, their intellectual authority being established by such figures as Albertus Magnus and St. Thomas Aquinas. The Dominicans played the leading role in the Inquisition.

drum, in architecture, a cylindrical wall, sometimes pierced by windows, supporting a dome.

entablature, in classical architecture, the part of a building between the capitals of the columns and the roof. It consists of the architrave, the frieze, and the cornice.

fresco (It. "fresh"), wall painting technique in which pigments are applied to wet (fresh) plaster (*intonaco*). To paint in this way is to paint *al fresco.* The pigments bind with the drying plaster to form a very durable image. Only a small area can be painted in a day, and these areas (known as *giornata*), drying to a slightly different tint, can in time be seen when the paint has completely dried. Small amounts of retouching and detail work could be carried out on the dry plaster, a technique known as *al secco* (dry) painting.

genii sing. **genius** (Lat.), in Roman mythology, a guardian spirit given to a person at birth; a protective spirit. In Renaissance art they are usually portrayed as child-like figures with wings.

genre painting, the depiction of scenes from everyday life. Elements of everyday life had long had a role in religious works; pictures in which such elements were the subject of a painting developed in the 16th century with such artists as Pieter Bruegel. Carracci and Caravaggio developed genre painting in Italy, but it was in Holland in the 17th century that it became an independent form with its own major achievements, Vermeer being one of its finest exponents.

gnostic (Gk. *gnosis*, "knowledge"), pertaining to a body of secret doctrines on mystical or spiritual knowledge.

gonfalonier (It. "standard bearer"), a high office in the government of several Italian Renaissance republics, notably that of Florence.

Gothic (Ital. *gotico*, "barbaric, not classical"), the style of European art and architecture during the Middle Ages, following Romanesque and preceding the Renaissance. Originating in northern France about 1150, the Gothic style gradually spread to England, Spain, Germany and Italy. In Italy Gothic art came to an end as early as 1400, whilst elsewhere it continued until the 16th century. The cathedral is the crowning achievement of Gothic architecture, its hallmarks being the pointed arch (as opposed to the Romanesque round arch), the ribbed vault, large windows, and exterior flying buttresses. The development of Gothic sculpture was made possible by Gothic architecture, most sculptures being an integral part of church architecture.

Great Schism (Gk. "separation, split"), a split in the Roman Catholic Church, 1378–1417, when there were two lines of papal succession, one in Rome and one (of the so-called antipopes) in Avignon in France.

humanism, an intellectual movement that began in Italy in the 14th century. Based on the rediscovery of the classical world, it replaced the medieval view of humanity as fundamentally sinful and weak with a new and confident emphasis on humanity's innate moral dignity and intellectual and creative potential. A new attitude to the world rather than a set of specific ideas, humanism was reflected in literature and the arts, in scholarship and philosophy, and in the birth of modern science.

iconography (Gk. "description of images"), the systematic study and identification of the subject-matter and symbolism of art works, as opposed to their style; the set of symbolic forms on which a given work is based. Originally, the study and identification of classical portraits. Renaissance art drew heavily on two **iconographical** traditions: Christianity, and ancient Greek and Roman art, thought and literature.

ignudi, sing. *ignudo* (It.), male nudes. The best-known are the male nudes on Michelangelo's Sistine ceiling.

lantern (Lat. *lanterna*, "lamp"), in architecture, a small turret that sits at the top of a dome or roof. Fitted with windows or openings, the lantern provides light to the space below.

Lapiths, in Greeks mythology, a mythical race inhabiting the mountains of Thessaly. They are best known for their battle with the Centaurs, a familiar theme in Greek art. Both in Greek and Renaissance art, the battle between the Centaurs and the Lapiths was seen as a battle between barbarism and human nature's darker side on the one hand (the Centaurs), and civilization and rationality (the Lapiths, ie the Greeks) on the other. The leader of the Lapiths was **Peirithous**. See: **Centaurs**.

Libyan Sibyl, the classical Sibyl (prophetess) who was thought to have predicted the coming of Christianity.

lunette (Fr. "little moon"), in architecture, a semicircular space, such as that over a door or window or in a vaulted roof, that may contain a window, painting or sculptural decoration.

Magnifici (It.) the "magnificent ones," that is, Lorenzo and Giuliano de' Medici.

Mannerism (It. *maniera*, "manner, style"), a movement in Italian art from about 1520 to 1600. Developing out of the Renaissance (and in particular the late works of Michelangelo and Raphael), Mannerism rejected Renaissance balance and harmony in favor of emotional intensity and ambiguity. In **Mannerist** painting, this was expressed mainly through severe distortions of perspective and scale; complex and crowded compositions; strong, sometimes harsh or discordant colors; and elongated figures in exaggerated poses. In architecture, there was a playful exaggeration of Renaissance forms (largely in scale and proportion) and the greater use of bizarre decoration. Mannerism gave way to the Baroque. Leading Mannerists include Pontormo, Bronzino, Parmigianino, El Greco and Tintoretto.

Mater Dolorosa (Lat. Mother of Sorrows), a depiction of the Virgin Mary lamenting Christ's torment and crucifixion. There are several forms: she can be shown with her heart pierced by a sword; witnessing Christ's ascent of Calvary; standing at the foot of the Cross; watching as the body of Christ is brought down from the Cross (**Deposition**); or sitting with His body across her lap (**Pietà**).

medallion, in architecture, a large ornamental plaque or disc set into a wall.

nave (Lat, *navis*, "ship"), the central part of a church stretching from the main doorway to the chancel and usually flanked by aisles.

non finito (It. "not finished"), of a work of art, deliberately left unfinished in order to heighten expressiveness.

oil paint, a painting medium in which pigments are mixed with drying oils, such as linseed, walnut or poppy. Though oils had been used in the Middle Ages, it was not until the van Eyck brothers in the early 15th century that the medium became fully developed. It reached Italy during the 1460s and by the end of the century had largely replaced tempera. It was preferred for its brilliance of detail, its richness of color, and its greater tonal range.

Palazzo Vecchio (It. "old palace") the city hall in Florence, seat of the city's government.

Peirithous. See: **Lapiths**

pendentive, a curving and concave triangular section of vaulting linking a dome to the square base on which it rests.

Pietà (Lat. [*Maria Santissima della*] *Pietà*, "Most Holy Mary of Pity"), a depiction of the Virgin Mary with the crucified body of Jesus across her lap. Developing in Germany in the 14th century, the Pietà became a familiar part of Renaissance religious imagery. One of the best-known examples is Michelangelo's *Pietà* (1497–1500) in St. Peter's, Rome.

pietra serena, a clear gray limestone that is a distinctive feature of architecture in Florence.

pilaster (Lat. *pilastrum*, "pillar"), a rectangular column set into a wall, usually as a decorative feature.

plasticity (Gk. *plastikos*, "able to be molded, malleable"), in painting, the apparent three-dimensionality of objects, a sculptural fullness of form.

putti sing. **putto** (It. "boys"), plump naked little children, usually boys, most commonly found in late Renaissance and Baroque works. They can be either sacred (angels) or secular (the attendants of Venus).

relief (Lat. *relevare*, "to raise"), a sculptural work in which all or part projects from the flat surface. There are three basic forms: low relief (*bas-relief, basso rilievo*), in which figures project less than half their depth from the background; medium relief (*mezzo rilievo*), in which figures are seen half round; and high

relief (*alto rilievo*), in which figures are almost detached from their background. See: *rilievo schiacciato*.

rilievo schiacciato, or *stiacciato* (It. "flattened relief"), form of sculptural relief developed by Donatello (1386–1466). It is a very low relief, almost two-dimensional, that allows the sculptor to create effects (particularly spatial effects) similar to those in painting.

rinascità (It.), rebirth. The idea of rebirth was central to the Renaissance, with scholars, artists, and political figures seeing their era as the *rinascità* of classical ideals.

sarcophagus, pl. **sarcophagi** (Gk. "flesh eating"), a coffin or tomb, made of stone, wood or terracotta, and sometimes (especially among the Greeks and Romans) carved with inscriptions and reliefs.

sepulcher (Lat. *sepelire*, "to bury") a burial vault or tomb, especially one cut into rock or made out of stone.

Sibyl of Cumae, in the ancient Roman world, a priestess of Apollo who could predict the future. Jewish and Christian additions were later made to the books of Sibylline prophecies, and the Sibyl of Cumae was widely seen as having foretold the coming of Christ. She is depicted, for example, on Michelangelo's Sistine Ceiling.

silverpoint, a method of drawing using a thin pointed rod of silver, on parchment or paper that has been coated with an opaque white ground. Silverpoint produced a fine, grayish line. Popular throughout the Renaissance, it began to be replaced by graphite pencil in 17th century.

spandrel, (1) a triangular wall area between two arches and the cornice or molding above them, or between the curve of an arch and the rectangular frameworks around it (for example at the top of an arched doorway; (2) a curved triangular area between the ribs in a vault.

stucco (It.), a protective coat of coarse plaster applied to external walls; plaster decorations, usually interior. During the Renaissance stucco decorative work. often employing classical motifs, achieved a high degree of artistry.

tectonics (Gk. *tekton*, "carpenter, builder"), the underlying structure or design.

tondo, pl. **tondi** (It "round"), a circular painting or relief sculpture. The tondo derives from classical medallions and was used in the Renaissance as a compositional device for creating an ideal visual harmony. It was particularly popular in Florence and

was often used for depictions of the Madonna and Child.

transept, in church architecture, the two lateral arms that project from the nave to form the shape of a cross.

triumphal arch, in the architecture of ancient Rome, a large and usually free-standing ceremonial archway built to celebrate a military victory. Often decorated with architectural features and relief sculptures, they usually consisted of a large archway flanked by two smaller ones. The triumphal archway was revived during the Renaissance, though usually as a feature of a building rather than as an independent structure. In Renaissance painting they appear as allusion to classical antiquity.

vestibule (Lat. *vestibulum*, "entrance"), small entrance hall or antechamber.

vita activa/contemplativa (Lat.), a life of action, of direct involvement in the world/ a life devoted to contemplation (spiritual or intellectual).

volute (Lat. *voluta*), a scroll-shaped architectural ornament. It was first used on Ionic capitals, and reappeared during the Renaissance, when it was sometimes used to decorate a support for a pediment or the drum of a dome.

SELECTED BIBLIOGRAPHY

Ackerman, James S.: "Architectural Practice in the Italian Renaissance", in: Journal of the Society of Architectural Historians XIII, 1954, pp. 3–11.

Baldini, Umberto: L'Opera completa di Michelangelo scultore, Milan 1973.

Baldini, Umberto: The complete sculpture of Michelangelo, London 1982.

Condivi, Ascanio: The life of Michelangelo, Oxford 1976.

Dussler, Luitpold: Die Zeichnungen des Michelangelo, Kritischer Katalog, Berlin 1959.

Einem, Herbert von: Michelangelo, London 1976.

Einem, Herbert von: Michelangelo – Bildhauer, Maler, Baumeister, Berlin 1973.

Evers, Bernd (ed.): Architekturmodelle der Renaissance (Exhib. cat.), Munich/New York 1995.

Frey, Karl: Die Handzeichnungen des Michelangelo Buonarroti, Berlin 1897.

Frey, Karl: Die Dichtungen des Michelangelo Buonarroti, Berlin 1897.

Frommel: Christoph L., Michelangelo und Tommaso dei Cavalieri, Amsterdam 1979.

Hamann, Richard: Geschichte der Kunst, Berlin 1933.

Hartt, Frederick: Michelangelo: the complete sculpture, London 1969.

Hartt, Frederick: The drawings of Michelangelo, London 1971.

Hauchecorne, L'Abbé: Vie de Michel-Ange Buonarroti, peintre, sculpteur et architecte de Florence, Paris 1783.

Haussherr, Reiner: Michelangelos Kruzifixus für Vittoria Colonna, (Wissenschaftliche Abhandlungen an der Rheinisch-Westfälischen Akademie der Wissenschaften, Vol. 44) Opladen 1971.

Hibbard, Howard: Michelangelo – Painter, Sculptor, Architect, London 1979.

Justi, Carl: Michelangelo, Leipzig 1900 and Berlin 1909.

Lisner, Margit: "Michelangelos Kruzifixus aus S. Spirito, in Münchener Jahrbuch der Bildenden Kunst 3, XV, 1964, pp. 7–31.

Lomazzo, Giovanni Paolo: Trattato dell'Arte de la Pittura, Milan 1584.

Milanesi, Gaetano: Le lettere di Michelangelo Buonarroti publicate con ricordi e i contratti artistici, Florence 1875.

Murray, Linda: Michelangelo. His life, work and times, London 1984.

Quasimodo, Salvatore: and Ettore Camesasca, L'opera completa di Michelangelo pittore, Milan 1967.

Ramsden, E. H.: The letters of Michelangelo, translated from the original Tuscan, edited & annotated, 2 vols., Stanford, (Calif.) 1963.

Steinmann, Ernst: and Rudolph Wittkower, Michelangelo-Bibliographie 1510–1526, Leizpig 1927.

Steinmann, Ernst: Michelangelo im Spiegel seiner Zeit, Leipzig 1930.

Thode, Henry: Michelangelo und das Ende der Renaissance, Berlin 1902–13.

Tolnay, Charles: Michelangelo, Princeton 1943–60.

Vasari, Giorgio: La vita di Michelangelo nelle redazioni del 1550 e del 1568, edited by P. Barocchi, Milan-Naples 1962.

Vecchi, Pierluigi de: and Gianluigi Colalucci, The Sistine Chapel, New York c1994.

Weinberger, Martin: Michelangelo the sculptor, London/New York 1967.

Wilde, Johannes: Italian drawings in the Department of Prints and Drawings in the British Museum, Michelangelo and his studio, London 1953.

Wilde, Johannes: Michelangelo, six lectures, Oxford 1978.

PHOTOGRAPHIC CREDITS

The publishers would like to thank the museums, collectors, archives and photographers for permission to reproduce the works in this book. Particular thanks go to the Scala photographic archives for their productive cooperation.

Bildarchiv Preußischer Kulturbesitz, Berlin Photo: Jörg P. Anders (24 left); © A. Bracchetti/P. Zigrossi, courtesy of the Vatican Museums, Roma (39, 40/41, 42, 43, 44, 45, 46, 47, 48, 49, 50/51, 52, 53, 55, 56, 57, 101); © The British Museum, London (97, 128, 129); Holkham Hall, Norfolk/Bridgeman Art Library, London/New York (33); © Könemann Verlagsgesellschaft mbH, Köln – Photo: Achim Bednorz (123); © Nicolò Orsi Battaglini, Firenze (30 right); Royal Academy of Arts, London/Bridgeman Art Library, London/New York (21); The Royal Collection © Her Majesty Queen Elizabeth II., Windsor, Berkshire (32 top); Scala, Istituto Fotografico Editoriale, Antella/Firenze (7, 9, 10, 12, 13, 14, 15, 16, 17, 18, 19, 20, 23, 24 right, 27, 28, 29, 30 left, 31, 32 bottom, 34, 35, 36, 59, 60/61, 62, 63, 64, 65, 66, 67, 68, 69, 70, 71, 73, 74, 75, 79, 82/83, 84, 85, 86, 88, 89, 90, 91, 93, 95, 96, 99, 100, 101, 102, 103, 104, 105, 106/107, 108, 110, 112, 113, 117, 118, 119, 121, 122, 124, 125, 127, 131, 132, 133); Isabella Stewart Gardner Museum, Boston, Massachusetts (115).